Color

Other Publications:

This volume is one of a series devoted to the art and technology of photography. The books present pictures by outstanding photographers of today and the past, relate the history of photography and provide practical instruction in the use of equipment and materials.

LIFE LIBRARY OF PHOTOGRAPHY

Color
Revised Edition

BY THE EDITORS OF TIME-LIFE BOOKS

TIME-LIFE BOOKS, ALEXANDRIA, VIRGINIA

For information about any
Time-Life book, please write:
Reader Information, Time-Life Books,
541 North Fairbanks Court,
Chicago, Illinois 60611.

TIME-LIFE is a trademark of
Time Incorporated U.S.A.

Library of Congress Cataloguing in Publication Data
Time-Life Books.
 Color.
 (Life library of photography)
 Bibliography: p.
 Includes index.
 1. Color photography. I. Title.
TR510.T55 1981 778.6 80-25753
ISBN 0-8094-4152-7
ISBN 0-8094-4150-0 (retail ed.)
ISBN 0-8094-4151-9 (lib. bdg.)

ON THE COVER: Three vivid color
photographs depicted as consecutive
frames on a simulated strip of 35mm
film demonstrate the dramatic ways color
can enhance three favorite
photographic subjects: a portrait, a
nature study and a landscape. At left,
stark white make-up intensifies the stage
presence of a famous *kabuki* actor in
a close-up portrait taken by Kishin
Shinoyama. At right, deep shadows
cast by available light and a lens
designed for close focusing helped
Ernst Haas capture in detail the brilliant
redness of a rose. Between them, a
photograph of Monument Valley by
Harald Sund reproduces the
unforgettable colors of a desert dawn.

Contents

Time Life Books Inc.
is a wholly owned subsidiary of

TIME INCORPORATED

FOUNDER: Henry R. Luce 1898-1967

Editor-in-Chief: Henry Anatole Grunwald
President: J. Richard Munro
Chairman of the Board: Ralph P. Davidson
Executive Vice President: Clifford J. Grum
Chairman, Executive Committee: James R. Shepley
Editorial Director: Ralph Graves
Group Vice President, Books: Joan D. Manley
Vice Chairman: Arthur Temple

TIME-LIFE BOOKS INC.
MANAGING EDITOR: Jerry Korn
Executive Editor: David Maness
Assistant Managing Editors: Dale M. Brown
(planning), George Constable, Martin Mann,
John Paul Porter, Gerry Schremp (acting)
Art Director: Tom Suzuki
Chief of Research: David L. Harrison
Assistant Art Director: Arnold C. Holeywell
Assistant Chief of Research: Carolyn L. Sackett
Assistant Director of Photography: Dolores A. Littles

CHAIRMAN: John D. McSweeney
President: Carl G. Jaeger
Executive Vice Presidents: John Steven Maxwell,
David J. Walsh
Vice Presidents: George Artandi (comptroller);
Stephen L. Bair (legal counsel); Peter G. Barnes;
Nicholas Benton (public relations); John L. Canova;
Beatrice T. Dobie (personnel); Carol Flaumenhaft
(consumer affairs); James L. Mercer (Europe/South
Pacific); Herbert Sorkin (production); Paul R. Stewart
(marketing)

LIFE LIBRARY OF PHOTOGRAPHY
**EDITORIAL STAFF FOR THE
ORIGINAL EDITION OF** *COLOR:*
EDITOR:Robert G. Mason
Text Editors: Peter Chaitin, James Maxwell
Designer: Raymond Ripper
Assistant Designer: Herbert H. Quarmby
Staff Writer: Kathleen Brandes
Picture Associates: Erik Amfitheatrof,
Carole Kismaric
Chief Researcher: Peggy Bushong
Researchers: Sondra Albert, Monica Horne,
Gail Hansberry, Shirley Miller, Don Nelson,
Kathryn Ritchell
Art Assistant: Jean Held

**EDITORIAL STAFF FOR
THE REVISED EDITION OF** *COLOR:*
EDITOR:Edward Brash
Picture Editor: Neil Kagan
Designer: Sally Collins
Chief Researcher: Katie Hooper McGregor
Text Editor: John Manners
Researchers: Elise Ritter Gibson,
Cathy Gregory, Jeremy N. P. Ross
Art Assistant: Carol Pommer
Editorial Assistant: Jane H. Cody

Special Contributors:
Don Earnest, Gene Thornton (text);
Mel Ingber (technical research)

EDITORIAL PRODUCTION
Production Editor: Douglas B. Graham
Operations Manager: Gennaro C. Esposito,
Gordon E. Buck (assistant)
Assistant Production Editor: Feliciano Madrid
Quality Control: Robert L. Young (director),
James J. Cox (assistant), Daniel J. McSweeney,
Michael G. Wight (associates)
Art Coordinator: Anne B. Landry
Copy Staff: Susan B. Galloway (chief),
Ricki Tarlow, Celia Beattie
Picture Department: Greg Schaler
Traffic: Kimberly K. Lewis

CORRESPONDENTS
Elisabeth Kraemer (Bonn); Margot Hapgood,
Dorothy Bacon, Lesley Coleman (London); Susan
Jonas, Lucy T. Voulgaris (New York); Maria Vincenza
Aloisi, Josephine du Brusle (Paris); Ann Natanson
(Rome). Valuable assistance was also provided by:
Judy Aspinall (London); Jane Walker (Madrid);
Carolyn T. Chubet, Miriam Hsia, Christina Lieberman
(New York); Mimi Murphy (Rome); Katsuko Yamazaki
(Tokyo); Traudl Lessing (Vienna).

*Portions of this book were written by Paul Trachtman.
The editors are indebted to the following individuals
of Time Inc.: George Karas, Chief, Time-Life Photo
Lab, New York City; Herbert Orth, Deputy Chief,
Time-Life Photo Lab, New York City; Melvin L. Scott,
Assistant Picture Editor, Life, New York City; Photo
Equipment Supervisor, Albert Schneider; Time-Life
Photo Lab Color Technicians, Peter Christopoulos,
Luke Conlon, Henry Ehlbeck, Robert Hall.*

Since 1970, when the first edition of this volume was originally published, there have been enormous technical and artistic changes in color photography, setting off a revolution in the medium that is reflected in this extensively revised edition. The speed of color films has doubled so that pictures can now be taken indoors without flash and outdoors without blurring, just as they can with fast black-and-white films. Home processing of color films and prints, made possible by kits of prepackaged chemicals and enlargers with built-in filters, has given photographers ultimate control over their images.

These new tools and techniques have had a far-reaching impact on the kinds of photographs that are made. Family and fashion pictures and portraits are now almost exclusively color, as is the work of serious nature photographers. In photojournalism the monopoly that black-and-white photography previously held has been broken, and news — whether from the laboratory or the battlefield — is now regularly reported in color not only in magazines but also in newspapers. During the 1970s several new magazines eliminated black-and-white pictures altogether. Eight new pages in this edition illustrate color's new role in picture journalism *(pages 38-45)*.

Even more dramatic is the swing to color among the artists who make photographs solely for their esthetic value. This serious interest has been aroused partly by the modern color darkroom, which has been streamlined by new materials and equipment. From it a new breed of artist-craftsmen has emerged: the color printmakers. Examples of their masterpieces — many of which have been displayed in galleries and museums — are represented on pages 208 to 214.

Most gratifying of all, perhaps, in this stampede of color, is the medium's discovery of its own recent past. Now, with a historical perspective impossible earlier, this volume devotes an entire chapter to four color innovators — a fashion photographer, a nature photographer, a photojournalist, a war reporter — who began their careers when modern color photography was still in its infancy and continue to influence it today.

The extent of the changes that have come to color photography is indicated by the extent of the changes made for this revision: Of the 275 pictures in this volume, 112 did not appear in the original edition; in all, 140 pages were updated or completely redone.

The remainder of this volume retains those parts of the original edition that will never go out of date. In its revised form it demonstrates more powerfully than was possible in 1970 the exciting extra dimension color gives to almost every kind of subject, and describes how modern film was invented, how it works and how to use it with ease. And finally it attempts to show the beauty that can be achieved in color. For today the only constraints on the color photographer are the limits of his own imagination.

The Editors

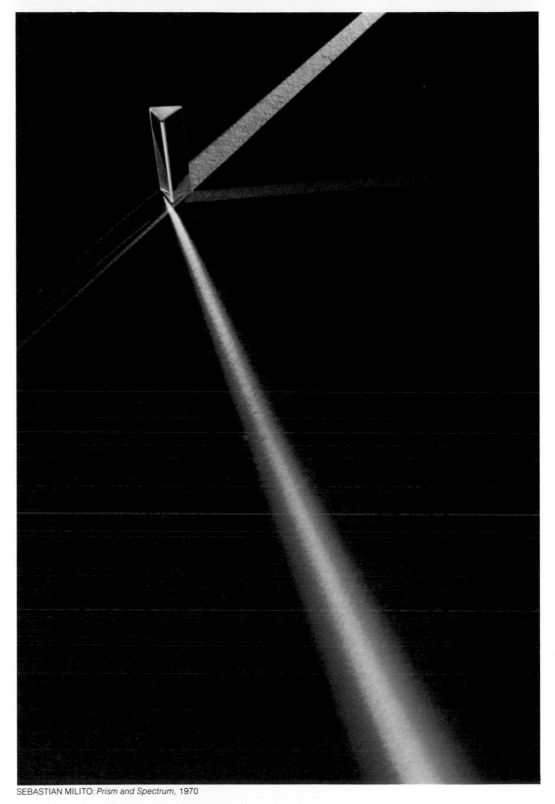

SEBASTIAN MILITO: *Prism and Spectrum*, 1970

Capturing the Colors in Light

From the first Stone Age hunters who painted images on the walls of their caves to the first moon voyagers who turned their cameras back upon a swirling blue planet alight in the dark sea of space, men have always sought to capture the colors of the world. The colors they capture—whether in pigment on a cave wall or on film in a camera—are, strictly speaking, not the colors of the material object pictured, but of the insubstantial light by which the object is viewed. For all color is the color of light, and all light possesses color, whether men perceive it or not. The particular color associated with an object depends on what happens to light that strikes it.

That light is the source of color was first demonstrated in 1666 by the 23-year-old English genius Isaac Newton, who was simultaneously busy inventing calculus and devising equations for gravity. Newton passed a beam of sunlight through a glass prism, producing the rainbow array of hues of the visible spectrum. This phenomenon, demonstrated on page 11, had often been observed before, but it had always been related to latent color that was said to exist in the glass of the prism. Newton, however, took this simple experiment a step further. He passed his miniature rainbow through a second prism that reconstituted the original white beam of light. His conclusion was revolutionary: color is in the light, not in the glass, and the light men see as white is really a mixture of all the colors of the spectrum.

A prism separates the colors of light by bending each color to a different degree. More commonly, the colors of light are separated in other ways. When light strikes a surface, for instance, some of the colors may be absorbed; then the only colors we see are those the surface reflects. An eggshell, in the example at right, reflects all colors of light, and so the eye perceives it as white. But an apple *(opposite)* reflects mainly red light, and absorbs most other colors, so the apple, in our eyes, looks red. Things that transmit light—such as color slides—also absorb specific colors, allowing others to pass through. Whether we look at a color transparency of an apple, a color print of an apple, or the apple itself, it is the color of the light that reaches our eyes that makes the apple look red.

The blue of the sky is the result of another method of natural color separation. As sunlight passes through the atmosphere, the air molecules redirect, or scatter, the wavelengths of light at the blue end of the spectrum more than those at the red end. What we see as the sky is the blue light scattered out of the sun's rays. The reds of the sun itself at sunrise and sunset also result from scattering. When the sun is on the horizon, its direct rays pass through more of the atmosphere than when it is overhead. Over this extra distance, so many of the blues are scattered out of the direct rays of the sun that mainly reds are left to color the image of the sun that reaches us.

How the objects of the world—from atmospheric molecules to apples

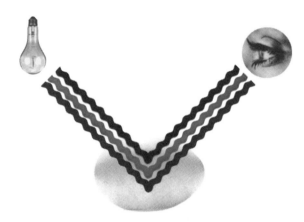

An eggshell looks white because it reflects all the hues, or wavelengths, of white light that reach it. The light supplied by an incandescent bulb includes wavelengths from all parts of the spectrum (reds, greens and blues), and this mixture, reaching the eye, appears white.

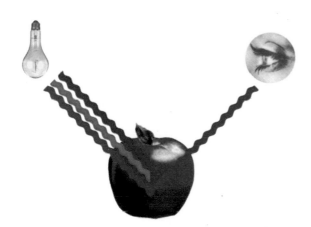

An apple's skin appears red because it absorbs most of the light waves reaching it, but reflects those in the red part of the spectrum. As illustrated above, most of the green and blue wavelengths in the light from an incandescent bulb are absorbed and never reach the eye.

—interact with light to separate its colors could not be fully understood before Einstein showed that matter and energy are, in effect, the same. Light is a form of electromagnetic radiation, which moves in waves rather similar to the ripples on a pond, except that light is vibrations of electric and magnetic forces. Described thus, light behaves as a form of energy. But whenever light interacts with matter—as when it is absorbed by a substance or emitted from a lamp—it behaves as a form of matter, composed of a stream of infinitesimal particles called photons.

The color properties of light depend on its behavior both as waves and as particles. Light is sometimes absorbed by an object, for example, because certain of its photons are captured by the molecules in the object. Different sorts of molecules capture photons of different colors. The chlorophyll in leaves captures photons of red light but not of green; the green photons bounce back out, providing the green light that gives the leaves their color.

For all practical purposes in photography, however, it is most convenient to consider light as waves rather than as photon particles. The lengths of these waves—the distance from wave crest to wave crest—determine their hues. The spectrum of colors we see ranges from reddish light, of relatively long wavelength, through a middle range of greens, to the blues of shorter wavelength. The difference between the shortest and the longest visible wavelengths is only .00012 of an inch, and within that small span are approximately 1,000 distinct hues. Ordinarily, however, "pure" colors of light composed of a single wavelength rarely reach our eyes. Most colors are mixtures of many wavelengths, and what we "see" as a color is the sensation that mixture produces in the human brain. The red light reflected from an apple, for example, consists mostly of wavelengths from the red region of the spectrum, but it also includes a certain portion of blue and green wavelengths (for simplicity these have been omitted from the drawing at left).

It would seem that each such complex mixture of wavelengths would have to be duplicated individually to reproduce the colors of an object in a picture. This was indeed attempted in the first color photographs (Chapter 2), and some success was achieved. But this direct recording of color has not proved practical. Modern methods of color photography take advantage of the fact, long known by painters, that nearly all the colors visible in light can be reproduced by mixing only a few basic colors. Color films are made with three color-sensitive layers, each of which records the wavelengths of light in a different third of the spectrum. Paradoxically, the initial recordings are not even in color; they are black-and-white representations of the three colors. From these three separate color impressions, all the colors of the subject photographed can be mixed during processing of the film—and the result provides light in colors that seem to duplicate the original.

To Make Colors, Add or Subtract

Photographically, there are two basic ways to create colors that will match those of the world's visible objects. One method, called additive, starts with a few lights of distinct colors and adds them together to produce some other color. The second method, called subtractive, starts with white light (a mixture of all colors in the spectrum) and, by taking away some colors, leaves the one desired.

In additive mixing, as illustrated at right, the basic colors, or primaries, generally used are red, green and blue lights (each providing about one third of the wavelengths in the total spectrum). Mixed in varying proportions they give nearly all colors—and the sum of all three primaries is white. In the subtractive method, illustrated opposite, the primaries are the pigments or dyes that absorb red, green and blue wavelengths, thus subtracting them from white light. These dye colors are cyan (a bluish green), magenta (a purplish pink) and yellow—the "complementary" colors to the three additive primaries. Properly combined, the subtractive primaries can absorb all colors of light, producing black. But, mixed in varying proportions, they too can produce nearly any color in the spectrum.

Whether a particular color is obtained by adding colored lights together or by subtracting some light from the total spectrum, the result is usually the same mixture of wavelengths and will look the same to the eye. The additive process was employed for early color photography. But the subtractive method, while requiring complex chemical techniques, has turned out to be more practical in use and is the basis of all modern color films.

Separate colored lights combine to produce various other colors in the additive method—a mixture of the red plus the green giving yellow, for example. When all three of these primary-colored beams of red, green and blue light overlap, the mixture appears white to the eye.

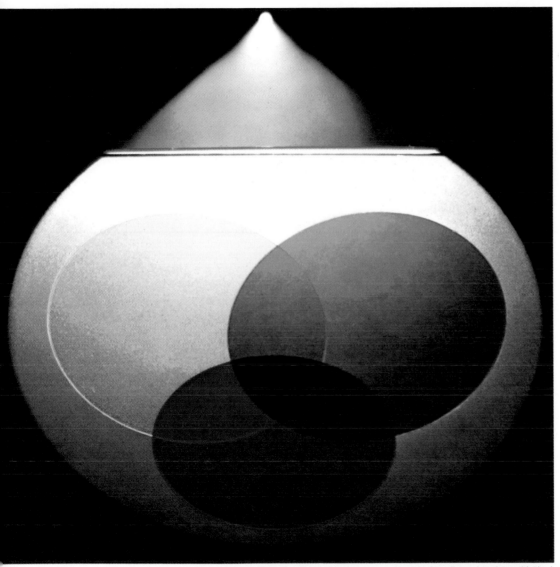

cyan filter blocks red

magenta filter blocks green

yellow filter blocks blue

The subtractive process works by taking some colors away from white light and permitting the remainder to come through. The three disks above are yellow, cyan and magenta filters. Superimposed in pairs over a source of white light, they pass red, green and blue. Where all three overlap, all wavelengths are blocked, producing black. As shown at right, each subtractive filter transmits two thirds of the spectrum and blocks one third. For example, a cyan filter (top right) transmits both green and blue wavelengths but blocks red.

For Slides, Reversal Images

Color photographs begin as black-and-white negatives. Color film consists of three layers of emulsion, each layer basically the same as in black-and-white film, but sensitive only to one third of the spectrum (blues, greens or reds). Thus, when colored light exposes this film, the result is a multilayered black-and-white negative.

To make color transparencies, color is produced as shown graphically at right. After the negative images are developed, the undeveloped emulsion remaining provides positive images by "reversal." The remaining emulsion is exposed (chemically or with light) and the film developed a second time with a different developer. As it converts the light-sensitive silver compounds to metallic silver, the developer becomes oxidized and combines with "coupler" compounds to produce dyes. The three dyes formed, one in each emulsion layer, are the subtractive primaries yellow, magenta and cyan. All the silver is then bleached out and each layer is left with a positive color image.

Thus reds in the subject produce a heavy silver deposit in the red-sensitive layer in the negative—but no trace on the other layers. In the positive, reversal has produced no image in the red-sensitive layer, but a yellow image and a magenta image in the other two layers. When white light shines through the transparency, the red wavelengths pass through all three layers, but blues and greens are absorbed by the yellow and magenta images. Thus the transparency produces the image of one color by subtracting the other colors from white light. Similarly, the superimposed subtractive primaries reproduce all the colors of the original subject.

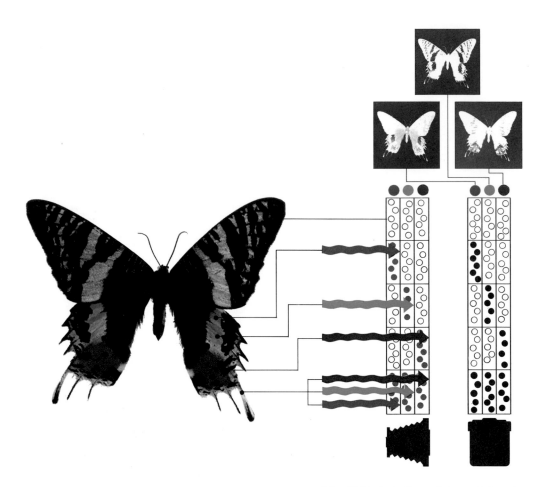

Colored light reflected by a moth is recorded on color-reversal film as three superimposed black-and-white images in three layers of emulsion, each sensitive to blue, green or red light (as indicated by color dots atop the film cross sections). In the exposed film (camera symbol) light of each color produces an invisible latent image, shown by gray dots, on the emulsion layer sensitive to it. Where the moth is black, no emulsion is exposed; where the moth is white, all three layers are exposed equally. During the first development of the film (tank symbol) each latent image is converted into a metallic silver negative image (black dots). Thus, three separate negative images (top) indicate by the density of the silver they contain the amount of each primary color in the moth.

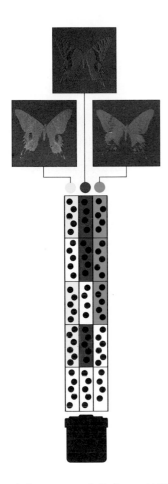

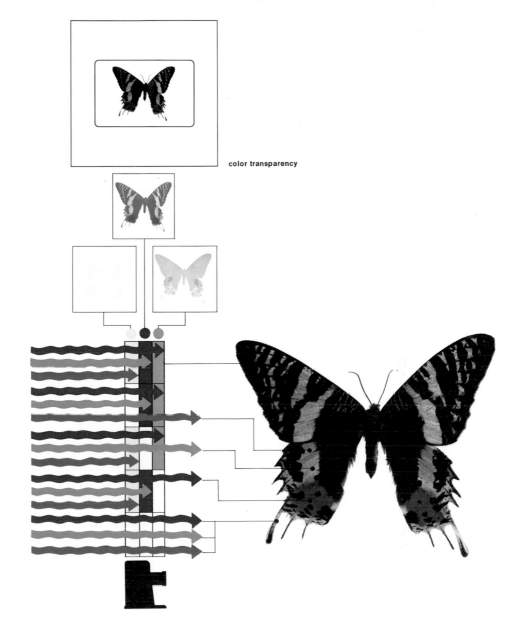

color transparency

Positive color images are created in the exposed film by the reversal process. The emulsion is exposed a second time, either by a flash of light or by means of a chemical agent that serves the same purpose. Silver which has not been previously deposited in the negative images can now be deposited by a second development to form black-and-white positive images (black dots) in the emulsion. As in the first development, the developer is oxidized as it converts the newly exposed silver compounds to metallic silver. The oxidized developer then combines with chemical couplers to produce dyes, forming three positive color images combined with the metallic silver positive images (top). In each layer the dye produced is the complement of the color of the light that was recorded there—yellow dye is formed in the blue-sensitive layer, magenta in the green-sensitive layer and cyan in the red-sensitive layer, as indicated by the color spots above the film cross section.

A color transparency is produced by bleaching out all silver in the emulsion, which leaves only the positive color images in each layer (top). When a beam of white light (projector symbol) is projected through these superimposed color images, each of the colors of the moth is reproduced by the subtraction of the other colors from white light. To reproduce the blue of the moth, for example, magenta and cyan dye images have been formed, but no yellow image has been formed. The greens and reds of the projector's white light have been subtracted by the magenta and cyan dyes, leaving blue. Similarly, varying mixtures of dyes in the transparency produce the whole range of colors of the moth. Black is produced where all the colors of white light are subtracted, white where no color is subtracted by a dye.

17

For Prints, Negative Color

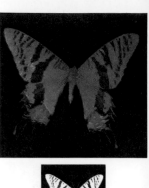

color negative

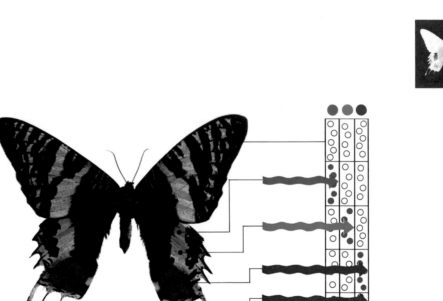

The film that is used to make paper prints in full color works in essentially the same way as reversal film, but with one important exception: It is almost always processed into a negative of the subject—that is, light areas show as dark areas, and colors appear as their complementary hues.

The negative color results because the dyes are formed during the first, rather than a second, development. After exposure, each emulsion layer is developed into a black-and-white negative. The oxidized developer and couplers then react to form a dye. Once the silver is bleached out, the three emulsion layers contain superimposed yellow, magenta and cyan images, each a complement (and a negative) of the original blues, greens and reds.

When white light is passed through this color negative, the layers of subtractive primaries absorb all the original colors of the image and transmit their complements. Where there was a red spot on the original, for example, red light is absorbed by its cyan image on the negative, while a spot of green and blue light is transmitted. Similarly, blues and greens in the original appear as their complements, yellow and magenta, in the negative image.

A color positive can be made by printing the color negative image on a three-layered emulsion like that of the original film (except that it is paper-backed). Once again, colors exposing the emulsion are recorded by complementary dyes, laid down with the silver that forms a black-and-white negative. When the silver is bleached out, a cyan spot of light has been recorded as yellow and magenta spots. This gives the red that was in the original.

When color negative film is exposed, the blue-, green- and red-sensitive layers of emulsion (color spots) record latent images (gray dots) that can be developed into black-and-white negatives, just as with reversal film. Blue light, for example, is recorded in the blue-sensitive layer, but leaves no impression in the other two. Colors that are mixtures of the primaries are recorded on several layers. Blacks do not expose any of the emulsion, while white light is recorded in all layers. Each color thus leaves a corresponding negative black-and-white impression on the emulsion.

When exposed color negative film is developed, a black-and-white negative image is produced in each emulsion layer (black dots). During this development, a colored dye is combined with each black-and-white negative image. The dyes are cyan, magenta and yellow—the complements of red, green and blue. Once the silver is bleached out, the three layers (colored dots) show the subject in superimposed negative dye images. The color negative has an overall orange color or "mask," (top) to compensate for distortions that would otherwise occur in printing.

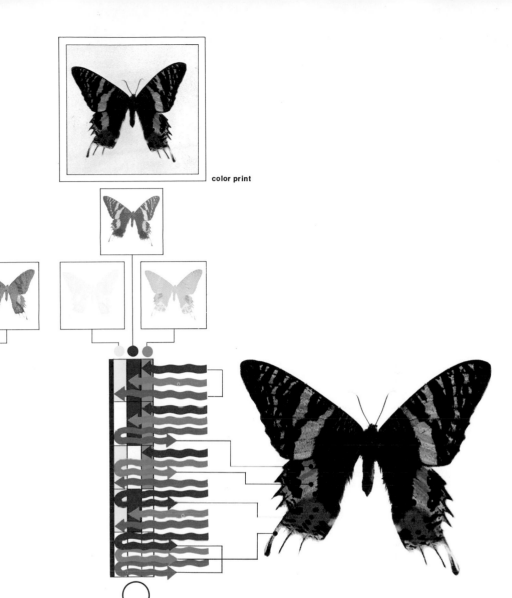

color print

After all silver has been bleached away, three dye images —negatives of the moth's colors —remain (top). This negative color image is then printed (enlarger symbol) on paper with three emulsion layers (coded by color spots atop the paper cross section), like those in film. Where there is a clear area in all negative layers, white light creates a latent image (gray dots) in each layer of print emulsion. But where the negative has a yellow dye image, for example, only red and green light passes, exposing only the red- and green-sensitive layers in the print emulsion.

The print is developed (tray symbol) by a process much like that used for the negative. Each layer of the exposed emulsion (color spots) develops into a black-and-white silver image—a positive image—corresponding to one third of the spectrum. As the silver is deposited, dyes are formed—for example, magenta and cyan in the layers affected wherever green and red light passed through the negative. The result is three positive images —each consisting of dye plus silver—as shown above. The silver is then bleached out, leaving the color images.

The colors that appear in a color print are those reflected back to the eye from the white light (lamp symbol) falling on the print (which above faces the opposite way from the preceding diagram). A blue spot in the moth, for example, looks blue in the print because cyan and magenta dyes in the emulsion layers absorb red and green wavelengths from the incident white light, and only blue lengths are reflected. The full colors of the print (top) are a product of the colors subtracted from white light by the three superimposed dye images, shown separately just above the diagram.

Pictures in an Instant

Like color reversal and negative film *(pages 16-19)*, instant color film relies on light-sensitive silver compounds and dyes of the subtractive primaries—cyan, magenta and yellow—to produce a color image. But with instant film, the multiple operations between exposure and finished print are accomplished in minutes in a "darkroom" inside the film itself.

The most common types of instant color film eliminate the throwaway negative required by the first instant color film *(pages 72-73)*. They use a processing fluid that is stored in a pod on each piece of film and is spread between the layers of the film by rollers as the film—soon to become a print—is ejected from the camera after exposure.

The two diagrams at right show the operation of Polaroid Time-Zero Supercolor SX-70 Land Film. During exposure (camera symbol), light passes through a clear layer to strike each of three emulsion layers. Minutes later, when the film's self-processing is complete (lamp symbol), dyes have migrated from the emulsion layers to the clear layer, where they absorb and reflect light to create the image.

The three diagrams opposite show the workings of Kodak's Instant Print Film PR-10. During exposure (camera symbol), light comes in not from the front, as in the Polaroid material, but from the back. Also, silver crystals in the PR-10 emulsion respond to light deep inside, rather than on their surfaces as do the crystals in other films. When developed, the PR-10 crystals create a direct black-and-white positive, eliminating the negative step altogether. The developer goes on to release dyes near the developed crystals. The dyes then migrate to the image layer to form the color image, which becomes visible through the front.

Polaroid Time-Zero Supercolor SX-70 Land Film

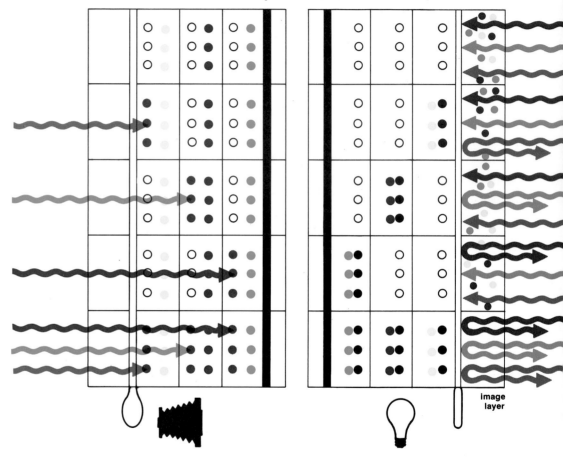

In Polaroid's Time-Zero Supercolor SX-70 Land Film, light exposes silver crystals (gray dots) in three layers. Crystals in each layer react to light of a different primary color. Each layer also has developer-dye (colored dots) that absorbs light of the same primary color. For example, the first layer contains crystals sensitive to blue, together with yellow developer-dye, which absorbs blue light. As exposed film is ejected from the camera, an opaque processing fluid (white bulb) is spread between the clear front layer (left) and the emulsion, cutting off light and starting processing.

The processing fluid activates the developer-dye, which reacts with exposed crystals (black dots) and becomes immobilized there. Around unexposed crystals (empty circles), there is no reaction and developer-dye migrates to the clear front layer (right). The image forms in this layer, where acid fixes the dyes. The white processing fluid becomes a backing for the image and hides immobilized dyes behind. Light striking the print (from the right in this diagram), is absorbed by the freed dyes or reflected by the backing to re-create the colors of the subject.

Kodak Instant Print Film PR-10

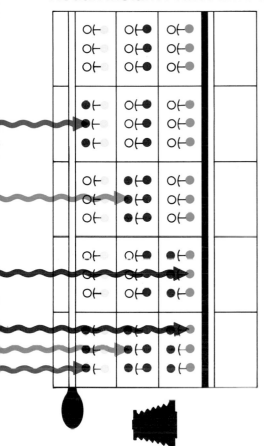

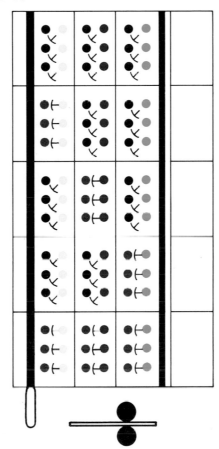

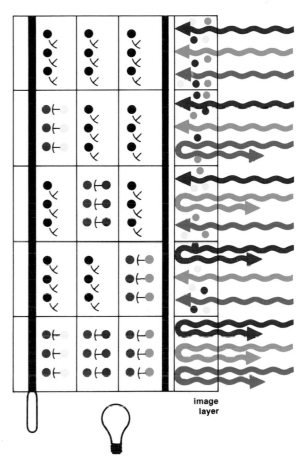

image layer

Colored light reaches the three layers of Kodak Instant Print Film PR-10 through its clear back, (left). Blue light, for example, exposes silver crystals (gray dots) in the blue-sensitive layer, white light exposes crystals in all three layers, and so on. Each emulsion layer also contains dyes chemically held in place (anchored colored dots); these dyes, like those in Polaroid's film, absorb the color of light to which the layer is sensitive.

After exposure, the film is ejected from the camera by rollers that spread the black processing fluid (bulb) throughout a thin layer behind the emulsion, sealing it off from light. A fast-acting fogging chemical in the fluid quickly reacts with all crystals: It affects exposed crystals (gray dots) only in the interiors but affects unexposed crystals (black dots) at their surfaces. The slower developer then goes to work, but affects only previously fogged surfaces, thus only unexposed crystals are turned into metallic silver. The developer also reacts with dyes near the developed crystals, releasing their anchors so that they can migrate to the layer at right.

Released dyes travel to the image layer, where they are fixed in place to form the color picture. In black areas of the image (top), dyes of all three colors are present since the black areas of the subject reflected no light and exposed no crystals. During processing, therefore, dyes of all colors migrated to the image layer, where they absorb all viewing light and make that area of the image appear black. Blue areas of the subject exposed crystals in the blue-sensitive layer so that magenta and cyan dyes in that part of the image were released during processing. They absorb all but blue viewing light, so that area of the image looks blue. Other colors are re-created similarly.

Matching the Emulsion to the Light Source

Color films sometimes record colors that the photographer did not see. When this happens, the picture may look wrong, but this is not the fault of the film. The colors of the world are recorded by the brain, which remembers the way things ought to look and automatically compensates for some alterations in color. Although a white shirt looks white both outdoors in daylight and indoors in artificial light, light from incandescent bulbs has more red wavelengths and fewer blue wavelengths than daylight; thus the white shirt reflects more red light indoors than outdoors. In consequence, it acquires a yellowish cast. Color film records such subtle differences. Therefore, color emulsions are formulated to balance colors in an image as we would see them, not as the balance of wavelengths in the light itself would dictate.

The balance of colors in light is measured by a quality known as color temperature. Temperature acts as the gauge because the spectrum of wave-lengths emitted by an incandescent light source varies as it heats up; the temperature of the source, in addition to its composition, determines what colors of light are emitted. The temperature reading is measured on the Kelvin scale and serves as a standard comparative measure of wavelengths present in the light we see.

Each color film is designed for use with light of a particular color temperature. Daylight film is adjusted to give natural colors with midday sunlight, electronic flash and blue flash bulbs, all of which have color temperatures that range between 4,000° and 6,000° K. Indoor films are balanced for incandescent bulbs—one film for 3,400° K. photofloods, another for 3,200° K. flood lamps.

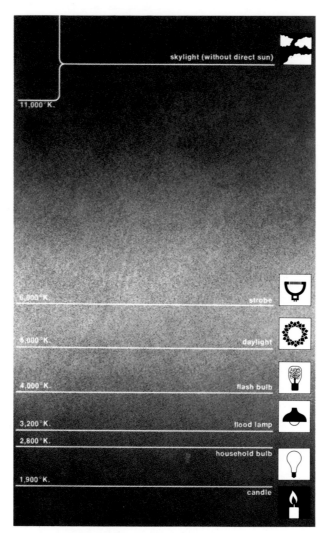

The color temperature chart above indicates the approximate color temperatures of "white" light sources a photographer may encounter. Light of low color temperature has more red wavelengths; light of high color temperature has more blue in it. Noon daylight, which is evenly balanced, has a color temperature of about 5,500° K. Unless a color film is chosen to match the color temperature of the illumination, the resulting picture will have an unnatural color.

The pictures opposite illustrate how color film formulated for different conditions of light-color balance—or color temperature—records different colors when exposed in the same light. The top pictures were all taken in daylight (color temperature 5,500° K.). Photographed with daylight film (left), the colors of the bus look normal. When shot with indoor (tungsten) film formulated for 3,200° K. (center), the bus takes on a heavy bluish cast. If a corrective 85B filter is used, however, indoor film can produce normal colors from outdoor light (right). The bottom row of pictures were all taken indoors in 3,200° K. light. The bride looks normal when photographed with indoor film (left), but daylight film in the same light produces a yellowish cast (center). But a corrective 80A filter can produce a near normal color rendition even when daylight film (right) is used to record the illumination from an incandescent bulb.

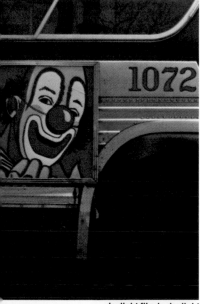

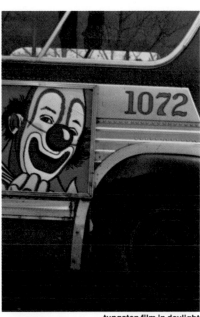

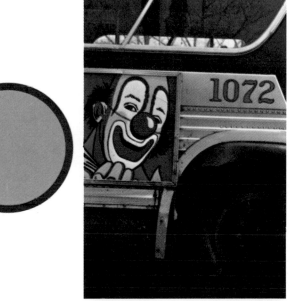

daylight film in daylight

tungsten film in daylight

tungsten film with 85B filter

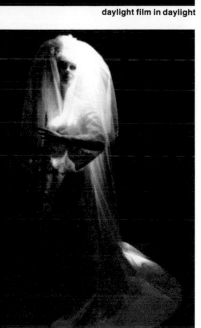

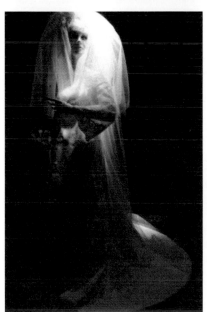

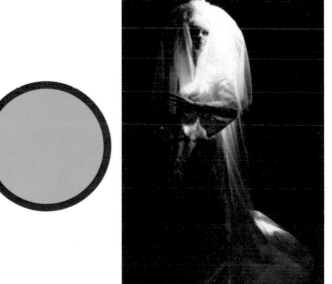

tungsten film in tungsten light

daylight film in tungsten light

daylight film with 80A filter

23

Filters to Correct Imbalance

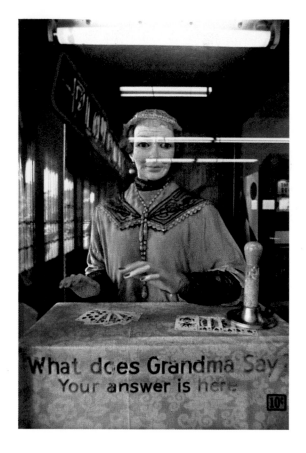

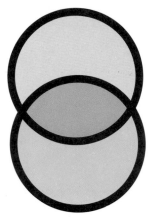

When a penny arcade fortunetelling machine under fluorescent light is photographed with daylight film (left), it takes on a greenish cast, produced by the predominance of green wavelengths in fluorescent light. But a combination of a magenta filter, which absorbs greens and a blue filter, which absorbs reds and greens, alters the light exposing the film so that the color image will look normal, the way the brain expects it to. Another useful filter for fluorescent lighting is an all-purpose FL, or fluorescent, filter.

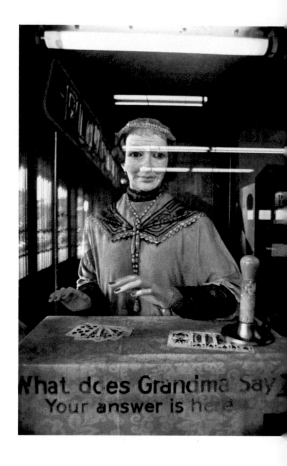

The various types of color film are balanced to match the color temperatures of only a few common light sources — daylight and two popular types of incandescent lamps. Any other lighting conditions give color that may appear inaccurate unless filters are used to compensate for the imbalance.

Such imbalancing light colors are far from rare. They are found late in the day, when the light is reddish (low color temperature) because of the low-lying sun.

They appear in outdoor scenes in shadows, which get no direct sunlight but are illuminated only by the scattered, high-color-temperature blue.

In a picture of a field of snow having a dark shadow, for example, the shadow area will be illuminated mainly by clear blue skylight, and the shadowed snow comes out blue when photographed with ordinary daylight film. A pale "skylight" filter, designed to block some of the sky's light, would reduce the bluish cast of the

shadows as the film records it. Actually, very careful examination of a snowfield under such conditions will disclose the bluish cast in the shadows — but, ordinarily, the brain adapts what the eye sees to what it expects the snow to look like.

A similar problem is posed when a source of light does not emit a smooth distribution of colors across the spectrum, but instead gives off concentrations of one or a few colors. Fluorescent lights are examples of this kind of "discontinu-

The portrait of a young woman illuminated by a dim incandescent bulb has a reddish tinge when photographed with tungsten film (left), because low-wattage lamps produce light of low color temperature. In this instance, an 82C filter compensates for the predominance of red in low-color-temperature light, and the same film gives an image (right) that appears normal.

ous" spectrum. These lights have, in addition to other colors, especially large amounts of blues and greens; however, no two fluorescent bulbs emit quite the same color of light. Although the eye will compensate for such uneven distribution, photographic emulsions cannot, and there are no color films that can record such light as the eye sees it.

The examples on these pages illustrate the inability of films to balance the colors in light from fluorescent and dim incandescent lamps. In both cases, filters adjust the light so that the image produced matches what the eye would see.

To take photographs with good color rendition, it is necessary to know the color temperature of the illumination and to match the film and filters to that temperature. A chart of the temperatures of the most common light sources appears on page 22. Detailed information for matching film and filters to the illumination is supplied by the film manufacturers. □

Extra Dimensions of Color

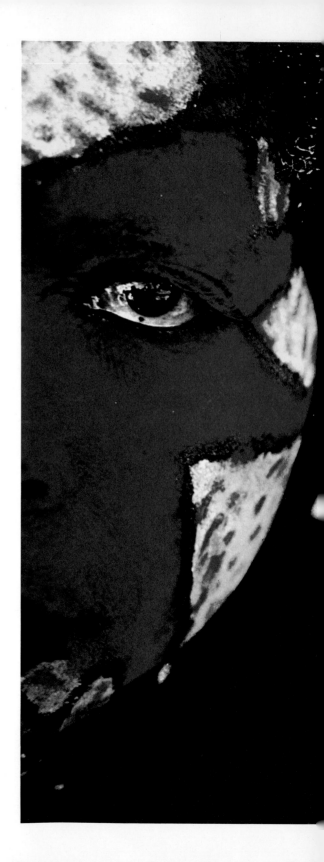

The single dimension of color paradoxically creates many dimensions in a photograph, multiplying a picture's impact in several different ways. Color adds to a photograph's esthetic appeal. But less obviously, it also adds to its meaning. Color can set a scene in time—of day, of year, even of period. (For guidance in taking color pictures at various times of day, see Chapter 3.) Color can mark a place, indicating the kind of locale that appeared before the camera. And it can add to what photographs tell about people, identifying them and illuminating not only their ideas but also their emotions.

In pictures intended to sell a product or promote an idea—like the luscious blueberries commissioned for a calendar of recipes on page 36—color can be an arresting, attention-getting device. Color also helps photographers express private feelings, whether they wish to communicate the joy of a perfect summer day *(page 30)* or the uneventful calm of small-town existence *(page 33)*.

In photographs of people, color becomes a badge that identifies the wearer and establishes him as a specific person in a particular context—and frequently it even reveals what he is doing at the moment. The team colors of a youthful athlete's uniform *(page 34)* are such a badge. So too are the personal designs New Guinea natives at right have painted on their faces.

In creative hands, color can bring out subtleties of personality and complexities of emotions. Marie Cosindas uses color to create an aura of nostalgia around the people she photographs *(page 28)*. Nature photographer John Chang McCurdy gives proof in the picture on page 29 that delicate colors in the right combination can awaken even a city-dweller's imagination to the joys of the coming of spring.

And for many great photographs, color provides even more meaning by adding beauty. Color is its own justification. It *makes* the picture in views of vivid sunsets, blue eyes, wild flowers, painted deserts, azure oceans—even the red-and-yellow-daubed natives of New Guinea.

Vividly painted faces of two women were photographed by Pete Turner at a celebration in the highlands of North-East New Guinea. The colors and designs were until recently traditional, identifying the tribe, but their original purpose has been forgotten and they are now created to suit individual tastes. To keep the colors strong and evenly lighted, Turner posed his subjects in the shade, with only tropical sunlight showing between them.

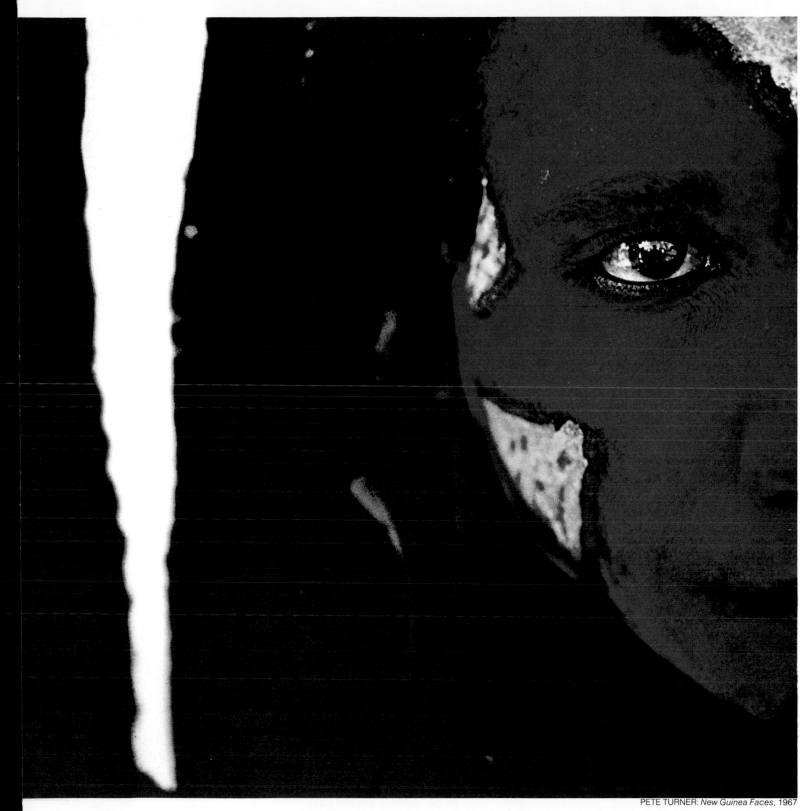

PETE TURNER: *New Guinea Faces,* 1967

Romantic Color

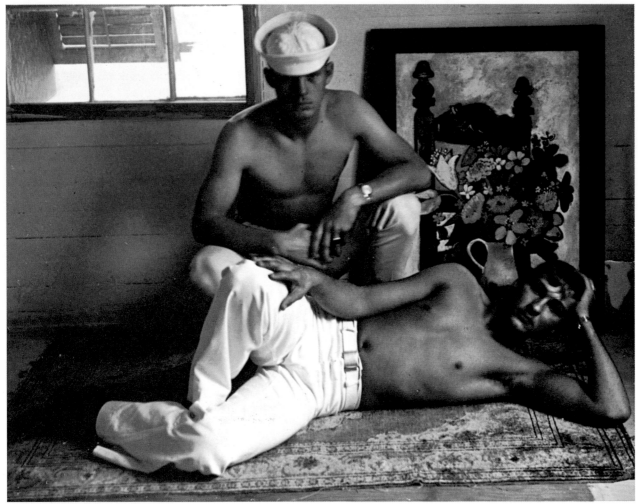

MARIE COSINDAS: *Sailors, Key West,* 1966

Marie Cosindas met these two sailors by chance while traveling in Key West, and by the special genius she showed in using Polacolor 1 film, placed them in a scene that suggested a romantic novel of the '20s. The effect she creates comes partly from muted colors and is caused partly by subdued light, often by long exposure times (as much as 10 seconds) and by extended developing time (as much as 90 seconds, instead of the regular 60 seconds).

Awash in sunlight, the delicate greens, browns and yellows of a meadow in the Great Smoky Mountains of Tennessee give an impression of spring. The picture was deliberately kept slightly out of focus, so that the subtle colors blend and intermingle.

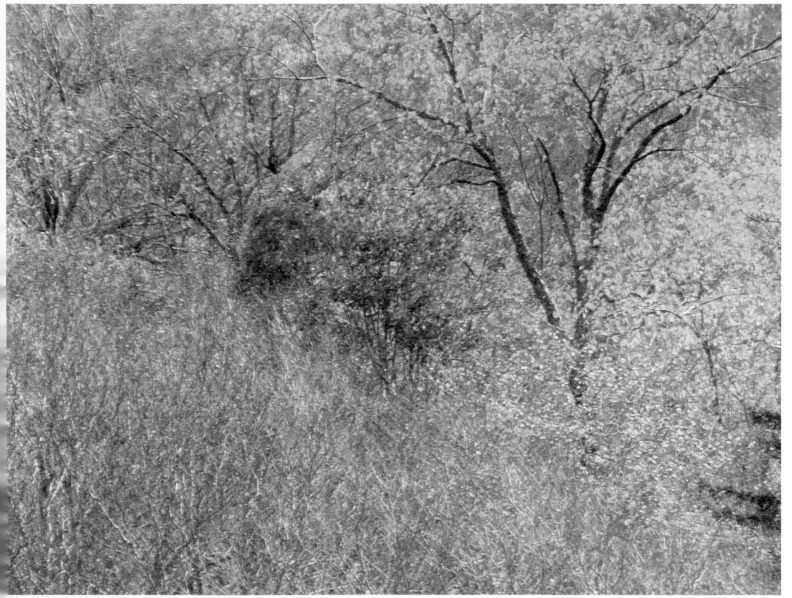

JOHN CHANG McCURDY: *The Smokies*, 1972

Colors of Time and Place

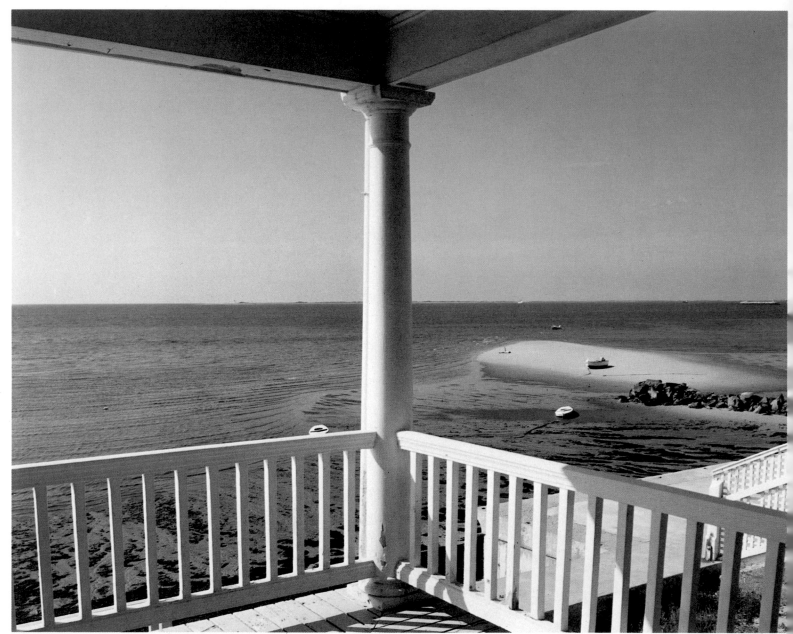

JOEL MEYEROWITZ: *From Porch Series, Provincetown,* 1977

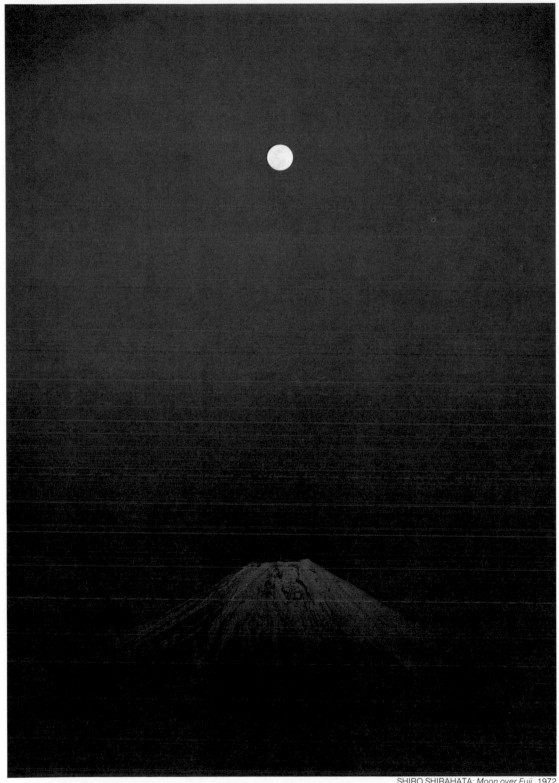

from the porch of a house in a New England beach resort, the radiant blues of sunlit sky and water are contrasted with the cool whites of porch railing and column to create the mood of a perfect summer day. The photographer used an 8 x 10 view camera to record the subtle gradations of light and tone that have become his trademark.

As formal and elegant as a Japanese wood-block print, this somber view of Mount Fuji, its snow-capped summit bathed in the light of a full moon, achieves majestic dignity with dark, muted colors. The photographer, who has published volumes of pictures on Japan's spectacular mountains, also traveled to the mountain ranges of Switzerland, Afghanistan and India to pursue his unusual photographic specialty. He often uses color to help convey the characteristics that distinguish one group of mountains from another.

SHIRO SHIRAHATA: *Moon over Fuji*, 1972

31

Color in the Commonplace

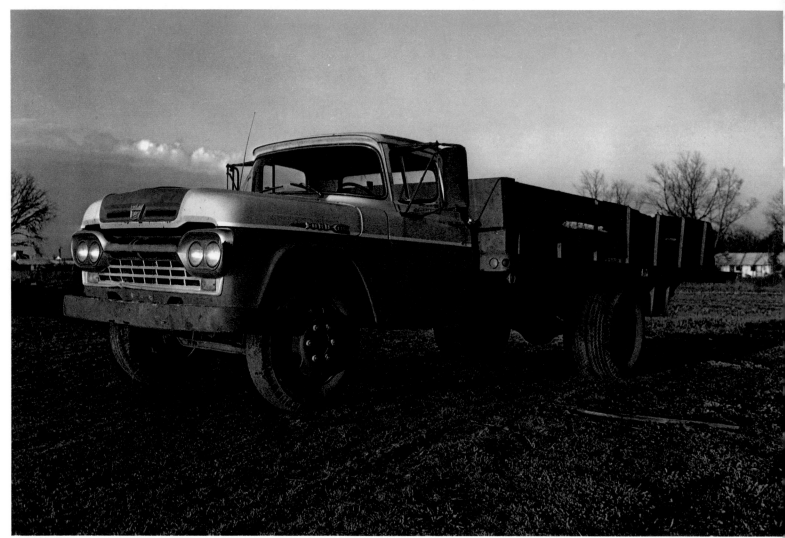

WILLIAM EGGLESTON: *Tallahatchie County, Mississippi,* 1971

Photographed from below to emphasize the contrast between its orange and yellow body and the deep blue sky, a Mississippi farm truck glows in late afternoon sun. Color prints like this one, enlarged 16 times from a 35mm transparency, add drama to the often banal subjects that Eggleston prefers

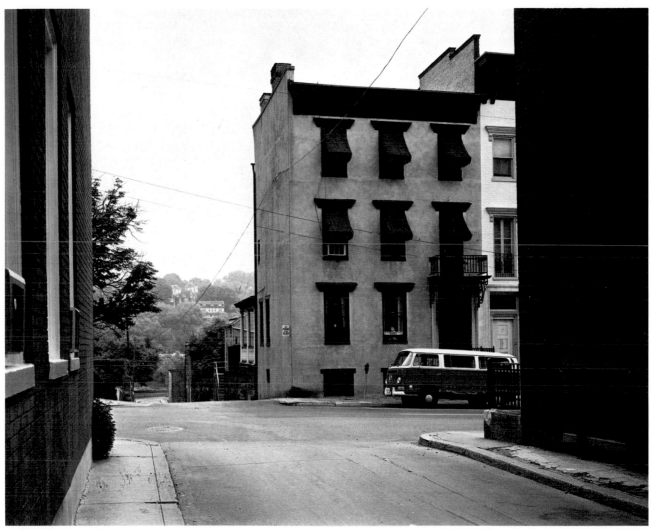

STEPHEN SHORE: *Church Street, Easton, Pennsylvania,* 1974

Gray sky and drab tan and red buildings are the surroundings of a child peering at vacant streets in this view of a Pennsylvania town, suggesting without criticizing the quiet monotony of small-town life. The photographer, a city-dweller who specializes in carefully composed views of American cities and towns, makes color prints from color negative film exposed in an 8 x 10 view camera to get the natural color his low-key approach requires.

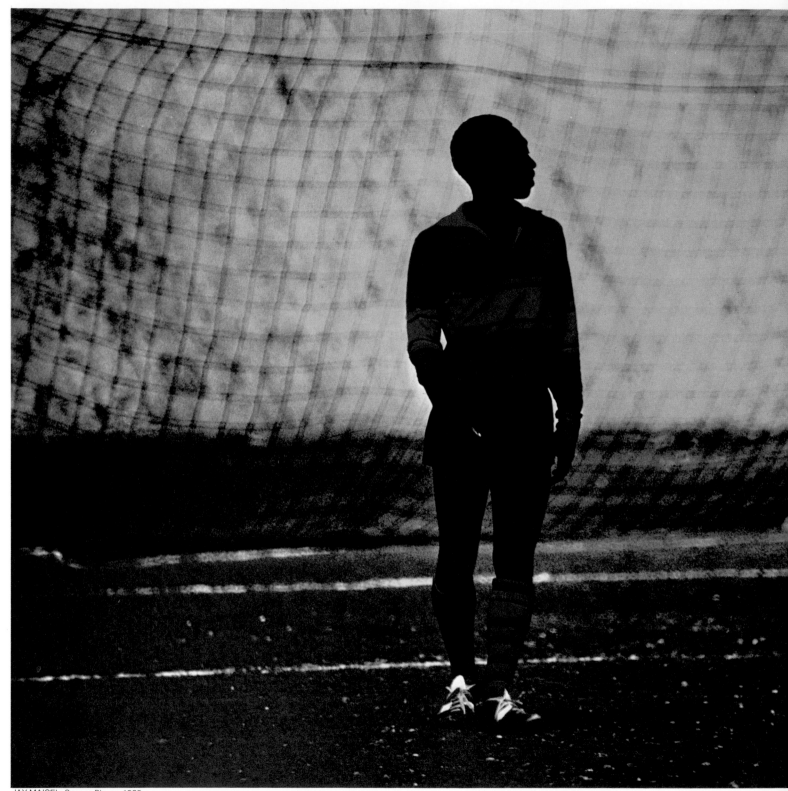

JAY MAISEL: *Soccer Player*, 1966

34

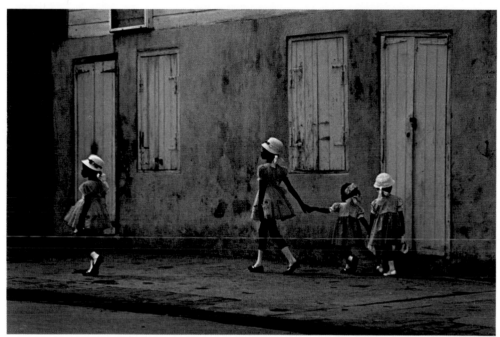

BILL BINZEN: *Sunday in St. Vincent,* 1967

Four little girls, gaily flaunting the pink of their Sunday dresses, make their way to church in St. Vincent in the remote Windward Islands of the Caribbean. They caught the eye of photographer Bill Binzen, who saw in the fresh pastel colors a subtle sign of the naturalness of a people and an island still little affected by the outside world.

Bold stripes of color in this soccer player's uniform are a proud badge of identification for his team in Dakar, Senegal. The colors, seeming to vibrate against the dark field and the yellowish light filtering through the goal cage, draw the eye directly to the figure in the center of the picture and add an intensity, believes photographer Jay Maisel, that the scene could not have attained in black and white.

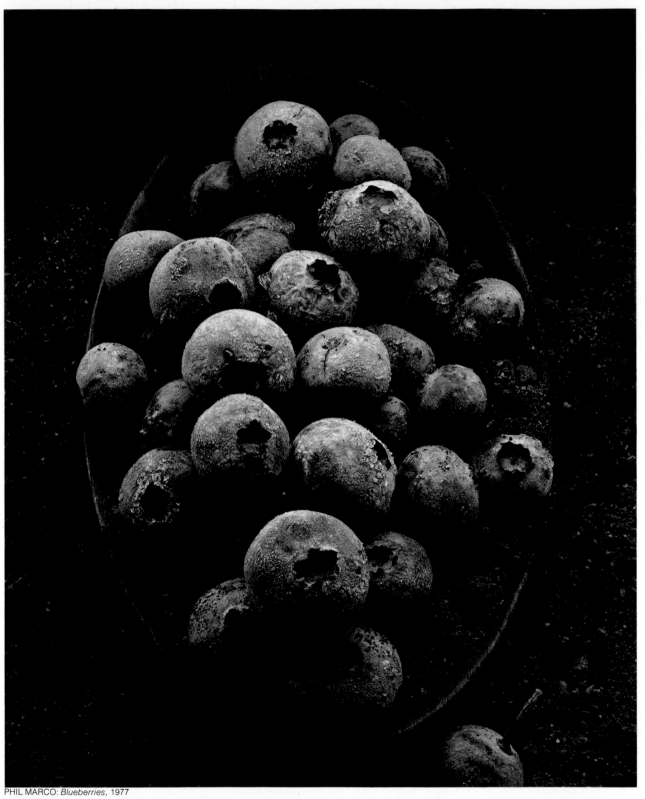

PHIL MARCO: *Blueberries*, 1977

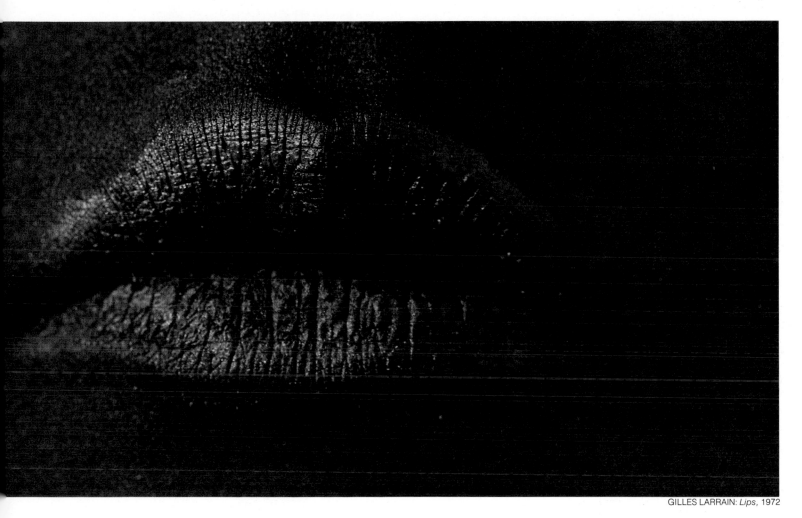

GILLES LARRAIN: *Lips,* 1972

The unnatural golden glitter of painted lips against the purplish brown of dark skin creates an effect at once seductive and haunting in this photograph by a French fashion photographer. He uses color to heighten the artificial aspects of human personality and, in this extreme close-up — produced in his studio by strobe light with a special 55mm macro lens that permits close focusing — strong shadows and sharp details reinforce the bizarre color effect.

he rich, frosty color of blueberries, rendered ith careful attention to their juicy roundness, uggests a world of good eating in this still life ken by a New York City advertising photographer. o illustrate a calendar for a printing company, e photographer created a series of food pictures to ccompany a collection of recipes.

The Color Document

Color not only arrests the eye, it also contributes something important to even the most prosaic of photographs—it adds information. In science, researchers exploring prenatal development, for example, or the surface of a distant planet are able, with the aid of color photography, to see these otherwise inaccessible subjects in approximations of their true colors. In journalism, color brings greater realism and emotional impact, not just to news of art, theater and fashion, but also to the reporting of such grim topics as war and poverty—subjects that formerly seemed inappropriate for color.

In documentary photography, the principal aim of which is to record life as it is, color provides an extra measure of immediacy; it can emphasize the small details that give meaning to a collection of visual facts—the work stains on a miner's hands *(page 43)* or the rich colors of a ceremonial costume *(pages 44-45)*.

The widespread use of color for factual reporting is a comparatively recent development. Until the 1970s, practically all news coverage was done in black and white; color film was slow and color reproduction techniques were costly and time consuming. But the advent of fast color films gave photographers flexibility to make pictures under almost any lighting conditions, just as they could with black and white, and the advances in printing methods make it possible to select color pictures for a story in the morning and see them in print the next day in hundreds of thousands of copies. Moreover, color photography has become so overwhelmingly popular that the cost of color film and processing has fallen in relation to black and white; some professionals find it cheaper to shoot in color.

But the basic reason for the growth in the use of color film in all kinds of reportage is that to most eyes, color makes a more interesting and believable picture. In the photograph of the cave-dwelling Philippine tribesmen at right, color introduces a feeling of warmth and immediacy to what might otherwise have been a rather cold anthropological document, transforming the picture into a moving evocation of the prehistoric past.

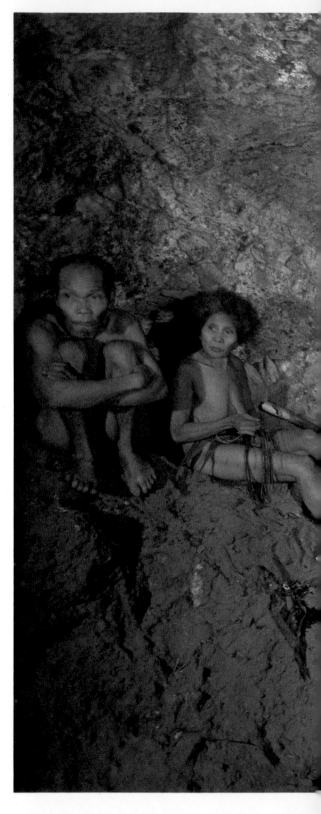

Cave-dwelling Philippine tribesmen called the Tasaday, possibly the last of the world's Stone Age peoples, were photographed by a National Geographic photographer only months after the outside world learned of their existence. With strobe units and Kodachrome film, he accurately reproduced the earthen colors that surround the Tasaday —colors that convey the primitive antiquity of their way of life.

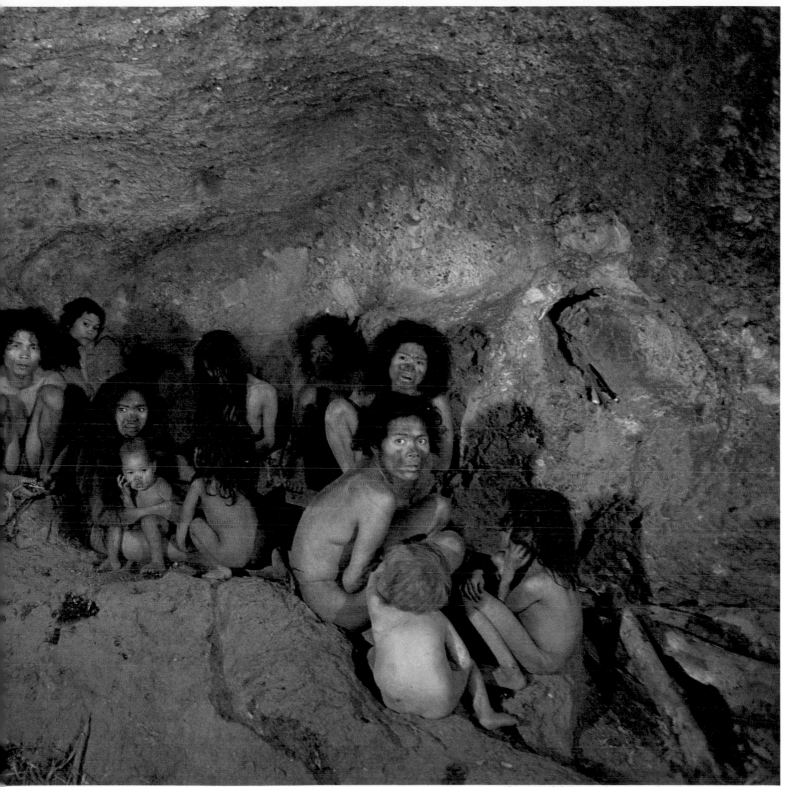

JOHN LAUNOIS: *Tasaday Tribesmen in Their Cave, the Philippines,* 1972

Inner Beauty, Outer Space

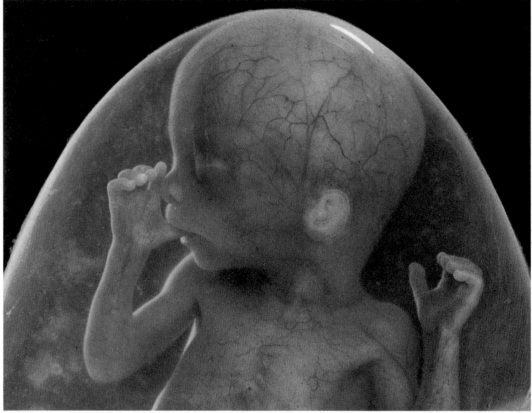

LENNART NILSSON: *Human Fetus*, 1965

In this amazing photograph taken in 1965 as part of a pioneering series depicting human growth, a fetus 18 weeks old sucks its thumb — a prenatal practice that prepares the baby to eat as soon as it is born.

An electronic camera aboard the Viking I spacecraft on Mars radioed to earth this color view of sunset on the planet. The picture was transmitted as a digital code to the Jet Propulsion Laboratory at Pasadena, California, where computers and a laser re-created the image on film. In this print, the shimmering violets and lava-like reds are artificially enhanced colors, heightened to show the rough terrain. The blue object in the right foreground is a generator on the lander. The rings around the sun result from the camera's inability to resolve sharp contrasts into the continuous tones of nature.

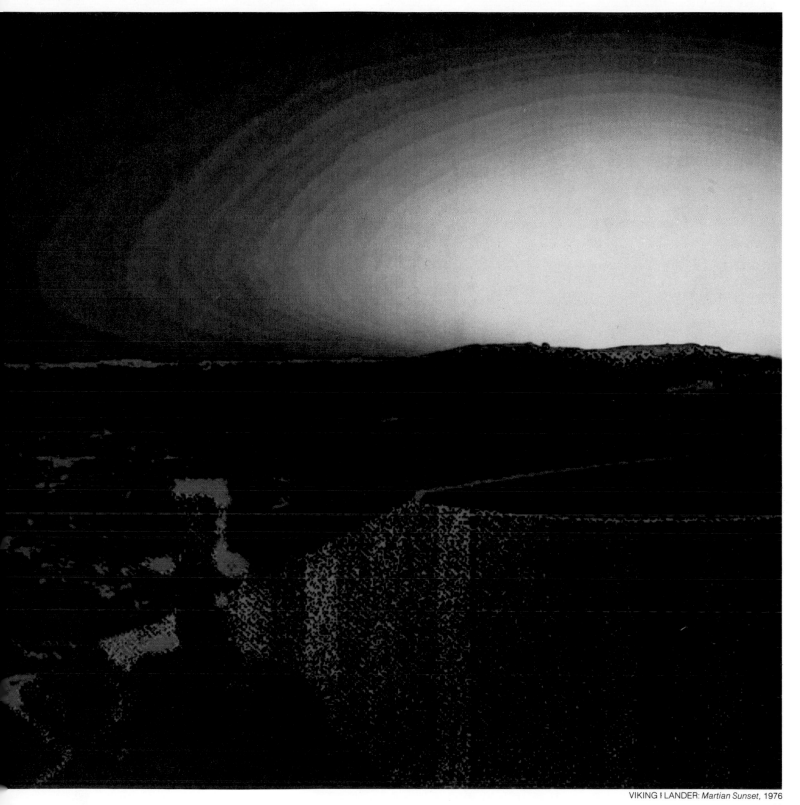

VIKING I LANDER: *Martian Sunset,* 1976

A Forceful View of Hard Truths

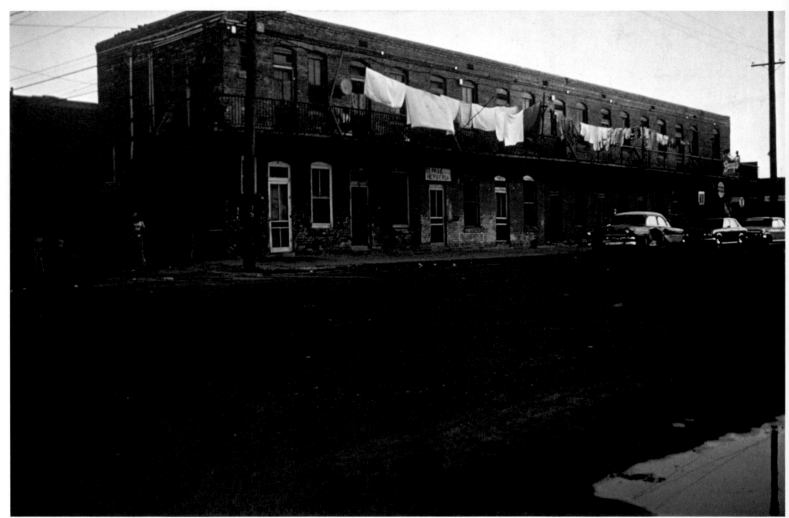

DANNY LYON: *Second Ward, El Paso, Texas, 1972*

Color — so often used to make pretty scenes prettier — here does just the reverse, making the grimness of an El Paso, Texas, slum neighborhood seem even grimmer. The picture was taken for the government-financed Project Documerica, a photographic study begun in 1972 that was intended to illustrate environmental problems in the United States and show what the Environmental Protection Agency and others were doing about them.

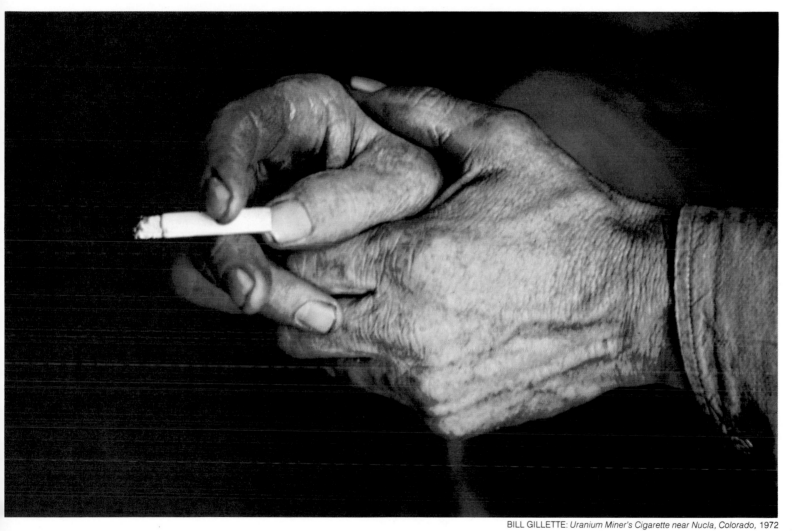

BILL GILLETTE: *Uranium Miner's Cigarette near Nucla, Colorado,* 1972

The hands of a uranium miner taking a cigarette break in an underground lunchroom were photographed for the federally sponsored Project Documerica. Color heightens the contrast between the flesh tones and the grime and stains, underscoring the harshness of a miner's life.

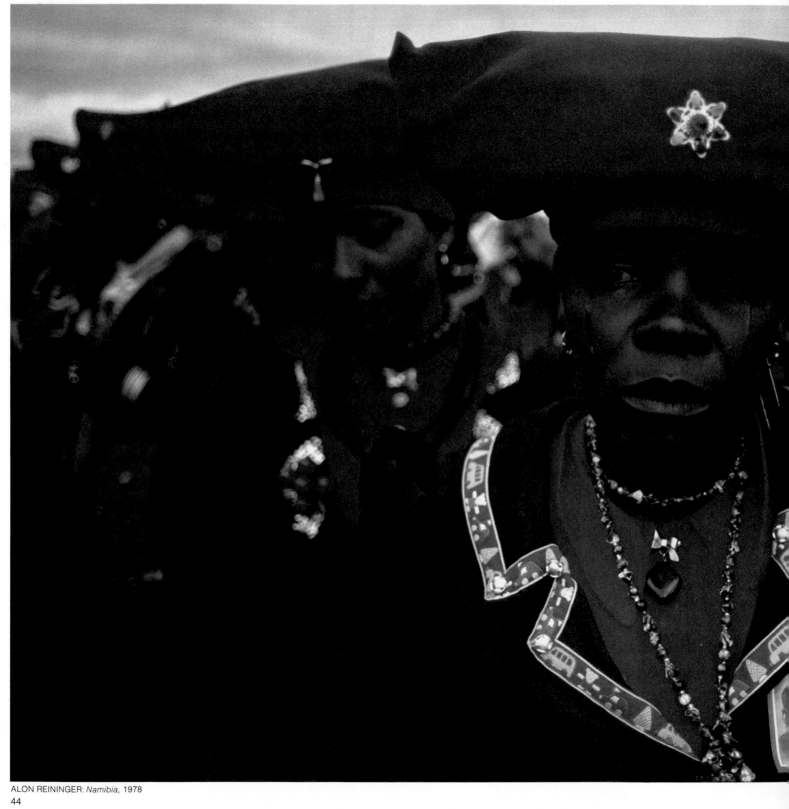

ALON REININGER: *Namibia,* 1978

The colors of ceremonial costumes and jewelry are caught by a New York-based photojournalist covering the funeral of an assassinated chief of the Herero tribe in Namibia—his portrait hangs prominently from the lapels of the grieving women.

Color for Color's Sake

In some of the best color photographs, color itself becomes the subject. One can no longer say of such photographs that color is what helps to make the picture; it *is* the picture.

A few adventurous photographers synthesize color for such purposes. They use a variety of techniques to deliberately distort, reverse and transpose the hues of the real world, or introduce tints of their own making, often with striking effect *(Chapter 7)*. But most photographers of color as color focus on the hues the eye can see. They use these natural colors in sophisticated ways in order to convey unabashed sensory pleasure. The colors communicate nothing in the way of literal meaning, and little if anything of atmosphere or emotion. They are simply there for the viewer to enjoy. And yet the approaches to such a pleasurable use of color are surprisingly varied.

Sometimes, as in the picture at right, the photographer finds a subject whose color is its most interesting aspect—and his task must be to isolate and emphasize the color for its own sake by skillful use of lighting, perspective and contrast-

ing colors. The rainbow hues painted on a wall are more vibrant and exciting when played off against irregular monochromatic patches introduced by a passing pedestrian and her shopping bag.

At other times, the photographer deliberately adds to his scene extra color of his own selection, using this visual spicing to enhance an essentially colorless object. The brass door handle on page 48 might gleam just as brightly in a black-and-white picture, but the addition of color transforms an architectural detail into an imaginative still life. And in some photographs the actual physical look of the subject is ignored. The color brings out a design that would be all but invisible in black and white—on page 54 transforming a familiar glass of soda into an exotic Oriental pattern.

In such pictures the tail exuberantly wags the dog. The color itself takes over as the center of attention and the ostensible subjects—the silverware, fruit, door handles, vegetables and other ordinary objects—are simply excuses for a photographer to celebrate the unsuspected beauty of the world's colors.

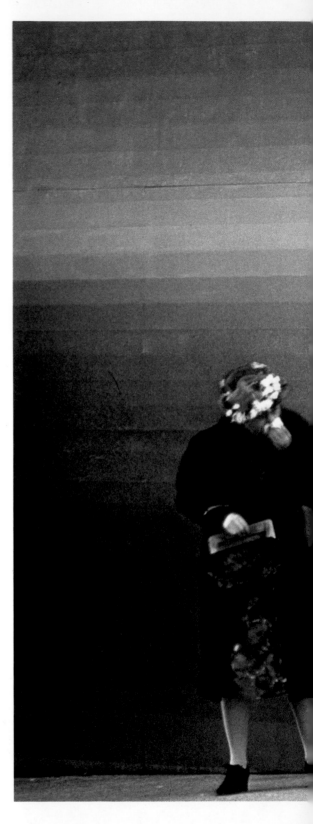

A rainbow of color, painted on the side of a Seattle theater, led the photographer to set up his camera on a tripod across the street and wait until just the right passerby, an elderly woman with a sober black coat and a tan shopping bag, paused to provide the one missing element—an effective contrast to the color. A 300mm lens was used on the 35mm camera to compress the perspective.

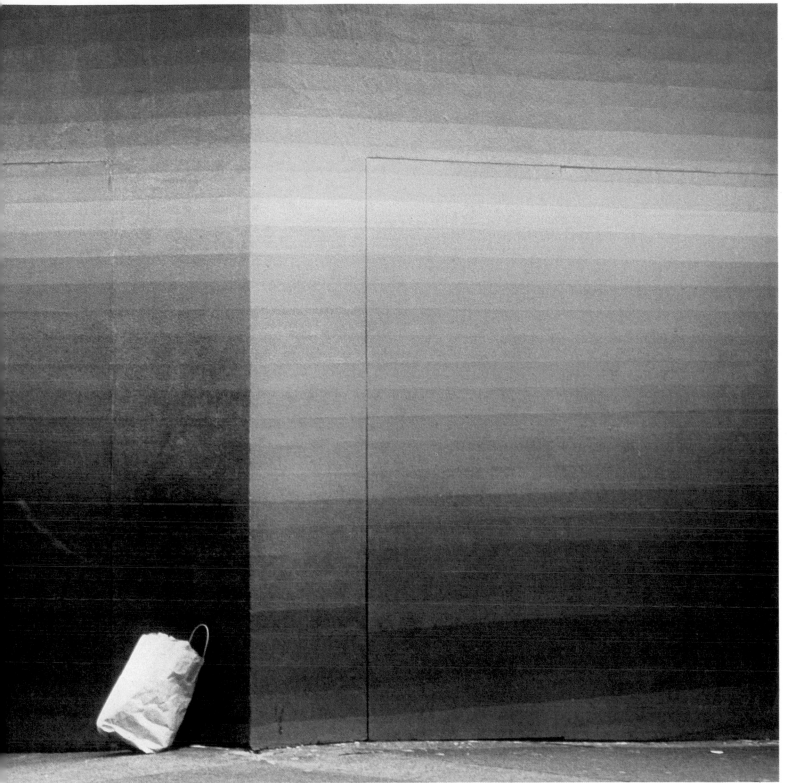

HARALD SUND: *Rainbow Lady*, 1973

47

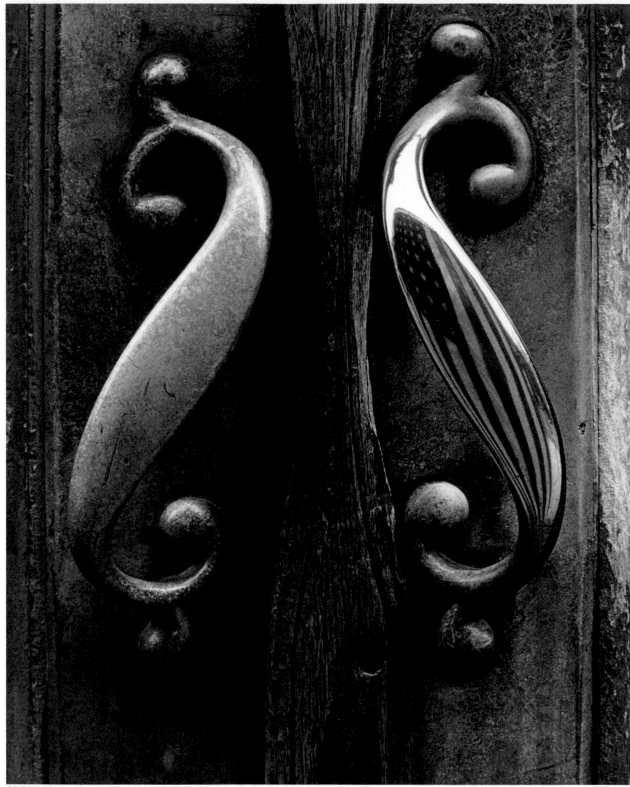

REID MILES: *The Flag*, 1966
48

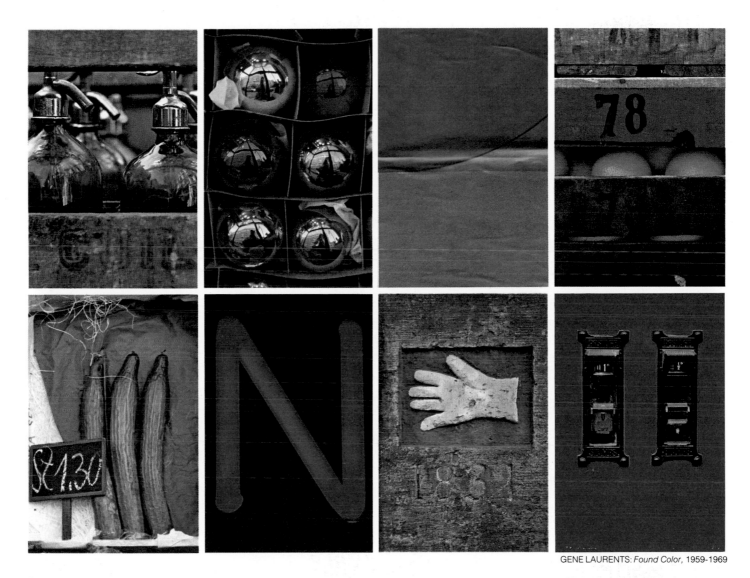

GENE LAURENTS: *Found Color*, 1959-1969

◄ *For a magazine cover with a patriotic motif, Reid Miles carefully set up this picture of a flag reflected in an antique brass door handle. Leaving nothing to chance, he first hunted up a door with an appropriate background color (it turned out to be the entrance to a bar in New York), then draped a nine-foot flag so its reflection fit the handle. "For me, composition is the most important thing," says Miles.*

"A visual game," is the way Gene Laurents describes his quest for colorful commonplace objects like the strange assortment—bottles, fruit, signs, hardware—shown above. "I just like shapes and colors," he says. Though the pictures look casual, they were chosen for their strong, saturated colors and composed to eliminate distractions. Laurents started his collection during a trip to Europe in 1959.

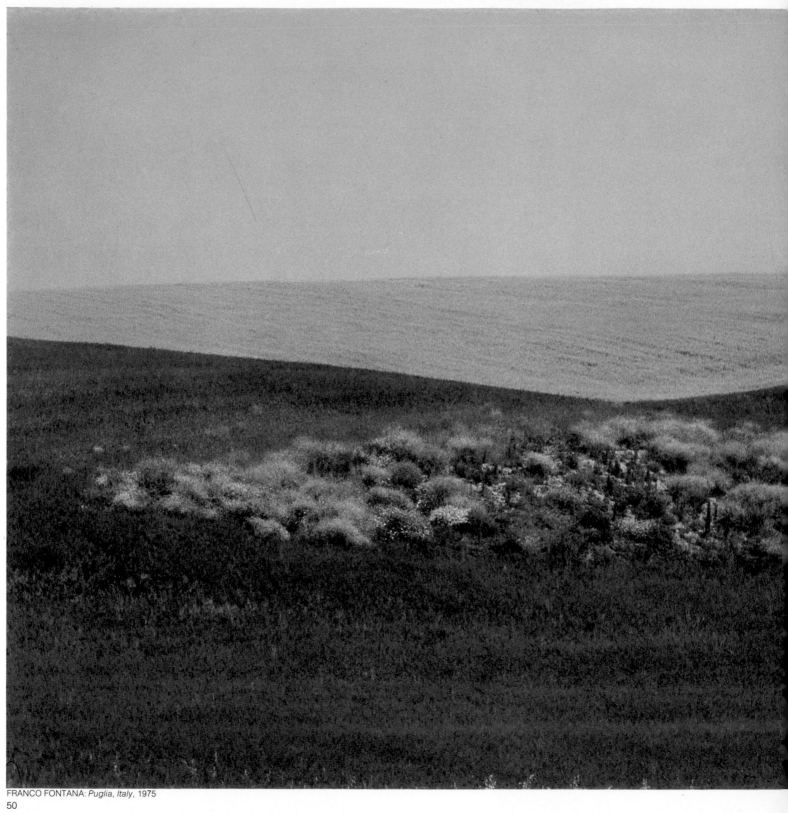

FRANCO FONTANA: *Puglia, Italy,* 1975

50

Patterns in Nature

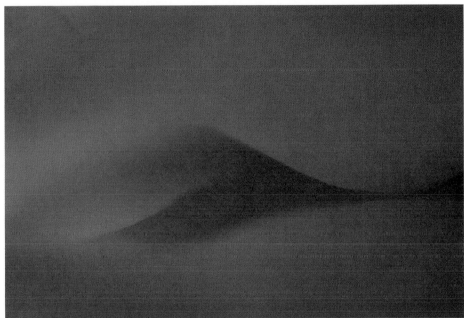

GARY BRAASCH: *Rose,* 1979

To turn the interior of a rose into this sensuous abstraction, a special macro lens was used to record the flower life size from one inch away.

◄ *A field of wild flowers in southern Italy was the setting for this picture, but its real subject is the interplay between the brightly colored patch of flowers and the bands of green and blue that frame it. The photographer creates such magical effects without special equipment: His pictures are shot with color negative film and printed full-frame by a commercial laboratory.*

Abstracting Color

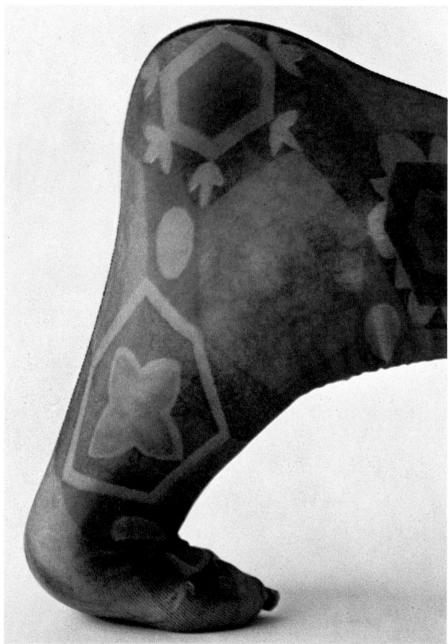

Art Kane took the picture at left to illustrate
a fashion magazine story about women's colored
stockings. Using his combined experience as a
photographer and an art director, he picked
decorative stockings whose colors would blend
easily into semiabstract but still recognizable
shapes such as the bent foot shown here.

Syl Labrot, a painter as well as a photographer, ran
across this curious paint job (right) on the back of a
parked truck in Colorado. Why it was painted this
way he never found out, but Labrot was so taken with
the soft, flat color abstraction — "it was such a
wild-looking thing" — that he took a whole series of
pictures with his 5 x 7 view camera.

ART KANE: *Stocking*, 1967

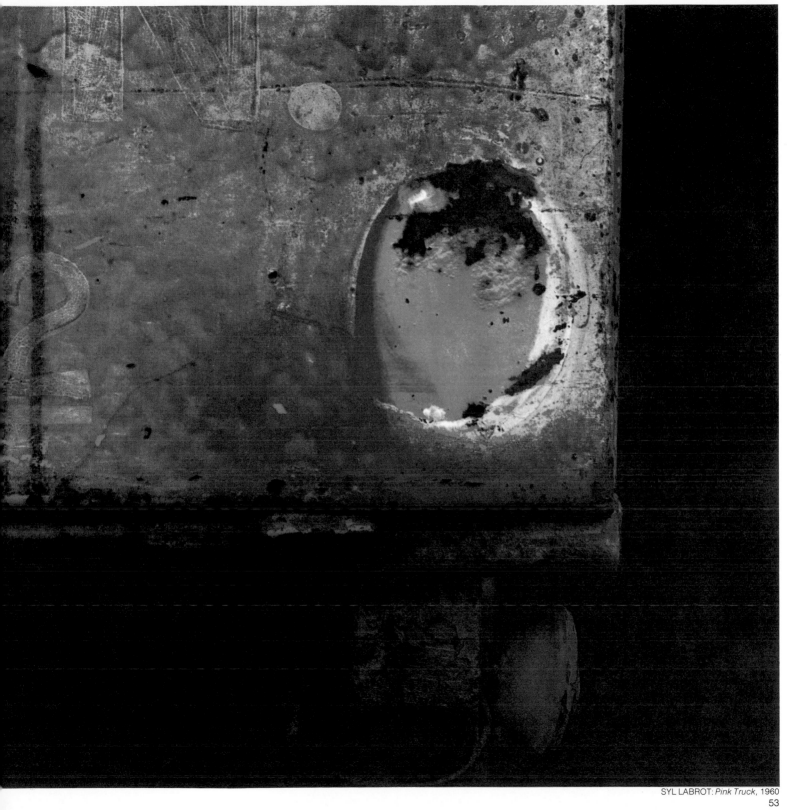

SYL LABROT: *Pink Truck*, 1960

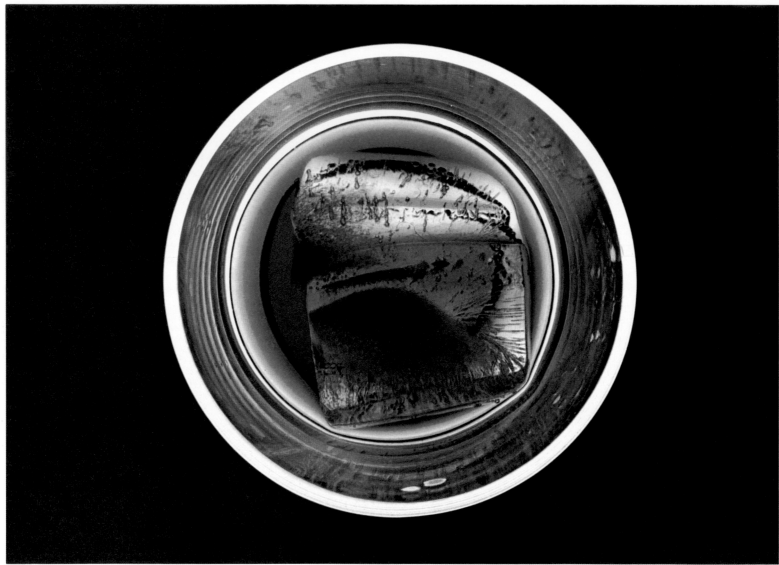

KEN KAY: *Coke,* 1969

Shooting down into a glass of iced cola, Ken Kay transformed a familiar object into an exotic design. With the glass lit from below, the beverage becomes so luminous the viewer hardly sees that the picture has but one main color.

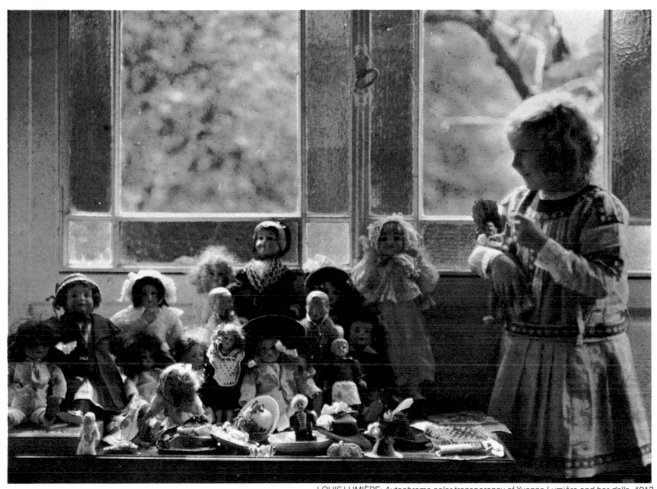

LOUIS LUMIÈRE: *Autochrome color transparency of Yvonne Lumière and her dolls,* 1913

The Musicians Who Found the Key to Color Film

The Kodak Research Laboratories in Rochester, New York, noted for its developments in esoteric areas of chemistry and physics, is not exactly a place where one would expect to find professional musicians. But working away in an equipment-filled section there in the early 1930s were two fine young instrumentalists, a pianist and a violinist, who were about to alter the course of photography by inventing the first simple and effective means of taking pictures in natural color. They were Leopold Godowsky Jr. and Leopold Mannes, scions of two well-known musical families and friends since their school days. What had begun as a teenagers' fascination with photography had now led them to put aside their musical careers and pursue the technological will-o'-the-wisp of color photography. They had formidable competition, for many photographic researchers were experimenting with color processes, and scientists at the famous Agfa plant in Germany were successfully developing methods very similar to their own. But the two young men won out; they became the first—if only by a few months—to produce a workable modern system of taking pictures in color.

The triumph of "Man" and "God" (as the young musicians were affectionately nicknamed by their Rochester colleagues) was an appropriate climax to a century-old search. It had intrigued all manner of men. Some of the greatest scientists of the 19th and 20th Centuries contributed basic methods. There were a number of swindlers promoting "secret color processes" that did not work. Also engaged in the search were a Baptist minister, a French Army captain, a cabaret entertainer and pioneer movie makers—as well as the men who invented black-and-white photography in the first place. For one of the strangest facts about color photography is that, while a method that was both simple and effective was not developed until 1935, fairly good color pictures could be made—if anyone wanted to take the trouble—as early as 1868. And color photographs of a sort were, according to some authorities, produced almost as soon as the first black-and-white ones were, in the 1820s.

The French lithographer Joseph-Nicéphore Niepce, who became the first man to take an actual photograph with a camera, wrote to his brother Claude, "I must succeed in fixing the colors." Louis Jacques Mandé Daguerre, who later formed a partnership with Niepce to create a commercially practical form of black-and-white photography, also worked on color. Evidently these efforts achieved some limited success, for Niepce wrote his son in 1827: "M. Daguerre has arrived at the point of registering on his chemical substance some of the colored rays of the prism. . . . But the difficulties which he encounters grow in proportion to the modifications which this same substance must undergo in order to retain the several colors at the same time. . . . My process seemed to him much preferable and more sat-

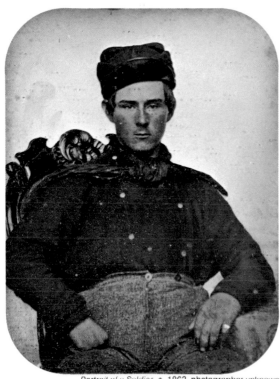

Portrait of a Soldier, c. 1863, photographer unknown

Long before color photography became practical, black-and-white photographs like this portrait of a Civil War soldier were hand-tinted to satisfy the public's desire for color. Only the sitter's skin and shirt were colored while the rest of the picture was left the normally rich tone produced by the ambrotype process that the photographer used—such partial coloring-in by hand was a common practice of the mass-production studios.

isfactory, because of the results which I have obtained." Exactly what processes were explored by Daguerre and Niepce remain lost to history. Certainly it is a measure of the problems to be overcome that, fully a hundred years before "Man" and "God" made color photography simple enough for anyone to use, Niepce and Daguerre had shown it to be possible.

The pioneers' lead was followed by many other inventors, including a number who were highly controversial. One such claimant was the American Baptist minister Levi L. Hill. He made color pictures by 1850, but how he did it he either would not or could not explain. Samuel F. B. Morse, the noted artist-inventor and a leading photography enthusiast, saw some of Hill's work and was enthusiastic: "The colors in Mr. Hill's process are so fixed that the most severe rubbing with a buffer only increases their brilliancy, and no exposure to light has as yet been found to impair their brightness . . . Mr. Hill has made a great discovery. . . ."

The minister was naturally pressed for a description of his process, most of all by professional daguerreotypists, whose business fell off for a time after Hill's work was publicized (their patrons, believing color photography was just around the corner, postponed sitting for portraits). Hill's only response was that he would make his invention available "when I think proper." Somehow the "proper" time never came. According to a photographic journal published shortly after Hill's death in 1865, he "always affirmed . . . that he *did* take pictures in their natural colors, but it was done by an *accidental* combination of chemicals which he could not, for the life of him, again produce!"

It now seems likely that Hill's pictures—and those of Niepce and Daguerre as well—reproduced color because some silver compounds will, under certain circumstances, actually record not only the intensity of light but something of its color as well. That is, the sensitive material adopts the color of the light reaching it. Wherever the emulsion is struck by green light waves —such as those reflected from grass—it turns a greenish shade, and wherever it is struck by blue light from the sky it turns blue. This direct color method was explored by a number of men, including Niepce de Saint-Victor, Joseph-Nicéphore Niepce's cousin. As early as 1851, the year after the Reverend Mr. Hill's announcement, Niepce de Saint-Victor duplicated Hill's accomplishment. The French photographer's claims were well established and he was able to produce naturally colored photographs over and over again, but his pictures, once taken, could be viewed for only a short time. When exposed to light so that they might be seen, they faded, and no way could be found to fix the colors permanently.

The lack of a fixer for direct-color coatings proved an insurmountable handicap (as it still is). So ingenious experimenters turned to indirect meth-

ods. They quickly realized that they could start with a black-and-white photograph and use its shades of gray to control color introduced into the picture at a later stage—either during processing or when the photograph was being viewed.

The first to succeed was a 30-year-old professor at Kings College in London, one of the greatest physicists of all time: James Clerk Maxwell, the man who formulated the mathematical equations connecting magnetism, electricity and light, conceived the idea of electromagnetic waves, and laid the basis for radio and television. Maxwell was primarily a theoretician, not an experimenter (for example, although he must have realized radio waves could be broadcast and received, he never bothered to try). His demonstration of color photography was an infrequent excursion into experimentation, and it was used, not to advance photography, but to illustrate a public lecture about color vision.

In those days of the Victorian era, when science was at least as popular a subject among educated people as it is today, the lecture platform was the principal means for communicating the latest discoveries to the public. And in 1861 a large crowd jammed London's Royal Institution to hear Maxwell expound a now partly superseded hypothesis that the eye is sensitive to only three colors in the visible spectrum—red, green and blue—and sees all other colors, including black and white, as mixtures of those three. To demonstrate this notion, Maxwell had three black-and-white photographs taken of a tartan ribbon. One negative was made with a red filter in front of the camera lens, intended to pass on to the emulsion only the red rays and absorb light rays from all other colors. The second was made with a blue filter on the lens, to pass only blue light, and the third with a green filter, to pass only green light. Lantern slides were then made from each of the three negatives, producing positive transparencies. The slides were all black and white, but each had tones that represented the amount of one of the three colors in the ribbon. To produce a colored image of the ribbon, each slide was placed in a projector fitted with a colored filter appropriate to the slide: red for the slide made with the red camera filter, blue for the slide made with the blue camera filter and green for the remaining slide. These filters colored the light passing through the slides so that now the "red" slide cast a truly red image, and so on. When the three projected images were thrown on a white screen so that they were precisely superimposed, the colors combined, in the additive method of color mixing *(pages 14-15)* to reproduce a single image of the tartan ribbon in its original hues.

Maxwell's demonstration of color photography was all the more amazing because it should not have worked nearly so well as it did. Although the physicist did not know it, the emulsion that had been used was sensitive only

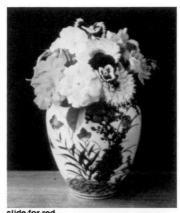
slide for red

red filter

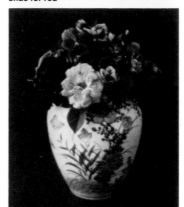
slide for blue

blue filter

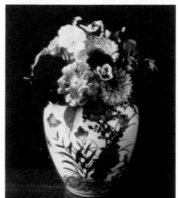
slide for green

green filter

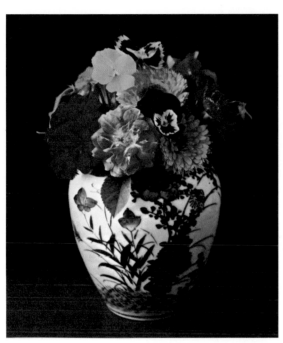

This color still life was made about 1900 by Frederic E. Ives from three black-and-white pictures like those at left. Using the additive method, his camera took three negatives at once, each through a different color filter. Positives were made and projected (below) through filters like those on the camera, the images overlapping to form a color picture.

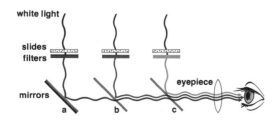

white light

slides
filters

mirrors

eyepiece

a b c

Ives built a viewer using the principle above to display his pictures. The three slides are set above filters like those used to make the negatives. Light, passing through the slide and filter for red, reflects off mirror (a) and passes through one-way mirrors (b) and (c) to form a red image before the eyepiece. Light from the slides for blue and green is similarly transmitted. The images overlap to create a color picture.

to light coming from the blue end of the spectrum, and was insensitive to both green and red. How then could he have recorded anything for his "green" and "red" slides? For a century this question puzzled researchers, and not until the one-hundredth anniversary of the experiment was the answer found. To commemorate the accomplishment, Ralph M. Evans of Eastman Kodak repeated the experiment, using materials like those available to Maxwell. Evans found that Maxwell had been helped by two phenomena he was unaware of. His green filter looked green, but it also passed some blue light; it was this blue that registered on the emulsion and gave an image for the green slide. Red appeared because the red cloth in the ribbon reflected not only red light rays but also ultraviolet rays, which are invisible to the eye but registered on the emulsion. Thus all three slides had images that became colored to the eye only because they were projected through color filters. It was simple coincidence that these false colors combined to produce a natural looking image of the tartan ribbon. But there was nothing wrong with the method; used with sufficiently sensitive emulsions, it works very well indeed.

Not long after Maxwell staged his demonstration, two young Frenchmen thought of another system that was to prove more significant. Although they worked independently of each other—and of Maxwell—they announced their ideas almost simultaneously.

The first report was the work of Charles Cros. Cros was a man of unusual and varied talents. During a lifespan of only 46 years he not only described a landmark process of color photography but studied philology, taught chemistry, practiced medicine, wrote poetry and humorous fiction, and described a device for recording sound the year before Thomas A. Edison patented the phonograph. But perhaps the accomplishment most highly appreciated in the bohemian circles of Paris was his revival of the art of the comic monologue, for Cros was often to be found in Left Bank bistros amusing the patrons as a standup comedian. In 1867, Cros deposited with the French Academy of Sciences an envelope that contained his theories on color photography. According to his instructions, the envelope was to remain sealed until 1876 (presumably to give him time to develop his ideas commercially). However, in 1869, Cros changed his mind and made his process public; he had just learned that his fellow countryman, Louis Ducos du Hauron, was preparing to publish a detailed account of his own accomplishments in color photography. While du Hauron's monograph, *Les Couleurs en Photographie, Solution du Problème,* described several alternative methods, one of them —historically the most important—closely paralleled Cros' speculations.

Du Hauron, born in Langon, near Bordeaux, in 1837, the son of a tax collector, was Cros' antithesis in almost every way. Where Cros was a

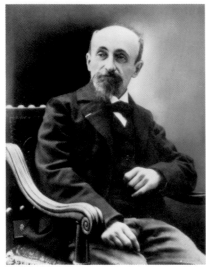

Louis Ducos du Hauron

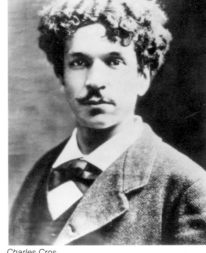

Charles Cros

cosmopolitan, a friend of poets and intellectuals, du Hauron was a provincial. Where Cros—with charming features, a moustache and erect bearing —cut a dashing figure, du Hauron, his body wizened and his small, sharp features hidden by a scraggly beard, seemed the model of a small-town pedant. Where Cros was ebullient and flamboyant, delighting in his ability to arouse laughter, du Hauron was serious. Where Cros flitted from one project to the next without fully exploring the practical possibilities of any, du Hauron was single-minded and determined. Yet despite their dissimilar personalities—and a flurry of antagonism when both claimed credit for inventing the same color process—they eventually became friends.

What Cros and du Hauron had developed was the process now called subtractive *(pages 14-15)*. This is the method that has become the basis of all present-day systems of still color photography *(pages 16-19)*, creating colors by combining dyed images instead of by mixing colored lights, as Maxwell's additive method does. Like the additive method, it requires three images in silver—black-and-white images—representing the red, green and blue in the subject. But the silver image is only an intermediate stage, not the final one as in the additive process. Each silver image is transformed by a series of steps into an image made of a dye, and the dye images are superimposed to provide a single picture with the color already in it. Du Hauron made many color photographs this way, and the few that survive are even today—a century later— astonishingly good renditions of colors.

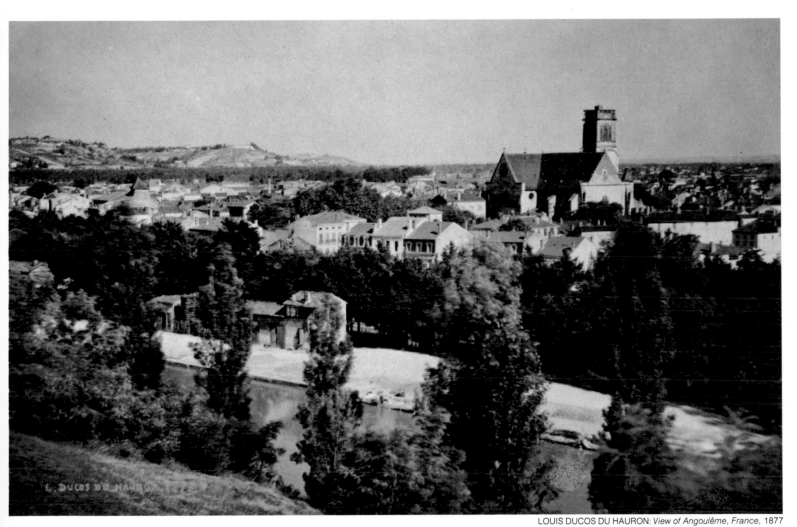

LOUIS DUCOS DU HAURON: *View of Angoulême, France*, 1877

A century ago this full-color landscape of Angoulême, France, was made by a subtractive method—the basis for all color photography today. It is a print composed of three layers of separately dyed images, each made from a separate negative, and was taken by Louis Ducos du Hauron (opposite, left). He proposed the method in 1869, the year Charles Cros (opposite, right) suggested it independently. Subtractive techniques proved impractical, and they were put aside until the mid-1930s.

Although the subtractive method eventually became pre-eminent, it did not do so until the 1930s, when Mannes and Godowsky and others finally overcame the complexities that had made it very difficult to use. For three quarters of a century Maxwell's additive method was more practical.

Both the subtractive and additive methods try to reproduce all the world's colors by mixing varying proportions of a few "primary" colors, usually but not necessarily three. This, unfortunately, never quite works, and some natural shades are omitted or misrepresented (how many depends on the number of primaries used as well as on the skills of the chemist making the film and the photographer using it). There is only one known method of reproducing all colors exactly as they are in nature, and as might be expected, it turns out to be impractical. It was demonstrated in 1891 by a professor of physics at the Sorbonne, Gabriel Lippmann (and won for him a Nobel Prize in 1908). His process made use of the phenomenon of light interference, the interaction of light waves that produces the brilliant arrays of colors seen in soap bubbles and oil slicks. It required a very fine-grain emulsion backed by a bath of mercury; reflections from the mercury surface created the interference in the emulsion that recorded the colors in black and white. Interference in viewing re-created the colors, which were unsurpassed as a literal replica of reality. But since the plate had to be held at a precise angle to the light if the colored image was to be seen at all, and the exposures required were lengthy, limiting subjects to still lifes and landscapes, Lippmann's accomplishment remained a scientific curiosity.

The first practical color photographs were made by variations of Maxwell's additive process, which could be put to work when black-and-white emulsions that were sensitive to the entire visible spectrum became available toward the end of the 19th Century. Both du Hauron and Cros had suggested several ways to simplify the additive system. One of the first such efforts to achieve a degree of success was developed by Frederic E. Ives, a Philadelphian who among other accomplishments introduced an essential element in the modern photoengraving process. In 1892 he built the first of a series of cameras that made three negatives on a single plate—each negative through a different color filter. From these negatives positive transparencies were made and placed in a viewing device—also an Ives invention—called a Kromskop. Filters on the Kromskop restored the colors, and mirrors in the device superimposed the images projected from the three transparencies. The viewer, peering through a peephole in the Kromskop, saw the picture in startlingly vivid color.

A further simplification was patented in 1893 by a Dublin physicist named John Joly, who combined the three separate plates for red, green and blue images into one by dividing the picture into minute interleaved strips (a vari-

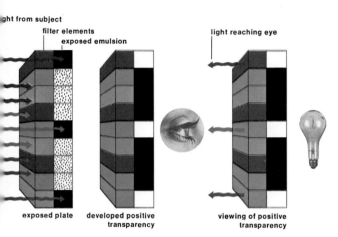

The first color transparencies that could be taken and viewed like modern ones adapted the additive color system to work with a single plate as diagramed above. In front of the emulsion thousands of microscopic color filters (left) break up the picture into minute fragments, each fragment on the negative recording (in black and white) the amounts of red, green and blue light coming from the subject. Red light, for example, passes beyond only the red filters and exposes only the emulsion segments behind them; it cannot pass the blue and green filters to expose their emulsion segments. After development, the negative image is chemically reversed to a positive (center), giving clear areas where red light has passed the red filters, opaque areas where red light was blocked by blue and green filters. When the transparency is viewed (right), the filters color the light passing through the clear segments, re-creating the original hues. Many variations of such a "screen plate" were devised; these illustrations show a greatly magnified section of the filters and the emulsion (their glass support is omitted) of the first screen plate patented by John Joly in 1893.

ation of an idea the foresighted du Hauron had also proposed). Joly covered a glass screen with thin transparent lines in the three colors in an alternating sequence, 200 to the inch. The screen was bound to a black-and-white plate and the sandwich was placed in a camera so that the plate was exposed with the light passing through the screen before it hit the light-sensitive emulsion. Each colored line acted as a filter for the narrow strip of emulsion behind it. One third of the strips recorded the scene's red light, while alternating strips recorded green and blue. After the negative was developed and a positive transparency made, the lined screen was again affixed to the positive, each colored line being superimposed on a strip for the image of that color in the transparency. When light passed through this sandwich of screen and slide, each line added the appropriate color to the strip of image behind it, and the interleaved strips blended to reproduce the colors of the original scene. (Modern color television works on a similar principle.) The Joly method, while certainly an improvement on all that had gone before, had distinct disadvantages. The placing of the screen and transparency together, for example, was a matter of critical importance, for if the colored lines and image strips failed to overlap in precise register by even a thousandth of an inch the color balance was ruined. And of course any great enlargement of the image made the individual strips apparent, breaking up the image into separate streaks of red, green and blue.

Many variations of this idea were later developed. Some employed colored line screens in various patterns—such as zigzags or crosshatching—and others such as the Autochrome plates *(pages 74-80)* invented by Auguste and Louis Lumière, who are most famous for their pioneering work in the movies, used colored dots. All suffered from many of the defects that plagued Joly's plates, but a number of the adaptations—the Autochromes in particular—were practical enough to find considerable use among professionals and some amateurs. They required no special equipment—the plates fitted into standard cameras and could be developed by fairly routine methods. The color that resulted, while hardly a precise rendering of nature by scientific standards, was generally quite pleasing. During the first quarter of the 20th Century, photographers like Edward Steichen, Alfred Stieglitz, and Louis Lumière himself turned out hundreds of delicately hued pictures, and the National Geographic Magazine displayed before millions of readers the exotic color photographs its correspondents brought back from Egypt, India and other romantic lands.

But during the years of World War I, two schoolboys decided they could do better with color photography. Leopold Godowsky Jr. and Leopold Mannes, then in their mid-teens, were classmates at the Riverdale Country School in New York City. Mannes was a promising young pianist whose father was the

noted concert violinist, David Mannes, and whose mother, Clara, was a sister of Walter Damrosch, the eminent conductor. Godowsky was a student of the violin and son of the internationally known pianist, Leopold Godowsky Sr. In addition to being the talented sons of famous musicians, the two boys were avid amateur photographers and they often went out on joint picture-taking excursions. In 1917, the year after they met, the two went off to a movie together, for they were interested in seeing a short called "Our Navy," which was billed as a color motion picture. And indeed the film was in color—of sorts, murky and unnatural tones in which only a portion of the spectrum was reproduced. The boys felt cheated. "We were blissfully ignorant," Godowsky recalled many years later, and with youthful bravado they set out to perfect color movies.

They got permission to use the school physics lab, and proceeded to re-invent Maxwell's additive system, as many another dabbler in color photography has done before and since. They designed and built a camera and a projection device with three paired lenses and filters, one for each of the three primary colors. The projection device had some ingenious features for superimposing the images, and these were sufficiently new to win them a patent—the first of many they would eventually hold. The elder Manneses and Godowskys were suitably impressed and, hoping to encourage their sons in this harmless but intellectually rewarding activity, they offered a loan of $800 for the purchase of equipment. It was a step both sets of parents would have second thoughts about in later years.

Even the boys' graduation from the Riverdale School in June 1917 did not stop their research. Godowsky went off to study at the University of California and to accept positions with symphony orchestras in Los Angeles and San Francisco, and Mannes registered at Harvard, where he continued to study music while working for a degree in physics. While they were separated by a continent, Mannes and Godowsky continued their collaboration by mail, exchanging ideas on improving color processes. During the summers or mid-year holidays they met, either in New York or in Los Angeles, to test their latest brainstorms.

One of these was an idea for an additive color movie process using only two primary colors, but, they hoped, capable of superimposing the color images more reliably than could similar methods that were then in use. Two color filters were used on a double-lens camera to take matched pairs of pictures, side-by-side on a single strip of film. The double-lens device was then transferred to a projection machine for showing the film. To test their idea under actual operating conditions, Mannes and Godowsky prevailed upon S. L. Rothafel, a well-known impresario of the period, under his nickname, "Roxy," to allow them to use his Rialto movie theater in New York. After fit-

JOHN GEORGE CAPSTAFF: *Portrait of George Eastman*, c. 1915

A natural color portrait of George Eastman was made about 1915 in an early attempt to produce dye-tinted transparencies somewhat like those of today. The process was invented by John George Capstaff, a Kodak researcher who contributed a number of key techniques to color photography; it produced a glass sandwich of green- and red-tinted plates, but its color range was limited and it was abandoned.

ting one of the projectors there with their own lens and filter setup, the two young men settled back in their seats to watch the new age of color motion pictures dawn on the mammoth screen. The color that they saw turned out to be quite satisfactory, but they ran into trouble with the theater's projectionist, who refused to be bothered with the chore of having to set up his machine specially to show their films.

Despairing of re-educating the country's projectionists, Mannes and Godowsky almost gave up their experiments altogether. But they soon decided that their approach was wrong: instead of trying to introduce color with filters in an additive process, they agreed to switch to the dyes of a subtractive process. Then the color would be in the film itself, and projection would present no special problems.

By now Godowsky had given up his orchestra jobs in California and rejoined Mannes in New York City, where both worked as musicians during the day and experimented with color photography in their spare time. Their parents' apartments were their laboratories, and they went about their research with single-minded enthusiasm. No bathroom, kitchen or closet in either home was safe from requisition as a makeshift darkroom. Nor was there any way of knowing where the amateur scientists would strike next. Shooed out of one room they merely moved down the hall to another, taking their equipment with them; expelled from one apartment, they invaded the other. But within a few months the two young men had produced a two-layer photographic plate; each layer of emulsion was sensitive to a different portion of the spectrum and could be dyed an appropriate color. Realizing that this was something scientists had been trying to achieve for a quarter century, Mannes and Godowsky quickly took out a patent on their process.

The success that they achieved was all the more remarkable considering the conditions under which they worked. Facilities for coating plates enjoyed by professional researchers in the field were unavailable to them. And their knowledge of chemistry was too limited to permit them to make their own emulsions. Instead, like other amateur photographers, they bought their photographic plates at retail outlets. Then, working entirely in a darkened room, they soaked the plates in water to swell the emulsion, scraped it off, melted it in a pot and recoated it on the glass.

At this point they desperately needed assistance. And, thanks to the first of a number of very timely interventions by influential people, they received it. Robert W. Wood, a renowned physicist at The Johns Hopkins University (and inventor of a not very practical color process of his own), was an acquaintance of the Manneses—the two families had been summertime neighbors at a New York beach resort. He had been shown the equipment made for the Rialto movie demonstration, and in 1922 he wrote in Mannes'

and Godowsky's behalf to Dr. C. E. Kenneth Mees, director of research at Eastman Kodak Company.

Mannes and Godowsky met with Mees at the Chemists' Club in New York, and Mees, after satisfying himself that the two young men were indeed making progress, offered to send them specially coated, two-layer plates prepared to their specifications. But while Mannes and Godowsky were finding allies in the worlds of academia and industry, they were rapidly losing the support of their parents. The elder Manneses and Godowskys were fed up with having their bathrooms and kitchens turned into laboratories. The final straw came when Godowsky Sr. walked into a bathroom and stepped into a tray of chemical sensitizers. What had started out as an admirable adolescent enthusiasm had by now become a source of concern to the parents. From their point of view, their sons—both promising musicians—were slighting bright careers in favor of futile tinkering. Both families took drastic action: eviction. If their sons wished to continue experimenting, it would have to be done somewhere else, not at home. Nor would there be a loan to finance a rented laboratory.

But now help came from an unlikely and unexpected source—the Wall Street investment firm of Kuhn, Loeb and Co. The secretary to one of Kuhn, Loeb's senior partners had struck up an acquaintance with Leopold Mannes aboard ship, while both were returning from a European trip in 1922. Mannes, bubbling over with excitement, described his research in color photography, and managed somehow to infect his fellow passenger with the same enthusiasm. Mannes had forgotten the incident when, some months afterward, a young man named Lewis L. Strauss (who three decades later would be Chairman of the United States Atomic Energy Commission) appeared at the Mannes apartment and introduced himself as a Kuhn, Loeb representative. Strauss said that his firm might be willing to invest a modest amount to further the researches of Mannes and Godowsky, and he asked to see samples of their color pictures. What followed was a scene that might have come out of a slapstick silent movie.

Working in Mannes' kitchen, the two young men showed Strauss some of their procedures. Then they made several exposures and began to process the demonstration pictures. During the tedious process of developing, Strauss was ushered into the living room, where Mannes' sister Marya (later a well-known author and critic) was detailed to entertain him. Usually, developing took no more than 30 minutes or so, but the apartment was unusually cold, and the developing solution would not act in the expected time. When 30 minutes had gone by there was no indication of images on the plates. Mannes and Godowsky hurried out to the parlor to assure their guest that the process would take but a short time longer. More minutes passed,

Two young amateur photographers, Leopold Mannes (left) and Leopold Godowsky Jr., musicians by profession, invented the first truly effective color process, Kodachrome, after years of research that began in their parents' bathrooms and ended in the Kodak Research Laboratories. This 1922 picture shows them in a lab they set up in a New York hotel.

and still no images appeared. Concerned that Strauss might become bored by the delay and walk out, the young men hurried into the living room again and again to try to reassure him. Finally they decided that something had to be done immediately to keep Strauss amused. Mannes and Godowsky left their darkroom-kitchen to play Beethoven sonatas for their important guest. Between movements they dashed back to the kitchen to check on the progress of their plates. Some several musical pieces later, the pictures were sufficiently developed to be shown. Strauss was impressed and persuaded his firm to put up $20,000 (one of the most profitable investments that astute company ever made).

The Kuhn, Loeb grubstake enabled the two musicians to establish a proper laboratory that, while hardly a match for the facilities at Eastman Kodak, was a considerable improvement over kitchens and bathrooms. At first it was set up in what had been a dentist's office, but the inventors later moved a block up Broadway to the Alamac Hotel, then a favorite lodging place for musicians. There, between experiments, Mannes and Godowsky joined fellow artists in performances of chamber music. A more practical advantage of the hotel was its cooperative staff, including bellboys who were eager volunteer lab assistants.

During these years of the mid-1920s, Mannes and Godowsky concentrated on developing their two-color subtractive system—a film with two emulsion layers, one to record green and blue-green and another for red—that had so impressed Mees. By 1924 they had made sufficient progress to receive a patent on their results and the following year they were delighted to find their work mentioned in a new treatise on the history of color photography by E. J. Wall. The Wall book, however, came to have another meaning for them, for it directed their attention to patents taken out just before World War I by the German chemist Rudolf Fischer, and to articles by Fischer and his one-time assistant Johann Wilhelm Siegrist.

Fischer and Siegrist proposed a radical change from the methods previously used for generating the color in pictures made by the subtractive process. Standard dyes had been used. They were introduced into the images after the black-and-white positives had been made from the original negatives and fully developed; each dye had to replace each black-and-white image, forming a color image in its stead. Mannes and Godowsky had done this by controlling the rate at which each dye diffused through layers of their film—a process that is tricky to manage for a two-layer film and even trickier for a three-layer one. As an alternative to this method, Fischer and Siegrist suggested using chemicals called dye couplers, or color formers. These complex substances can be incorporated into an emulsion with the light-sensitive silver compounds, but they have no effect until acted upon by

the developer; then they turn into dyes, generating colors as development of the silver black-and-white images proceeds. In this way the colors are automatically controlled by the progress of the black-and-white development, and processing is greatly simplified.

The two Europeans never applied their idea to a multiple-layer film, but its significance was not lost upon chemists at Kodak in Rochester and Agfa in Germany, who began research into dye couplers—nor upon Mannes and Godowsky. After reading Wall's book, the two young men abandoned the methods they had been using previously and began a long search for dye couplers that could be adapted for use in multilayer film. It was a very difficult effort, for such couplers as they experimented with shared a common and crucial failing: they wandered from one layer of the emulsion to the next, spoiling the quality of the tones.

By 1930 Kodak researchers had perfected black-and-white emulsions that seemed particularly suited to adaptation for color film. Mees, who realized that this discovery could aid his amateur protégés, invited them to come to Rochester and join forces with the Kodak staff.

For Mannes and Godowsky, the move to Rochester was a mixed blessing. Now, of course, they had up-to-date research facilities, and instead of bellhops as helpers they could call upon the assistance of talented physicists and chemists. And somewhat to their surprise, they found themselves at home in the small city of Rochester. It is the home of the Eastman School of Music, and fellow artists there welcomed the two young chemists who dropped in of an evening to join in their music. Godowsky, in fact, was soon playing host to well-attended chamber music sessions at his own house, and once when his father arrived on a visit, assembled a small orchestra in his living room to provide a proper greeting for the senior Godowsky.

But now the two young men also felt constrained to produce something salable; the economic depression of the 1930s was deepening, and as Godowsky put it many years later, "The Kodak Company may not have wished to continue the luxury of two musicians chasing the rainbow in esoteric darkrooms." And they could sense that their most enthusiastic supporter, Mees, was under considerable pressure from the company directors to turn out a marketable product—or fire them.

By 1933 Mannes and Godowsky, with the help of the Kodak research staff, had come up with a color film for home movies. It used only two primaries, but gave reasonably good colors and was much easier to use than amateur color-movie processes then in use (additive types that required specially equipped cameras and projectors). Mees was so impressed that he wished to market the two-color process right away, and despite appeals from Mannes and Godowsky for delay, he ordered final tests prior to public an-

The natural quality that brought instant success to the first modern color film, Kodachrome, is still evident in a beach scene taken in 1936 by Kodak photographer Albert Wittmer. Although most of the early Kodachromes have faded over the years, the colors shown here still accurately duplicate those of the original. They are reproduced from a color print that was made soon after the transparency was processed. Over the years, the print was carefully preserved to keep the color from becoming faded.

nouncement. Mannes and Godowsky were opposed to these moves because they were confident that within a relatively short period of time they would be able to produce a film employing three primaries and therefore providing much more realistic colors.

Mannes and Godowsky determined to perfect a three-color process before the two-color film was placed on sale. Working at a frantic pace, the two young men sought to solve what had become the most difficult problem remaining—that of developing the pictures. Fischer and Siegrist had suggested that the dye couplers, which would ultimately color the images, be included in the layers of emulsion, but Mannes and Godowsky were unable, at that time, to find a method by which these color formers could be properly controlled while they remained an integral part of the film. Now they suggested that this problem be side-stepped for the moment, and that the couplers instead be added to the developing solution and controlled by the diffusion method they had used years before. This required such complex control of the processing operation that it could only be carried out in an elaborately equipped laboratory; photographers would have to send their film back to Rochester for processing—just as, 42 years earlier, the first amateurs using George Eastman's Kodak No. 1 had done with their black-and-white films. (Since this color film was for home movies, which had always been returned to the factory for processing, this system would not seem a strange one to the customers.)

On April 15, 1935, Eastman Kodak placed on sale the film called Koda-chrome, largely the product of the genius of two musicians. The year after its introduction in amateur movie-camera size it was offered in 35mm rolls for still cameras. With the limiting factor that inexpensive paper prints could not yet be made from Kodachrome—like all preceding color films, it produced a positive transparency—the century-old goal of a practical form of color photography was achieved. At first Kodak executives doubted that still photographers would want tiny transparencies that had to be held up to a light to be seen. Then, in a farsighted move, the company decided to return each transparency mounted in a frame of two-by-two-inch cardboard so that it could be inserted in a slide projector and shown on a screen. And the slide show, almost forgotten since the Victorian craze for magic lantern exhibitions, was reborn in a new guise.

Meanwhile, Mannes and Godowsky, together with the Kodak research staff, continued to work on several new variants of the three-color, dye-coupler subtractive color process. From these efforts came Ektachrome, a film with the couplers included in the emulsion so that it could be developed in any well-equipped darkroom, and Kodacolor, a negative-color film from which contact prints and enlargements could be made. But in the race to find

a way to include the couplers in the emulsion, Kodak was outstripped by the German firm Agfa, for within months of the announcement of Kodachrome, Agfa began marketing its own color film, Agfacolor, which included the color formers in the film itself.

Toward the end of the Second World War, United States troops seized the Agfa plant at Wolfen, Germany, and "liberated" the secret details of the method of making Agfacolor; the patent rights were seized as war indemnity, becoming public property, and the formulas were soon distributed to film manufacturers throughout the world. Agfacolor thus became the basis for a variety of color processes, and by the mid-1950s many companies were producing high-quality, easy-to-use color film.

With the perfection of various forms of dye-based color films, a new era opened. So easy was color film to use and so pleasing were the results that by the mid-1950s hundreds of thousands of camera enthusiasts had abandoned black-and-white photography altogether. By 1964 American amateur photographers were taking more pictures in color than in black and white. But ease of use was not matched by ease of processing. While some films could be developed at home, the operation was considerably more involved than that required for black-and-white pictures.

It was all the more astonishing then, when Edwin H. Land, president of the Polaroid Corporation of Cambridge, Massachusetts, announced in late 1962 that his picture-in-a-minute black-and-white process had been adapted to produce color photographs with a film called Polacolor. After snapping the shutter, the photographer simply pulled on the film tab at one end of the camera and 50 seconds later had in his hands a finished print in natural hues.

Although processing the original Polacolor film was simplicity itself, the chemistry on which it was based was extremely complex. All of the chemicals — for automatic processing as well as for coloring — had to be included in a roll of film that was thin enough to fit inside a small camera. Contained within the .001-inch negative part of the film — about half the thickness of a human hair — were six distinct layers (plus a base and two spacers) required to create the negative image. There were three layers of emulsion, each layer being sensitive to only one primary color (no filters were necessary). Next to each of these emulsion layers was a layer that contained specially designed molecules of developer-dye. In addition, there were four other layers that formed the positive image and one layer that contained a pod of an alkaline chemical solution that triggered the processing.

When the user pulled the film tab, the film moved between two rollers that broke the pod and released the alkaline solution. This solution seeped through all layers and activated the other chemicals to start the developing process. When the alkaline solution activated the developer-dye molecules,

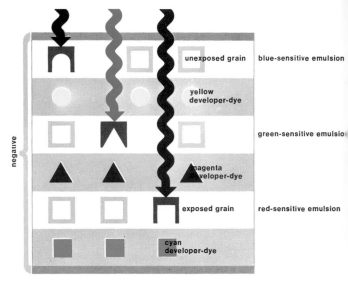

The pioneering Polacolor 1 negative consisted of three double-tiered sections, each one divided into an emulsion layer of silver halide grains (gray-bordered squares) and a layer of developer-dye. Each emulsion layer was sensitive to one of the primary colors. Where blue light struck, grains in the blue-sensitive layer were exposed (black symbols), setting up molecular traps for the yellow color dye chemicals nearby. Green light exposed the emulsion in the green-sensitive layer, passing through the blue section without affecting it. Similarly, red light passed harmlessly through the blue and green layers to expose the red-sensitive grains.

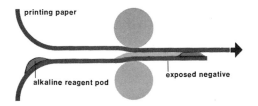

Development of an exposed Polacolor 1 picture began after the tab on the camera was pulled. Attached to the film was a pod filled with an alkaline reagent. As the negative and positive were squeezed through rollers, the pod broke, releasing the reagent to trigger development.

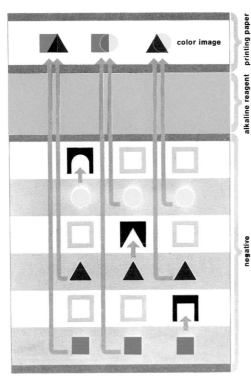

color image

printing paper

alkaline reagent

negative

The alkaline reagent in Polacolor 1 film, spread between the negative and positive, quickly traveled through the negative layers, releasing the special developer-dye molecules. These then spread (arrows) through the negative layers toward the printing paper. Wherever a developer-dye molecule touched an exposed grain of silver halide (black symbol), the molecule reacted with the grain, developing it and becoming trapped there. Because all developer-dye molecules started moving almost at once, they got a chance to react only with grains in the first emulsion layer they reached. Thus the yellow developer-dye reacted with — and was trapped by — exposed grains only in the blue-sensitive layer. The magenta and cyan in that part of the negative, encountering no traps, passed through that layer and reached the printing paper, where they mixed to create blue. Similarly, exposed grains in other layers trapped one color and permitted the other two to pass. All this took 60 seconds. By that time the alkaline reagent had reached acid in the printing paper; the reaction between the acid and alkali stopped all chemical action and bound the dyes into an image of luminous color.

they moved to the associated emulsion layer, developing a negative image and anchoring dye in each negative image area. Elsewhere — outside the negative image — developer-dye was free to move to the paper to form a positive dye image. Thus, yellow dyed the negative image in the blue-sensitive emulsion. Since the yellow dye was stopped at the blue negative image, only the other two dyes — magenta and cyan — got past that part of the negative image and moved on to the positive, where their blending produced various shades of blue.

The same principle applied to the other two color-sensitive emulsion layers and their associated layers of dye and developer. By this method, all three dyes could find their way to the proper positive layer where they combined and produced all the hues of nature. Fixing occurred in the last few seconds when a small amount of the alkaline solution reached the acid molecules in one of the positive layers. The combination of acid and alkali generated water, which washed the remaining alkali from the positive image, thus halting the developing process. The dye molecules then could move closer together, forming a permanent bond that sealed the picture.

In 1974 Polaroid introduced the SX-70 instant-picture system *(page 20)*. The first integral instant film, SX-70 was not only self-timing but also eliminated the pulling of tabs and the peeling of positive from negative. The film used metallic dyes that had been developed especially for it, producing exceptionally brilliant pictures that resist fading. Two years later, using the same dyes it had developed for SX-70 film, the company came out with Polacolor 2, whose basic process is similar to that of the pioneer Polacolor 1. Like SX-70 film, however, Polacolor 2 provided brilliant color and remarkable fade-resistance, and was much sharper than the original Polacolor. In 1976 Eastman Kodak finally broke Polaroid's 28-year monopoly on instant pictures with its PR-10, a revolutionary film that produced positive images by a direct-positive method, a scheme that had been little used previously *(page 21)*.

Since photographers have a wide variety of color processes to choose from now, equipment and methods usually associated with the chemist's laboratory no longer are needed to produce colorful pictures. The majority of the films can be used in any camera, from the cheapest to the most expensive, without special accessories. They take pictures readily in dim as well as bright light, matching the speed of commonly used black-and-white films. Some produce a finished print on the spot, while others can be processed in an ordinary darkroom by techniques quite similar to those used for black-and-white films *(pages 174-195)*. All can reproduce the hues of the world with astonishing reality (or, at the photographer's option, with surprisingly effective unreality). Yet, each reproduces tones in a different way allowing every photographer to choose a film that presents his private vision of color. □

The Color of the Past

Charming color pictures were being taken as long ago as the first decade of the 20th Century. The procedures that were used were cumbersome by modern standards, but the results were remarkably good, as the pictures on the following pages show. These examples were all made by the first practical color process, Autochrome, which was invented by the brothers Auguste and Louis Lumière of Lyons, France.

The Lumière brothers built up the photographic supply business that had been founded by their father (it still bears the family name and is one of the principal manufacturers of photographic equipment in France). The brothers were also pioneers in motion pictures; in 1895 they invented one of the first projection machines, a very ingenious combination of camera-projector-processing unit—all in one portable box—and sent crews out to take movies of far-off lands. Their firm produced more than 1,800 short films within a few years, but the brothers were less interested in entertainment than in experimental work (medical research occupied Auguste for much of the latter half of his 92-year lifetime).

Near the turn of the century the Lumières turned their talents to color photography and by 1907 had perfected the Autochrome process. Like other techniques of the time, it employed the additive method *(pages 14-15, 60-61 and 64-65),* recording a scene as separate black-and-white images representing red, green and blue, and then reconstituting color with the help of filters. To do this on a single plate, the Lumières dusted it with millions of microscopic, transparent grains of potato starch that they had dyed red, green and blue. Then they applied pressure to the plate to squash the grains flat and fill the plate more evenly. The interstices between the starch grains were filled with carbon black, and the plate was covered with a thin coating of black-and-white emulsion. Exposure was made with the glass side of the plate facing the lens so that the grains acted as tiny color filters, each passing along light of its own hue; they thus broke the image up into dots representing the primary colors. After the plate was processed into a positive transparency, light passing through the grains gave each dot in the image its color.

Autochrome produced color more reliably than earlier processes, but it did have its own defects—principally the color spots that are noticeable in some pictures. These spots are not individual grains of colored starch—the diameter of each grain averaged .0005 inch, much too small to be visible in a reproduction. The spots appear because the tiny starch grains could not be uniformly mixed, and some stuck together in like-colored clumps, which are big enough to see.

In spite of its shortcomings, Autochrome quickly found wide use, and by 1913 the Lumière plant at Monplaisir, on the outskirts of Lyons, was turning out 6,000 plates a day. Autochrome plates continued to be produced until 1932—only three years before the introduction of the first modern color film. In that quarter century, they were used by amateurs and professionals in many countries to take informal family pictures as well as formal studio portraits. But seldom were the results any more delightful than in those Autochromes photographed, like the one on the opposite page, by Louis Lumière himself.

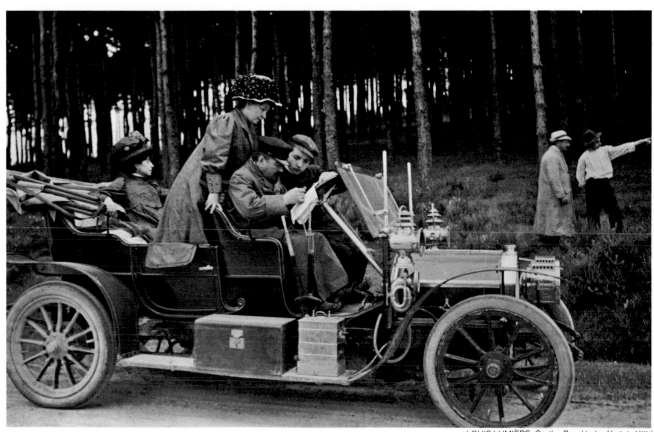

LOUIS LUMIÈRE: *On the Road to La Ciotat,* 1907

*Along a country road in the south of France,
members of the Winckler family of Lyons
—relatives of the Lumières—pose for a picture
by Louis Lumière. The Wincklers, traveling in an
elegant 1907 Peugeot Phaeton, were on their
way to the Lumière summer home in the resort
of La Ciotat. The subdued colors probably result
from the diffusion of light by the thick foliage.*

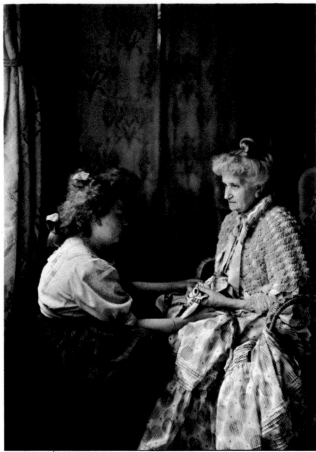

LOUIS LUMIÈRE: *Mme. Antoine Lumière and Granddaughter,* c. 1915

*Andrée, Auguste Lumière's eldest daughter,
shows her embroidery to her grandmother in a
portrait taken by her Uncle Louis. An indoor
Autochrome such as this required patience on
the part of the subjects; the plates were so slow
a pose had to be held for about 90 seconds.*

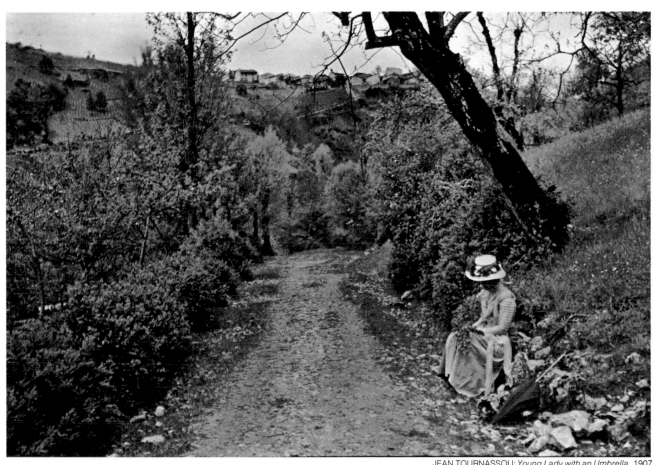

JEAN TOURNASSOU: *Young Lady with an Umbrella*, 1907

In a scene reminiscent of an Impressionist painting, this Autochrome made by the head of photographic services for the French Army captures all the subtle colors of a spring day, including the pink of a nature lover's dress and the rich red of the umbrella beside her. Even the wild flowers in her lap can be seen distinctly.

JEAN TOURNASSOU: *French Soldiers in the Field*, c. 1915

*Vividly uniformed French infantrymen on
bivouac near a shallow stream were recorded by
Commander Jean Tournassou. The red of the
breeches, the blue of the tunics and the muted
greens and browns of the landscape illustrate
the range of colors that Autochrome plates could
reproduce faithfully.*

Lady in Lawn Chair, 1908, photographer unknown

A proper gentlewoman, an ornate chapeau of daisies and net perched on her head, poses in a garden in 1908 for an English amateur photographer. Precise, easy-to-follow directions for making color pictures were printed on every box of Lumière Autochrome plates, and they were used by some amateurs.

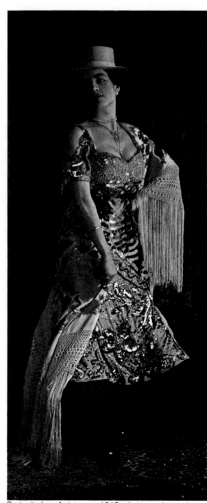

Portrait of an Actress, c. 1912, photographer unknown

An English actress, her name now lost, strikes a theatrical pose for a 1912 color portrait in London's Dover Street Studios. The studio gave such pictures its own trade name—Dovertypes —but the plates were actually Autochromes, which were sold around the world.

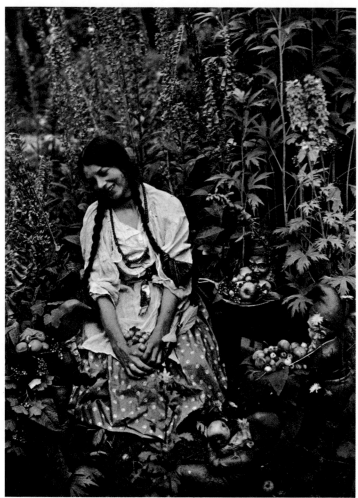

MRS. G. A. BARTON: *Harvest Bounties,* 1919

This harvest fantasy was photographed in 1919 in England by an amateur, Mrs. G. A. Barton, whose skill made the most of Autochrome's capacity for recording the true colors of fruit, flowers, foliage—and that most difficult of color subjects, the human complexion.

Colors of the Day **3**

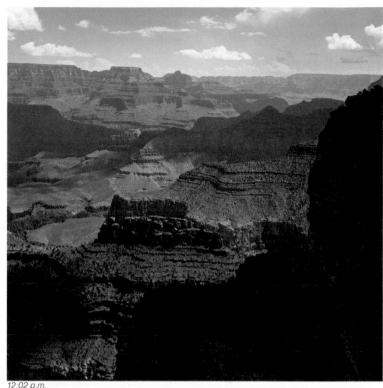

HARALD SUND: *Hopi Point, Grand Canyon* 6:02 a.m.

12:02 p.m.

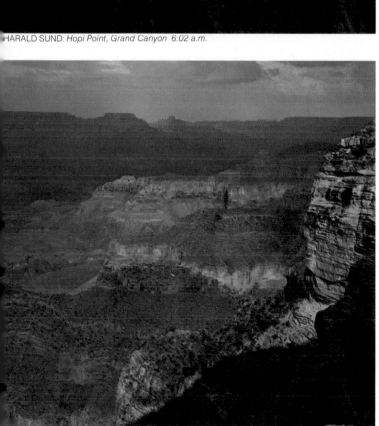

4:31 p.m.

7:20 p.m.

83

Shooting Color Early or Late, Rain or Shine

The rules for beginners say: For natural-looking colors, take pictures in the middle of the day in sunlight or open shade. And the first time a photographer breaks the rules—risking a shot in fog or twilight—he may be astonished at what comes out of his camera. Some of the most beautiful color photographs are those that ignore the rules and, like the four photographs of Grand Canyon on the preceding page, take advantage of the infinite variations of hue provided by natural light. All four were taken from the same point of view on the Canyon's South Rim, providing a vivid demonstration of the way tones and colors change over the course of a single August day in 1971.

Sunlight from a cloudless sky at midday seems to be without any special color cast of its own—it is white light—and the human brain tends to accept midday colors as standard. The blues and greens and reds we see under those conditions are what blue and green and red *should* look like. Once we get those relationships fixed in our minds, we tend to carry them along with us, no matter what the actual light conditions may be. For example, we have learned, through years of looking, that the house on the hillside across the way is white and the trees around it green. Whenever we glance at them, we still think of them as being white and green—even though, in the glow of sunset, the house may have turned pink and the trees bluish or purplish black.

Although the human brain may be fooled, the camera is not. Color film reproduces what it sees, and this fact can be put to valuable use in getting varied and subtle pictures. Changes in light follow a predictable cycle:

Before sunrise
In the earliest hours of the day the world is essentially black and white. The light has a cool, shadowless quality. Colors are muted. They grow in intensity slowly, gradually differentiating themselves. But right up to the moment of sunrise they remain pearly and flat.

Early morning
The instant the sun comes up, the light changes dramatically. Because of the great amount of atmosphere that the low-lying sun must penetrate, the light that gets through is much warmer in color than it will be later in the day—i.e., more on the red or orange side because the colder blue hues are filtered out by the air. Shadows, by contrast, look blue, because of their lack of gold sunlight and also because of the blue they reflect from the sky.

Midday
The higher the sun climbs in the sky, the greater the contrast between colors will be. At noon, particularly in the summer, this contrast is at its peak. Since there is no color in the white light coming from the noonday sun, there will be

no distortion of the relationships between colored objects. Each stands out in its own true hue. Shadows at noon are black.

Late afternoon

As the sun goes down, the light will begin to warm up again. This occurs so gradually that the photographer must train himself to detect it; otherwise the increase of red in the light will do things to his film that he does not expect. Luckily, these usually turn out to be beautiful things. Shadows lengthen and become blue. Surfaces become strongly textured and interesting.

Twilight

Just after sunset there is a good deal of light left in the sky, more often than not reflected in sunset colors from the clouds. This light sometimes produces delicate pinkish- or greenish-violet effects. Just as before sunrise, there are no shadows and the contrast between colors is reduced. As evening falls, the tinted glow rapidly vanishes into the elusive colors of night.

Night

By taking advantage of dim natural and artificial illumination that the night affords, a careful photographer can extract from the darkness enough color to make rewarding pictures. Nighttime's deep blues, pale yellows and pinks are as magical and mysterious in a photograph as they can be in real life. But a tripod or a clamp is essential and the nighttime photographer must be aware that long exposures change the behavior of the color elements in the film. Green may not respond as fast as red, for example, giving a reddish cast and black where greens belong. This is one result of what is known as reciprocity failure, and it can be corrected somewhat by filters. Or it can be ignored if the imbalance is unimportant — or desirable.

Weather

There is no such thing as bad weather for color pictures, for anything that obscures sunlight alters colors in useful ways. Fog gives pearly, muted tones, much like those recorded before sunrise. Rain can dim some colors and enrich others, while creating shining surfaces with startling reflections.

For what is "good" color depends on the photographer's intent. As the great photographer Andreas Feininger has pointed out, color can achieve one of three goals. It can be *natural,* i.e., the color in the transparency can match the color of the object viewed in white light. It can be *accurate,* in which case it may not look natural. It can be *effective,* esthetically satisfying, regardless of accuracy or naturalness. These goals can be achieved by exploiting the ways in which light changes with time of day and weather. □

Color from Dawn to Dark

The first light of day is a magical time. The world is wet and still, and dew lies on the grass. Delicate wisps of fog often blur the landscape. In the early hours, before the light is strong enough to see well, there is little point in trying to capture these misty colors, even at long exposures. Most of nature is seen—by eye as well as film—in shades of black and gray, with perhaps a tinge of blue.

But as the light strengthens, colors begin to emerge; as soon as more of these can be differentiated, the photographer can go to work. In the picture at right, faint hints of green and blue are already appearing in the water. The grassy bank is definitely green, a single positive note of color in what is otherwise a mysterious and luminous near-monochrome. All of these qualities will change markedly as the time passes and the light intensifies. Many photographers take advantage of the shifting and strengthening of tones that the day brings by looking for one good subject and then shooting it over and over as its values alter.

A tripod is often required for early-morning work because exposures may be long. Check the meter reading frequently; the light increases faster than seems possible. And bracket the shots: half a stop up for a transparent bright effect (as in this misty lake scene by Jean-Max Fontaine), half a stop down for a stronger, richer picture.

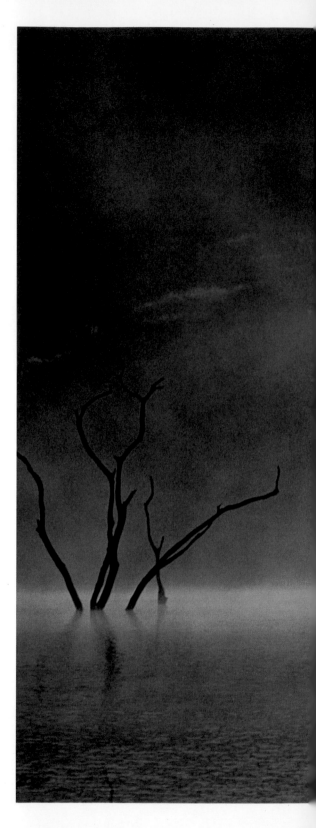

By rising even before the animals that frequent this waterhole, French freelance photographer Jean-Max Fontaine was able to record an eerily pale early-day view of India's Periyar Lake. His 35mm single-lens reflex camera's long-focal-length lens (200mm) added to the effect of unreality by distorting the relative sizes of the trees. Surprisingly, there was ample light—Fontaine made this exposure at 1/125 second and f/8.

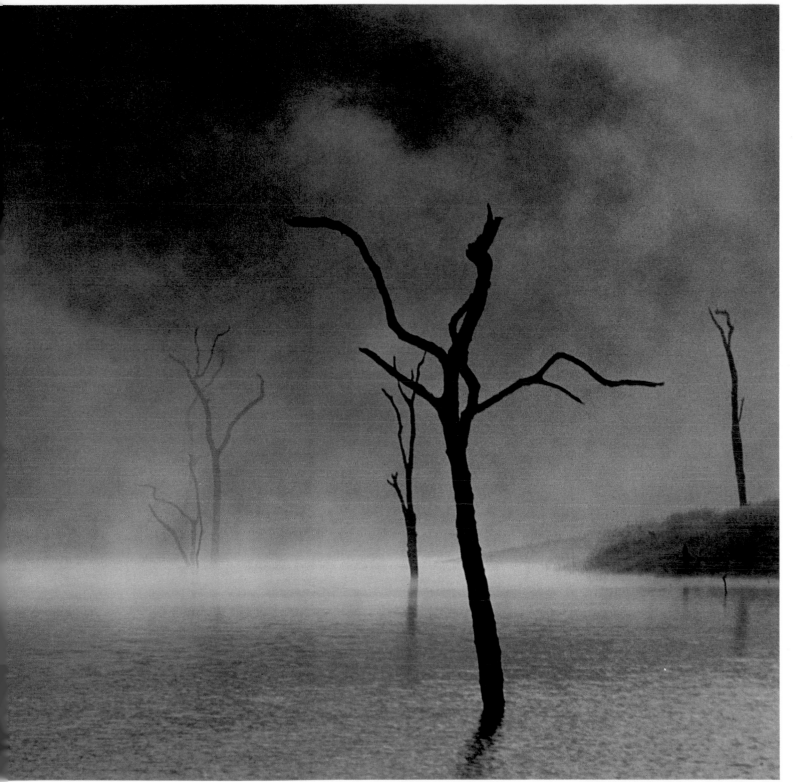

JEAN-MAX FONTAINE: *Periyar National Park*, 1966

The Warm Glow of Early Morning

The sun is now up, but still very low on the horizon. The light is warm enough to make the bricks of these houses glow. At midday they will be just as red, but their relationship to the other tones in the picture will be different, and that warmth of brick will be lost among the hard colors and black shadows that surround it. Here the areas that are not hit directly by the sun are touched with blue. The large shadow at far right has blue in it. The white storefront at the far left has become blue. Even the windows swim with blue reflections.

It is these elements — these subtle color imbalances — that make of this picture not just any street, but a special, after-sunrise, empty street, silent still, but about to erupt into the roar and clutter of the day. The picture was taken by Bill Binzen from his own apartment window. He had watched the early-morning light creep across the street many times and finally decided to photograph it because it reminded him of a painting by the 20th Century American artist Edward Hopper — an almost identical view of a row of almost identical brick apartments that conveys the same sense of silence, of waiting for the day's work to begin.

Another aspect of the early-morning light that the photographer can exploit is the beautiful shadows cast by the low sun. Here the fire escapes announce themselves with stripes elegantly slanted across the building fronts. At noon this effect would be lost; the shadows would fall straight down and disappear among the slats of the fire escapes.

Early light of a September morning gives a warm glow to the buildings along a still-quiet New York street. Using a wide-angle lens (20mm) to include four buildings only a street's width away, Bill Binzen exposed for 1/125 second at f/6.3.

BILL BINZEN: *Tenth Street,* 1967

The Brilliance of Midday

With the sun at its zenith, the light is the closest to pure white that it will ever be, and the contrast between all colors is at its strongest. The result is an extremely bright picture. In the example shown at right, the sky is a strong blue, the water even stronger. The boats are bright orange rimmed with green, the boatman's slicker bright yellow. The clashing colors, found only in a photograph taken at the blaze of noon, make the heat strongly felt. The viewer is tempted to escape by crawling into one of those puddles of shade under the boats.

But in spite of all the brilliant colors, this is not a really "colorful" picture. The very strength of the different tones tends to be self-defeating; they cancel each other out. What remains is a powerful assault on the eye, to convey an impression of heat and light pounding down on a tropical beach at midday.

By their very brightness, and by the accent on form that results from the sharp contrasts between dark shadows and the hard highlighted surfaces, pictures made at midday tend to become abstractions. It is not a good time to photograph people. There are 10 persons in this picture, but none—with the possible exception of the two children—comes alive as an individual. Their faces are hidden in the shadows cast by their hats, and they are merely decorative figures in a landscape.

As the midday sun scorched the sands of one of the West Indies islands called Les Saintes, inhabited by fishermen of Breton descent, Bill Binzen attached a 28mm lens to his 35mm rangefinder camera to get this vivid photograph at 1/250 second and f/8. The wide angle of view provided by the short-focal-length lens enabled him to include not only the small boat anchored just offshore but also the beached rowboats in the foreground.

BILL BINZEN: *Îles des Saintes*, 1967

The Richness of Late Afternoon

This is generally considered the most rewarding time of day for photography, and for a good reason. As in the early morning, the elements of low, warm light and long shadow are present, but unlike the situation in the morning this is not a vanishing condition—it grows stronger and more dramatic as sunset approaches. The photographer finds himself working faster and faster to keep up with the wonderful enrichment of the scene that develops before his eyes. Once again, he should pay close attention to his exposure meter; the light at this time dims fast and longer exposure times are needed every few minutes. If he can bring himself to stay in one place, he should do so. He should also try to anticipate what will happen to specific objects. They may be cut off from the sun by an intervening hill or building before the peak light condition is reached. Many photographers walk around and watch what happens to a scene as the sun goes down, then come back the next day and put the observations to work.

The picture at right is a superb example of the use of warm light and long shadow. The trees are golden on one side, greenish-black on the other. The whole graveyard stands out, more unreal than real, thanks to the shadowed hill behind it. The angle of view is perfect—if the photographer had stood farther to the right, he would have seen too much of the sunny sides of the tombs. Here he has caught only their edges; enough to give them form, enough to do justice to the pale colors of their shaded sides, yet not enough to overpower the glints of light on the smaller headstones, or even the shoes of the people walking across the field.

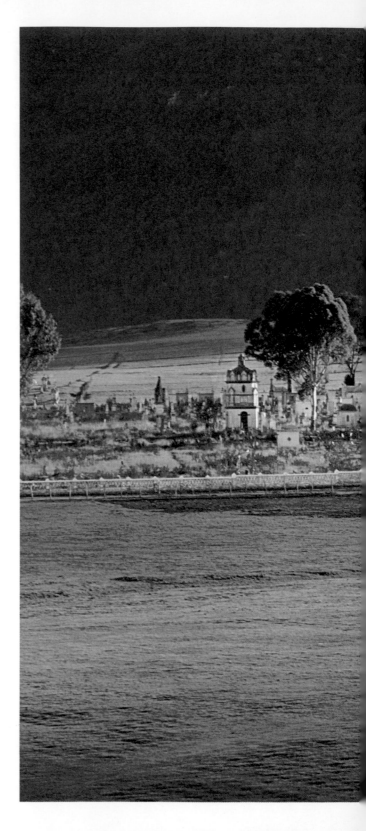

A combination of late afternoon lighting and a long-focal-length lens gives the impression of a Mexican metropolis until the tombs and the tiny, dark figures of the walkers reveal it as a cemetery. Douglas Faulkner shot the picture with a 105mm lens on his 35mm single-lens reflex camera, and underexposed slightly—1/125 second at f/4—to emphasize the deep, rich colors.

DOUGLAS FAULKNER: *Graveyard in Chiapas, Mexico,* 1969

MAITLAND A. EDEY: *Amalfi Twilight*, 1963
94

The Pale Hush of Twilight

The normally bright-blue color of Italy's Gulf of Salerno becomes purple while the houses of Amalfi take on a cool glow in the last light of day as the sun disappears below the horizon.

Just after the sun drops below the horizon, a special quality of light comes and passes quickly. Too early, and the hush of twilight is not there; too late, and the colors of night have taken over.

The example shown at left has caught the unique aura of twilight at its peak. Traces of a fine sunset linger in the sky and are reflected from the sea. These two sources of light produce a bath of blue-violet that suffuses the mountainous Italian coast. It is getting dark down in the streets of Amalfi, a few lights wink on, a faint wave washes up on the beach. But the façades of the houses perched on the cliffs are still aglow with just enough illumination to indicate that one is white, another pink. In minutes these subtle differences will be lost, engulfed by the violet hues of evening.

Twilight pictures can be taken with a hand-held camera, provided high-speed film and a fast lens are used. However, slower films—which provide color tones preferred by many photographers—require a tripod or clamp. And because twilight illumination is so difficult to gauge, extensive bracketing is required.

This photograph was made by an amateur who took five different exposures: at the aperture indicated by his meter reading, at half an f-stop wider, at half a stop smaller, at a full stop wider and at a full stop smaller. As it turned out, the shot that was a full stop over the indicated setting produced the best picture. The great amount of light in the sky and sea had weighted the meter reading, and the other shots were all too dark.

The Subtle Shades of Night

In the evening, the eye reduces the world to mere gradations of black and white, but color film perceives that subtle colors remain. To capture nighttime's delicate hues, the photographer must take special measures. The long exposures of night photography require a tripod, especially—as in the photograph at right—when a long-focal-length lens is used, for long lenses magnify camera shake.

Long exposures pose another problem because all films respond more slowly to light when exposure is longer than 1/10 second. To compensate for this effect, the exposure shown on the light meter must be increased according to charts available from film manufacturers. A sensitive hand-held meter generally has to be used, for nighttime light is often too dim to measure with the meters built into most cameras. Most hand-held meters are four to eight times more sensitive to light than built-in ones, and indicate a greater range of exposure combinations.

Exposures of such long length present a more complicated problem, causing shifts in color rendition. This "reciprocity failure" occurs because of the way modern color film is designed. It is composed of three layers, each sensitive to one primary color. During normal exposures— 1/10 to 1/1000 of a second—the layers respond essentially equally to light, creating a balanced color image. During longer exposures the layers respond unequally, resulting in distorted colors.

In the picture at right—exposed for three seconds an hour and a half after sunset—the exposure was too short to cause a color shift. Some photographers purposely prolong exposure to exploit these shifts for esthetic effect *(page 210).* They can be avoided by using filters recommended by the film manufacturer. □

The photographer used a lunar calendar to find a night when a full moon would rise just after sunset before he shot this nighttime panorama of the Seattle skyline. A three-second exposure time records the sky's dusty blue color without allowing the moon to become a blurred streak.

HARALD SUND: *Seattle After Sunset,* 1977

Color and the Weather

As if a photographer were not challenged enough by the different angles and colors of light at different times of day, his options are even further expanded by weather. Because it is raining or snowing there is no reason to stay indoors; pictures can be found that are unlike anything one can make in clear weather. (One caution, however: Cameras must be carefully protected against moisture.)

Fog is a challenge in any form, from the thin wisps that cling to the ground at sunup to heavy pea soup that seems to blanket everything from view. Even impenetrable fog is useful if the photographer can find some vantage point — perhaps a hill or skyscraper — from which he can shoot down at trees or other buildings whose tops have broken through into the clear colors of the open air. Or he can discover rich colors in strong-shaped foreground subjects like street corners or archways, allowing them to loom through the murk while everything else disappears.

Ground fog offers many more opportunities. It is often not solid and if the photographer can find a subject with strong receding elements in it — like the dead trees on pages 86-87 — then he can exploit their progressively paler forms to convey a sense of space, almost of infinity. Here again, a powerful foreground shape helps.

Overall light mist *(right)* can produce pictures of unusual delicacy. Their colors will be muted, often to the faintest of pastel tones. Details will be blurred (it is best to avoid subjects for which good definition is important). Scenes also have a tendency to flatten themselves out into two dimensions; do not count on shadows to provide contrast or modeling — there will not be any.

Exposure in mist is flexible; it depends on the effect desired. But be careful not to overexpose: There is more light than there seems to be in that pearly air. In order to obtain rich, saturated colors, deliberately underexpose at least one f-stop.

Life photographer Alfred Eisenstaedt waited two hours for the fog-diffused light to create a balance of colors at Connecticut's Mystic Seaport — the grayness of still water matching the mist-filled atmosphere and the red roof at right faintly brighter than its reflection.

ALFRED EISENSTAEDT: *Mystic Seaport in Fog*, 1969

Strange Hues from a Dark Sky

FARRELL GREHAN: *Martha's Vineyard*, 1963

Some of the most interesting pictures are often found during the moments before a storm, when the sky darkens and colors are strangely transformed. In the picture above, taken shortly before a thunderstorm broke, reflected light has thrown green shadows into the porch but created strong blue accents in the windows. These unexpected colors provide a startling backdrop for the rich, natural hues of the flowers.

In the picture opposite another storm gathers and the children scuttle for cover, their shirts bright under the lowering clouds, the side of the church darkened by a rich green shadow. If this had been taken in bright sunlight, it would have been just another routine snapshot.

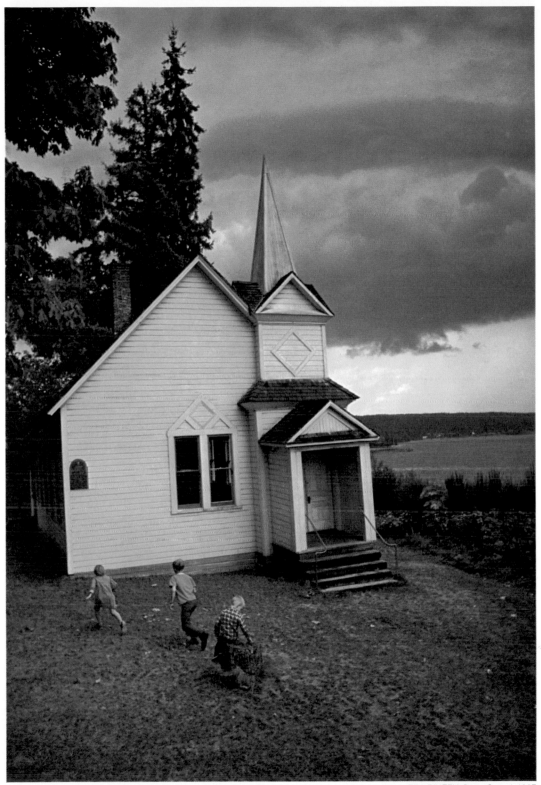

The twin spires of a steeple and a fir tree direct the viewer's eye to the gray clouds of an approaching storm—an ominous backdrop for the bright colors of children on the lawn—in Bill Binzen's photograph of the Pearson Point Baptist Church on Washington's Puget Sound. It was shot at f/5.6 with a 28mm lens.

◄ Without showing the darkening skies that loomed over a summer house on Martha's Vineyard, Farrell Grehan conveyed the gloomy weather by catching the distorted background colors, which contrast sharply with the rich orange and pink of the flowers along the porch.

BILL BINZEN: *Puget Sound,* 1967

DON HINKLE: *Wet Motorcycle,* 1970

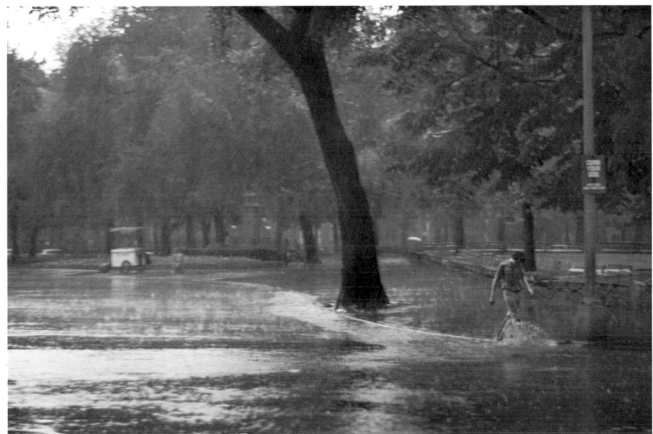

LEIF-ERIK NYGARDS: *Washington Square Park,* 1967

Swedish freelancer Leif-Erik Nygards used a shutter speed of 1/60 second with an aperture of f/4 on his 90mm lens to shoot the waterlogged scene above. The soft shades of green are only briefly interrupted by the muted yellow of the refreshment stand's awning and by the action of the youth sloshing his way through the park.

◀ *After a spring rain, Don Hinkle went out on New York City's streets with a 35mm camera and a 35mm lens. Fascinated by the glistening colors of a parked motorcycle, he managed to mirror the similar fascination of a rain-drenched youngster. Hinkle used a relatively long exposure time — 1/15 second at f/2 — but he was still able to get a sharp picture with his hand-held camera.*

Rain is interesting to the photographer for several reasons. The first reason is what it does to the atmosphere and to overall color balance. The second is the challenge of photographing the rain itself. The third is what it does to surfaces and their colors.

Overall, falling rain has a dimming and blurring effect. Color contrasts are lessened, details are lost. In the picture above the whole scene is a soft, sopping green. It is wet in the pools rap-

idly gathering on the ground, in the hunched figure of the man with his clothes plastered to him, in the slanting streaks of the raindrops themselves.

The color of things is heightened by water. Wet rocks, otherwise a grimy gray, become interesting shades of brown, green and purple. Shiny surfaces like the motorcycle opposite glow with silver and blue droplets. And puddles provide dramatic color accents like the red of the traffic light.

103

The Color Extremes of Snow

NORMAN ROTHSCHILD: *New York Snowstorm*, 1968

Snow is a problem. During snowstorms colors are very subdued, and detail disappears. To avoid total monochrome, it is necessary to find a tinted light source somewhere. That is what Norman Rothschild did with the neon sign in the picture above. He also was able to pick up a subtler and fainter glow in the farthest shop window.

The opposite problem is posed by sunlit snow. Contrasts of light and dark are extreme and very difficult to handle because the light reflected from the snow on the ground, added to that from the sky, is overpowering. It also gives too-high meter readings, which lead to underexposed pictures.

By far the best time to photograph sunlit snow is late in the day. Then it takes on lavender or golden tints, and its surface texture begins to show. And if the angle is properly chosen, the low sun vibrates in a million points of light reflected from the snow crystals. ☐

Pausing at a corridor window on the 17th floor of his apartment building, Norman Rothschild was struck by the orange glow of the restaurant's neon sign blazing through a New York City snowstorm. He attached an 85mm lens to his 35mm camera and made this picture on high-speed Ektachrome, exposing a full second at f/1.4.

Techniques of Color Photography 4

EVELYN HOFER: *Portrait in Windowlight,* 1969

107

Getting the Most from Color

Most people, most of the time, photograph subjects they cherish: their families, their friends, their pets, houses and gardens. Color is what often makes images of these subjects especially memorable. A color photograph of a human face can capture the most intricate and subtle play of tints; a still life of apples can suggest the very essence of deliciousness; a fine color picture of a dog all but re-creates the bark. The techniques for getting good color pictures are the same as those for black-and-white pictures — but they are a little more demanding, for color film cannot tolerate nearly as much error in exposure, nor is it particularly good at revealing detail in both the very dark and the very light portions of a scene.

The most common subject of color pictures is, of course, people, and justifiably so. The human face is the most interesting and — when successfully shot — the most rewarding image to capture on film. But the colors in the human skin are extraordinarily complex, and deserve to be approached with all the care and respect that the photographer can muster.

Paradoxically, it is the studio portrait taken under controlled-light conditions that can turn out to be the trickiest, for unless the photographer knows exactly what he is doing he can get into all kinds of trouble. His strong studio lights will bring out with pitiless clarity every flaw and blemish in the face, along with whatever sallow or mottled tones the skin may have. The more lights he uses to "control" the situation, the greater his problems. A light used to reduce a shadow in one part of the face may create shadows in another part. He may even find himself with overlapping shadows, and wind up with a totally unreal and artistically disastrous result.

Natural light is usually simpler to handle, although it puts limits on what a photographer can do. A masterful solution to a natural-light problem is shown in the photograph on the previous page, depicting a young woman standing close to a window. It is nearly midday. The sunlight is sharply angled and pitilessly hard, but it is striking a counter and wall that are predominantly white. This throws so much reflected light around the small room that overall contrast is reduced. The critical decision in this picture was in the placing of the subject. The photographer put her in front of the sunlight, which now acts as a hard backdrop for a figure that can be reproduced much more tenderly and in greater detail by the reflected light bouncing off the white surfaces of the room. Although it is not actually doing so, the light seems to be pouring through the window directly onto the young woman, leaving half her face in shadow and giving a wonderfully sculptured effect to her body, picking out the smallest wrinkles in her shirt in a way that only a combination of direct and reflected light could do.

Out-of-doors, the direct rays of the sun may pose some rather more awkward problems. This is particularly true if the sun is high, near midday, when

it gets in people's eyes and casts shadows below the nose and lower lip. Yet there are solutions to these difficulties. Sunglasses and hat brims can keep the subject from squinting. Faces shot in profile may not be as harshly shadowed as front views *(pages 112-113)*. And using the direct rays of the sun for backlighting yields some of the most arrestingly beautiful pictures of all *(pages 114-115)*.

Open shade or a cloudy sky offers much more kindly illumination outdoors. The most delicate colors show up under soft and diffused light, and shadows will be absent or merely suggested. Indirect light can impart extraordinary luminosity to the human face, although the photographer's eye cannot see this as well as color film can. There is one major pitfall, however: faces shot under foliage may carry a faint greenish glow from the leaves; those shot in the shadow of buildings, particularly white ones, may become faintly bluish from the reflection of the sky. These shade-induced tints, like all the subtle tonal imbalances encountered in color photography, can be exploited to advantage, or they can be balanced out by filters.

The esthetic options—and cautions—involved in taking color pictures of people apply also to color pictures of things. Each kind of photograph brings its own special set of conditions that may handicap or help the photographer. But there are techniques that make it fairly easy to master even the most difficult subject—the complex hues of a painting, for example, or the colors of both the outdoors and the indoors in a shot that includes both. Advances in equipment now make it possible to take candid color pictures in situations that not long ago would have been all but impossible. Automatic flashes bring light wherever it is needed. Electronically controlled cameras and films nearly as fast as those available for black and white open a beguiling, subtly hued and shaded chiaroscuro world of low-light color photography. The marvel of modern color film is that, despite the bewildering lights and hues of the world, it can meet nearly any challenge. □

The Natural Beauty of People

JAY MAISEL: *Young New Yorker,* 1964

Standing in shade and illuminated by late-afternoon sunlight reflected by a white wall, a young woman radiates youthful health. Jay Maisel took the picture with a 90mm macro lens, which can focus on very near objects, at 1/250 second and f/4.

Character, the essence of portraiture, is a sum of myriad elusive clues—hues, scars, wrinkles and twinkles so subtle as to be often camouflaged or erased by the glare of a flash unit or by direct sunlight. In the gentle ambiance of indirect light, however, a face is most free to be itself. A woman aglow with youthful vitality, a man motionless in quiet relaxation—such portraits are as different as the faces themselves, similar only in the naturalness of their lighting.

This picture was shot on an overcast Irish day, and the light filtering through the large window is as soft and diffuse as a cloud. The light side of the face is set against the shadowed corner of the room, the dark side silhouetted against the light wall, their colors superbly balanced. We know this quiet drinker, the emphasis first on his patient cynical face, second on the glass in his hand. The patterns of his pullover and cap add just the right touches; everything else in the picture is dark and unobtrusive.

HUMPHREY SUTTON: *Aran Islander*, 1966

Bold Uses of Direct Light

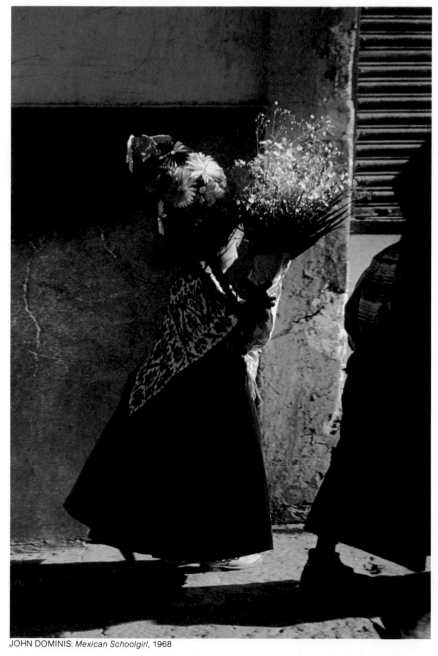

JOHN DOMINIS: *Mexican Schoolgirl*, 1968

Strong, direct sunlight is usually the worst possible illumination for pictures of people. It may draw dark shadows across a face or cause the subject to squint—but it can perform magic as well. In the shot of the Mexican child on her way to a school ceremony, the direct rays of the morning sun evoke a very special mood, a lovely mix of little-girl happiness and modesty that is expressed by her luminous, averted face. And the low-lying sun casts no facial shadows. John Dominis could have shot from another angle to emphasize the brilliance of her costume, but he wisely kept the dress in shadow. Her face alone, lighted up as if by excitement, conveys the special meaning of the festive moment.

Since the girl's face was turned away from the camera, the photographer did not have to worry about her squinting. Vernon Merritt's picture on the opposite page shows another solution to this problem: The young woman was able to look toward the bright sky with open eyes because she was wearing sunglasses. Here, direct lighting is used to suggest the outdoor nature of the subject. Deeply tanned, with a spark of light leaping from the rim of her stylish glasses, she truly looks like a sun worshiper.

John Dominis caught this candid shot with a 35mm lens on his 35mm camera, set at 1/100 second and f/5.6. The exposure was set to capture the shadowed colors of the girl's fiesta dress.

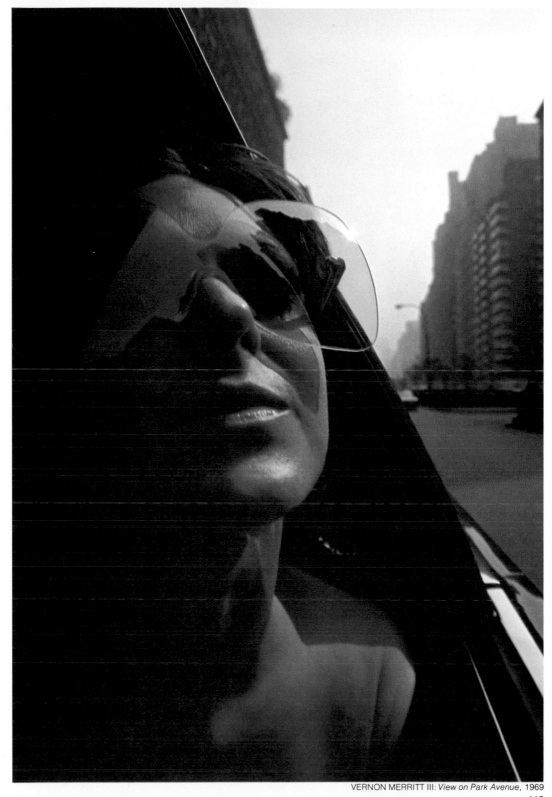

Vernon Merritt used a wide-angle 28mm lens for his picture of a young woman viewing New York City from a car. The lens makes her chin seem large but emphasizes the skyward tilt of her face.

VERNON MERRITT III: *View on Park Avenue*, 1969

A Gentle Aura from Backlighting

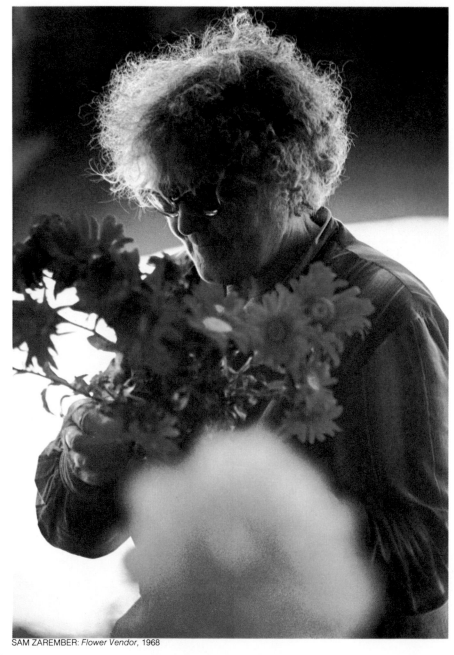

SAM ZAREMBER: *Flower Vendor, 1968*

One way of defeating the hardness of direct sunlight with its ugly nose and lip shadows is to turn the subject away from the sun so that his whole face is shaded. This technique can result in pictures of great originality and beauty. Care must be taken to keep the direct sun off the lens: Use a lens hood, or shade it with a hand or piece of cardboard. The picture at left was shot early in the afternoon with the sun coming in high over the woman's right shoulder. It made a magnificent nimbus of her hair, which succeeded in lighting up the right side of her face, and even sent a glow around front to fill in her features.

The later the hour, the harder it is to keep the sun out of the lens when shooting toward it. Try to put the sun behind something, or above the picture frame *(right)*. In these situations accurate exposure is a guess. As Sam Zarember said of the photograph at right: "I started by making a black picture and ended with a white one. Somewhere in between I knew I would get what I wanted."

The focus in this picture was on the woman's eyeglasses; it was kept deliberately shallow to blur the strong colors in the foreground. As a result, everything else appears to be a fuzzy blaze of light. The gleaming crescent at the bottom of the left eyeglass pulls the whole picture together and is a lucky accident.

The light for this picture had to be very low to ▶ shine through the petals of the jonquils—and to penetrate the young woman's dress to indicate her pregnancy (right). It was shot almost directly into the sun, which would have burned out the face if a lock of hair had not been there to soak up the rays and reveal the profile.

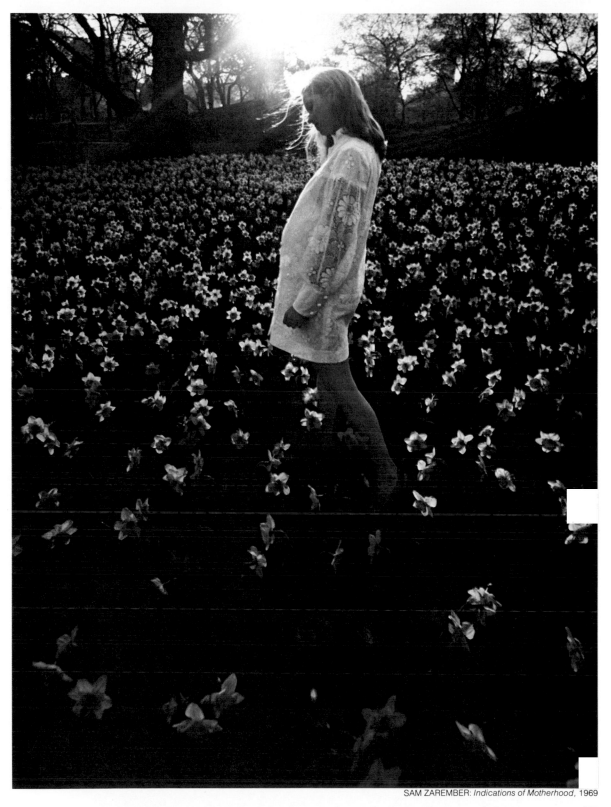

SAM ZAREMBER: *Indications of Motherhood*, 1969

The Fleeting Drama of Low Light

Some of the most beguiling color picture situations happen to be among the very toughest to pull off—challenging, dimly lit evanescences so fragile that any effort to photograph them may destroy their look and mood. These taunting moments —a maestro glowing in the dim fire of his podium lamp or dancers swirling in a ballroom—take place in light that is nearly too faint and fleeting for any record but memory. By using modern flash equipment and high-speed color film, however, freelance photographer Enrico Ferorelli captured such images, their moods and resonant colors undisturbed.

To portray Leonard Bernstein conjuring a musical fantasy from his score, Ferorelli used some tricks of his own. He deliberately employed fast film that is color balanced for natural daylight and not for the illumination found in a concert hall; this choice gave him the speed he needed for exposure in dim light and, because of the mismatch between film color reaction and light color, also imbued the portrait with its golden glow.

A different trick caught the dancers locked alone in the embrace of the music against a background swirl of rival contestants. Ferorelli linked the motor drive of his camera to an electronic flash that can generate a powerful, brief burst of light every two seconds.

ENRICO FERORELLI: *Leonard Bernstein, 19*

Using only the light from the podium lamp with
color film, the photographer avoided shatter
conductor Leonard Bernstein's absorbed solitu
with a flash, and gave the portrait a drama
golden hue as w

ENRICO FERORELLI: *Eastern U.S. Ballroom Dancing Championship*, 1978

*While these two dancers competed for a national
dancing championship, the motorized camera made
a series of exposures, freezing their motion with
the light of a synchronized series of flashes.*

Fill Lighting for Indoor Shots

With artificial light, a photographer can orchestrate his pictures almost like a musical conductor, adding shadows to emphasize the shape of a face, creating highlights, employing diffused illumination for a subdued mood or otherwise modulating the lighting devices at his disposal. However, in color photography—as in music—a slight misstep can do a considerable amount of esthetic damage. Freelance photographer Peggy Barnett purposely demonstrates a common error in the portrait of her 89-year-old grandmother at right.

Light was provided by two electronic flash units to the left of the subject, and a diffusing screen of tracing paper was used to soften the illumination. But, as the picture shows, the shadowed side of the woman's face has gone almost completely black even though it was receiving some illumination. The contrast range of color film—its ability to show detail in both the light and dark areas of a scene—is much less than that of black-and-white film.

To reduce the contrast in the face and reveal a natural-looking amount of detail in the shadowed area, the photographer set up a "fill" board, which bounced light from the flash units back into the shadow. (Posing her grandmother near a white wall would have done the job just as well.) The outcome of this simple addition to her lighting arrangement is the excellent portrait shown on the opposite page.

Even though the picture at right was shot in very diffused lighting, there was still not enough illumination striking the right side of the subject's face; the result is a black shadow. If the photographer had exposed for the shadows, the highlights would have been overexposed.

Two electronic flash units plus a reflecting fill board set up as shown above illuminated the portrait at right. Two flash units are set about four feet from the subject, behind a sheet of ordinary tracing paper, which softens and spreads their light. A sheet of cardboard perpendicular to the diffusing paper prevents light from spilling onto the background. On the other side of the table another sheet of white cardboard reflects light onto the shadowed side of the subject. Peggy Barnett does not use a tripod when shooting portraits because she wants maximum freedom to vary her angle.

Here the shadow is preserved, but enough light is reflected from the fill board to show detail in the subject's face. To catch this animated expression, Peggy Barnett had her grandmother recite poetry during the shooting session.

Matching Artificial Light to the Setting

Pictures that depict people in their everyday surroundings possess an extra dimension of naturalness that studio portraits cannot match. To preserve the authenticity of the setting, the light ordinarily used in the room is ideal for picture taking, but it may well turn out to be inadequate for the exposure requirements of color film.

Faced with a need for artificial illumination in such situations, many photographers deploy lights or reflector boards just as they would in a studio, striving for good detail and modeling. However, in the pictures shown on these pages, freelance Evelyn Hofer took a different tack: She attempted to re-create the normal light of the settings with her artificial lights.

The aproned man at right owns a small Italian delicatessen that is normally illuminated by two bare bulbs. Miss Hofer retained the lighting milieu by setting up a single electronic flash unit beside the nearest bulb. Although it cast deep shadows that might have been unacceptable in a studio portrait, this harsh, angled light evokes the cramped atmosphere of a neighborhood store with great success.

The subject of the portrait on the opposite page is an artist who works in a barnlike loft that is ordinarily illuminated by fluorescent lights on the ceiling. These could not be used, since fluorescent light gives a green cast to color pictures unless special filters are employed. Instead, Miss Hofer matched the original illumination by aiming two electronic flash units at the ceiling. The bright light, cascading from above and bouncing off the walls and floor, dispelled all shadows—but it showed the artist in her natural environment.

For a picture of artist Kiki Kogelnick in her studio, Evelyn Hofer directs two electronic flash units straight up at the ceiling (above). Although the subject is drenched with light from overhead, her face is clearly visible under the brim of her hat because of the high degree of reflection from the white walls. A black outfit isolates her from the blaring colors in the background. The picture was shot with a 120mm lens on a 4 x 5 view camera.

To mimic the light cast by dangling, bare bulbs in a New York delicatessen, Miss Hofer set an electronic flash unit eight feet high and aimed it downward at a 30° angle (below). Her unit contained a modeling light—a nonflashing light turned on by a switch—so that she could check how the shadows would fall before triggering the flash. The final picture (left) was shot with a wide-angle lens to gather in a sizable view of the grocer's shelves.

The Pitfall of Unwanted Color

Practically every photographer has, at one time or another, fallen into the trap demonstrated in the two pictures at right, in which a subject takes on the colors cast by the walls he is leaning against. This unwanted tinting is not the fault of the photographer's equipment. Quite the contrary; the film has honestly recorded the fact that the subject is being illuminated by colored light reflected from the walls.

Portraits shot beneath trees offer the most familiar example of this problem. A pretty girl photographed under such seemingly flattering conditions is likely to appear a seasick green, since the sunlight that reaches her is filtered and reflected by the green foliage. Too late, the photographer remembers that the eye tends to perceive almost every scene as if it were being illuminated by white light, whereas color film detects the true spectral make-up of light.

With experience, a photographer will learn how surroundings affect the colors of a subject. Once he has learned to see—or at least anticipate—true colors, the pitfall of color reflections can become an asset. He may, for example, create a lovely and unusual portrait by showing the color that is cast by a flower held close to a child's face.

The reddish cast that is given to hair, skin and even the blue in the young man's jeans is solely the consequence of red light reflected off the brilliant wall of this corridor. Indoor color film, appropriate to the light produced by bulbs along the corridor, was used, and the exposure—a long 12 seconds because of the dimness of the corridor—was correct.

A similar color contamination occurs when the student leans against a green wall. The reflected color makes one side of his shirt appear to be painted green. But the colors of his skin and jeans are more natural because they are farther away from the wall and are also illuminated by light reflected from the red ceiling and the blue wall on the other side of the corridor.

Capturing the Hues of Man's Possessions

As much as color contributes to pictures of people, it becomes still more an asset—even a necessity—in photographs of such still-life subjects as flowers, fruit or room furnishings. To get a pleasing, accurately colored appearance in pictures of this kind, professional photographers have developed a number of specialized techniques.

John Zimmerman, a professional who has photographed many houses on assignments for magazines, wanted to include both the outdoors and indoors in a single shot of the long, window-walled living-and-dining room opposite. Since he was using daylight film to record the exterior colors, he could not illuminate the interior with ordinary flood lamps, lest the room appear to have an unnatural yellowish cast. Zimmerman was able to circumvent this difficulty by inserting blue "daylight" bulbs in his floods and also in the recessed light fixtures in the ceiling of the room. He also used a blue-tinted light-balancing filter (82B) on his lens.

An accurate reading of both indoor and outdoor light was indispensable in this difficult situation. To make sure that he balanced the colors properly, Zimmerman made his first exposure in mid-afternoon when his light meter indicated an aperture one-half f-stop higher than that for indoors. He continued shooting for about 20 minutes until the outdoor reading indicated a setting one-half f-stop lower. This bracketing of exposures ensured that he would get at least one photograph in which the exterior and interior light were correctly balanced.

John Zimmerman's lighting set-up for his study of a modern interior included four blue flood lamps—three near the camera end of the room (top), the fourth between the ceiling beams (bottom left) close to the fireplace to hide the flood from the camera. Cardboard deflectors were taped in front of the upper parts of each flood in order to preserve the shadows in the beamed ceiling. Zimmerman inserted blue bulbs in the room's light fixtures (bottom right).

*Sun-dappled trees, blond wood and white
interior walls all retain their true colors in
Zimmerman's carefully balanced light. The final
picture, taken with a 20mm lens on a 35mm camera,
was a two-second exposure at f/8. This lens and
aperture yielded excellent depth of field — everything
from foreground to outdoor background is sharp.*

Colorful Surroundings for Animal Portraits

Nina Leen has a way with animals (she talks to them while she is photographing them), but it is her careful arrangement of background colors as much as her relationship with her subjects that makes her animal pictures outstanding. Woodsy surroundings are particularly suited to the shaggy black and white Old English sheepdog at right, but the features of this purebred could easily have been lost if it had been posed in front of the woodpile: The color and texture of the bark on the logs echo the dark portion of the dog's coat. Placing the dog atop the woodpile solved the problem, particularly after the lens was adjusted to blur the lawn and trees in the background.

Miss Leen likes to photograph pets outdoors in cloudy weather. Not only does this produce soft, even colors, but it also averts the difficulties of hot floodlights that may cause animals to pant and become restless. Although the picture of a whippet against a tapestry looks like a studio shot, it actually was taken outdoors. Miss Leen went to the trouble of arranging this unusual backdrop because she recalled that whippets were often depicted in medieval tapestries of hunting scenes; not only does the embroidered foliage suggest the aristocratic lineage of the sleek hunting hound, but the russet color serves as a subtle counterpoint to its light-brown markings.

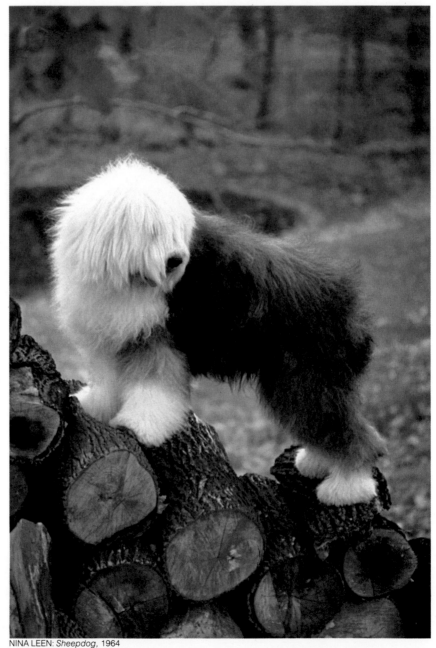

Using a 105mm lens on her 35mm camera, Nina Leen photographed this champion sheepdog, Fezziwig Ceiling Zero, at 1/250 second and f/5.6. The large aperture and moderately long focal length yielded an out-of-focus background that is recognizably wooded but does not distract from the shaggy presence of the dog.

NINA LEEN: *Sheepdog,* 1964

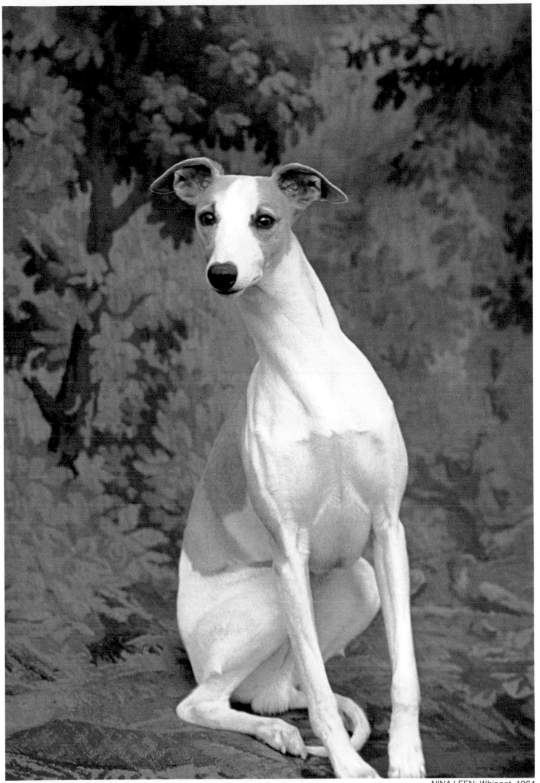

A champion whippet, Courtney Fleetfoot of Pennyworth, was taken with an 85mm lens at 1/125 second and f/8. The dog's ears are perked up because the photographer got its trainer, who was out of sight, to speak out just before the picture was taken (Miss Leen felt that the dog would have resembled a too-perfect porcelain statue without this alert expression).

NINA LEEN: *Whippet*, 1964

127

Diffuse Colors for Appealing Still Lifes

Lighting is the crucial consideration for still lifes. If the illumination is too diffuse, the subject will lack the modeling that suggests its three-dimensional qualities; if the light is not diffuse enough, awkward double shadows will be cast, and colors in the shadows will look artificially different from those in the highlighted areas.

A perfect balance was struck by freelance photographer Dick Meek in his striking picture of red and golden apples. He used an electronic flash unit as a single light source, directing it from above at a 45° angle. He also set up a sheet of white cardboard to reflect light back onto the apples for soft, fluid lighting. The camera was aimed through a hole cut in the reflector sheet, and it was positioned so that no direct light fell on the lens.

When flash is used for still lifes, it is advisable to judge the lighting in advance by setting up a small floodlight close to the position of the flash unit and noting how the shadows will fall in the final picture. The arrangement of lighting and subject should be made on the basis of what is seen through the camera's viewfinder—not what is seen by the naked eye. If the still life contains a very shiny object, its glare can be subdued by moving it to the back of the arrangement and focusing on the foreground objects—thus throwing the spots of reflection out of focus.

In setting up this picture the photographer determined his f-stop by measuring the distance from the light source to the subject (top) and then used this figure to compute exposure after checking the suggestions supplied with his electronic flash unit. After arriving at the best arrangement of fruit by examining the apples through his viewfinder (bottom), he snapped the picture with a cable release to avoid jarring the camera—and got the clear, natural still life opposite.

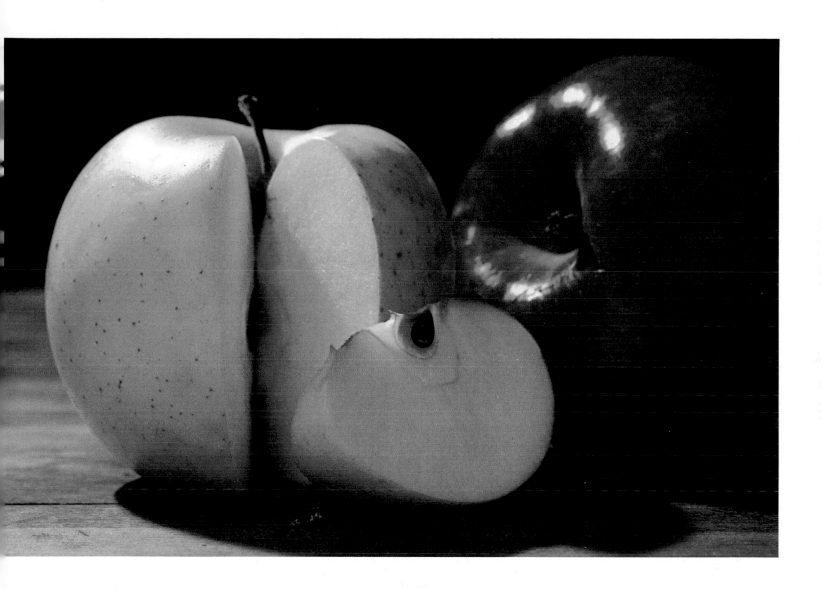

The Essence of Flower Colors

The beauty of a trout lily is lost in a clutter of colors and light because the background, while out of focus, is still too clear. A very small aperture, f/22, counterbalanced the depth-of-field limitations of a long lens—180mm.

When the photographer opened his aperture to f/4, the background became more flatteringly blurred. Grehan also shaded the lily with an umbrella, thus further isolating it from the brighter background, which is in full sunlight.

A third version, taken in full sunlight, shows the lily at its most colorful. Farrell Grehan shifted his angle of view slightly to silhouette the flower against a dark rock and retained the f/4 setting to keep the background out of focus.

Photographing flowers is a meticulous business in which small adjustments can make a big difference. Farrell Grehan, noted for his floral photography, spends a great deal of time studying a flower through his viewfinder, moving his 35mm single-lens reflex camera a few inches to one side or the other to select background colors that will suit his subject. The three pictures of a trout lily above demonstrate how crucial a few simple shifts of lighting and background can be to the final photograph.

Grehan generally shoots from "flower level," resting his camera on an equipment case or on the ground to get the picture. As a rule, he sets his shutter speed at no less than 1/100 second, since flowers will tremble in even the slightest breeze. He frequently tries to show the whole plant: "I'm interested in its leaves, its petals, how it comes out of the ground and what its surroundings are like." Certain subjects, however, require selection of only one or a few elements for emphasis. This was his approach to the flowering deerhorn cactus on the opposite page, which he shot from directly overhead in a manner that greatly limited the depth of field and entirely isolated the lovely red blossoms from their stems.

Shooting from directly overhead, Grehan created a lovely composition of cactus blossoms, enhanced by the presence of a feasting bee. To prevent the brilliant desert light from overwhelming the subtle colors of the flowers, he shaded the cactus with an umbrella, and to focus attention on the blossoms, he restricted the picture's depth of field with a long lens (105mm) and a large aperture (f/4).

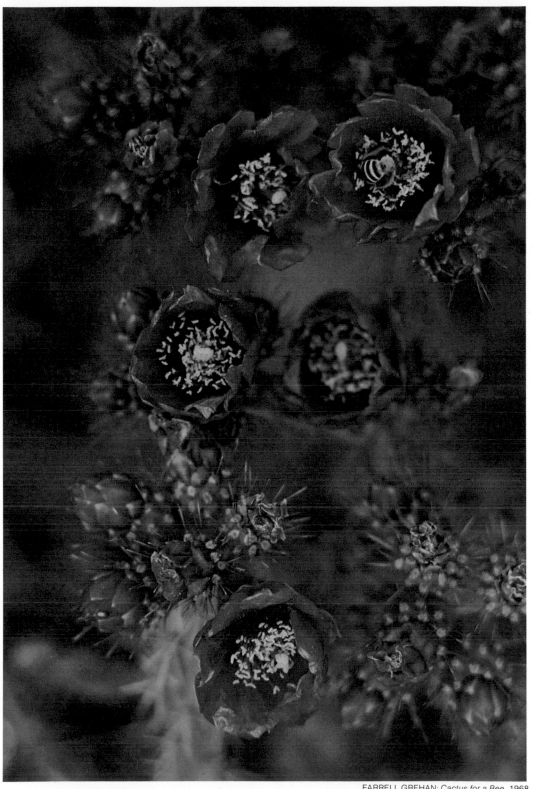

FARRELL GREHAN: *Cactus for a Bee,* 1968

The Fine Art of Copying Fine Art

To gauge color, scales of standardized gray and color-control patches are attached to the frame. The best shot can be selected by comparing the scales with their photographic images.

The angle of the painting is measured by ▶ holding a level against the frame. Since hung paintings are rarely perfectly vertical, this measurement helps to prevent focusing errors.

The angle of the film plane is made parallel to that of the painting by holding the level against the back of the camera and tilting the camera until it matches the painting's tilt.

The amateur who tries to make a souvenir picture of a museum painting or prepare a slide from a treasured family portrait may be disappointed the first time. Producing an accurate copy of fine art requires special techniques. On these pages Lee Boltin shows how to copy paintings. Copies for books are made on 4 x 5 film, but the procedures used apply to smaller sizes as well. If they are painstakingly followed, an accurately colored, distortion-free copy results. Achieving faithful reproduction of the painting's colors is trickiest. As a guide, Boltin sets two comparison scales on the frame, as shown above. One is a gray scale and is marked with 10 squares printed in tones ranging from pure white to solid black. The other is a color-control scale marked in nine squares of standardized colors (both scales are sold by photo stores).

By comparing the reproduction of these scales in the photograph with the actual scales, Boltin can tell how accurate his copy is. This enables him to choose the best of several exposures, or if a print is to be made, to compensate for color distortions.

But Boltin also takes other precautions. He makes sure the available voltage is that specified for his lights. He uses an inexpensive photographic level to make sure that the plane of his film is parallel to the plane of the painting; he thus guarantees perfect focusing for every part of the picture. After blocking out all other light, he checks the evenness of his two light sources by comparing shadows cast by a pen. And he gauges the exposure on a gray test-card to get a reading unaffected by color. The result of all this care by Boltin is shown on page 134.

Two floodlights, each at the height of the painting's center, give even illumination. They are equidistant from the painting and angled so no glare is reflected to the camera.

To balance the light, Boltin holds a white ▶ card in the middle of the painting. When equally dense shadows are cast on either side of a pen, the lights are correctly positioned.

◀ Metering the light, the photographer takes a reading from a standard gray test-card instead of the painting itself. This card matches the reflection of an "average" indoor subject.

To avoid blurring caused by camera movement, Boltin snaps his picture with a cable release. He bracketed his exposures widely to be sure of reproducing the colors accurately.

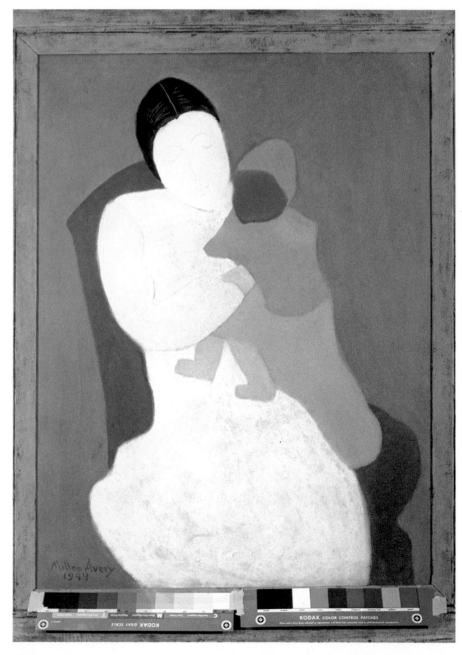

The photographic copy of Milton Avery's painting, "Woman and Child," retains the original's appeal by capturing its subtle modulations of color—such as the difference between the mother's arm and the child's leg. These unsaturated colors are the reason so much care must be taken in copying, for they are the most difficult to reproduce faithfully.

The Modern Innovators **5**

IRVING PENN

ELIOT PORTER

ERNST HAAS

LARRY BURROWS

Four Who Led the Way

When the four photographers represented in the following pages — Irving Penn, Eliot Porter, Ernst Haas and Larry Burrows — began taking pictures in the 1930s and 1940s, color photography was still in its infancy. As their careers unfolded, during the 1950s and 1960s, they watched the use of color overtake that of black-and-white film among professional as well as amateur photographers. By the 1980s, color had all but monopolized most fields of photography. This phenomenal increase in the use of color film can be explained partially by technical improvements — faster speed ratings, more natural reproduction and easier processing. But what color film needed to gain popular appeal was for innovative photographers to put it in their cameras. What follows is the story of four who did. The pictures reproduced on the following pages are not new; what is new is the realization of the role each man played at the outset of the color era. To a great extent, they set the standards for the dominant position that color holds in modern photography.

Pictures in color — very good ones — had been made in the 19th and early 20th Centuries *(pages 63 and 74-80)*. However, producing them was so expensive and difficult that few photographers, amateur or professional, made the effort. Once film that recorded natural color reached the mass market in the late 1930s, it became a simple matter for any photographer to take color pictures, and millions did. By 1964, American amateurs were purchasing more color film than black and white, and 12 years later nine out of 10 pictures were being taken in color.

Color transformed commercial photography as well. As soon as the new films came on the market, portraitists, photojournalists and advertising and fashion specialists began experimenting with it. Magazines such as *Vogue, Harper's Bazaar, National Geographic* and *Vanity Fair* had always published color photographs from time to time, but the number of pages devoted to color photography suddenly increased as color film and faster, more economical printing equipment made it easier to take and reproduce color pictures. With the birth of *Life* in 1936 and its competitor *Look* one year later, the market for all kinds of photography soared — and the percentage of color pages used in picture magazines gradually increased until, by the mid-1960s, *Life* was printing more pages in color than in black and white.

Although publishers and advertisers enhanced their messages with pictures in color during those first few decades of the color era, most influential critics and museum curators persisted in regarding color photographs as calendar art. Color, they felt, was at best merely decorative, suitable, perhaps, for exotic or picturesque subjects but a gaudy distraction in work with serious artistic goals. One exception was the master photographer Edward Steichen. In 1947, when Steichen took over the direction of the department of photography at The Museum of Modern Art, then the only great art institution in the world to display

photographs on a regular basis, he began to give color photography an important place in its exhibition program. Five years later, however, his enthusiasm for color had noticeably cooled, in part because the expense of making high-quality prints needed for museum exhibition was too great for the budgets of most photographers — or the museum.

Not surprisingly, photographers whose pictures reached the public through museum and gallery shows, rather than books and magazines, generally stuck to black-and-white during the 1950s and 1960s. It was left to the men who made their living taking pictures for publications — which welcomed and even required color — to develop the art of color photography.

Irving Penn, Eliot Porter, Ernst Haas and Larry Burrows evolved approaches to subjects and assignments that were uniquely suited to color.

Irving Penn's first picture for *Vogue* was a cover for an October 1943 issue: It showed a purse, gloves and scarf with lemons, oranges and a huge topaz. All of Penn's pictures, whether they were advertising illustrations *(page 141)*, portraits *(page 147)* or still lifes *(pages 142-143)* had a classic elegance that was instantly recognizable.

Ernst Haas specialized in the evocative photographic essay; his style varied with his subject, but whether he was shooting the ritualized movements of a bullfight *(page 159),* the misty tranquillity of Venice *(page 158)* or the vast reaches of the American Southwest *(pages 162-163),* Haas found a way to tell his story with color.

Larry Burrows, a veteran war photographer in black-and-white and an acknowledged master at making photographic copies of museum paintings in color, combined his experience to produce war photographs in Vietnam *(pages 164-170),* East Pakistan and the Middle East that were as true to the harsh realities of war as they were to the dramatic qualities of color.

Eliot Porter trained as a physician but forsook his medical degree as soon as he had earned it in order to pursue a career in nature photography. His photographs, which first appeared in a series of books that were published by the conservation-minded Sierra Club, used delicate color to record a vital dimension of natural beauty and to communicate Porter's concern that that fragile beauty be preserved *(pages 148-155).* □

Irving Penn's Virtuoso Palette

In the elegant photographs that he began making in 1943, Irving Penn brought to color pictures—fashion, portraits and still lifes—an artist's feel for the medium and a technician's command of experimentation with its materials. At a time when most color photographers lighted their subjects from the side so that the shadowed forms were defined in terms of dark and light, Penn mounted batteries of lights and reflecting panels behind, around and above his subjects to create diffuse, directionless illumination and to achieve effects of pure color, undisturbed by shadows *(pages 142 and 143).*

Penn also enlarged grainy negatives with a special light in his enlarger to achieve effects associated more with impressionist painters, as shown in the pictures on these pages, than with the precisely detailed renditions then preferred by color photographers. Even at his most traditional, in the photograph of Moroccan dancers *(page 147),* which was lighted from the side like many a studio group portrait, he achieved drama by isolating a few strong, colorful shapes against a neutral background.

Fishing on the Seine, 1951

A solitary boatman on the Seine outside Paris rows through hazy summer heat. The grainy effect was achieved by using 35mm negative color film made in 100-foot lengths for movie studios, which the photographer cut into cassette-sized lengths for his camera. When he inserted or removed the film, its surface was damaged, resulting in yellow slashes that marred the image but delighted him. "An act of God," he remarked.

What appears to be the photographer's chance discovery of young lovers on a romantic evening is actually a carefully staged advertising photograph for a diamond company. The scene, photographed on a pond in Long Island, New York, was inspired by Penn's view of the Seine (opposite) shot three years earlier, and it was made with the same type of film. To emphasize the grain in the final print, he used a detail-enhancing zirconium-arc lamp in his enlarger.

Two in a Canoe, 1954

Still Life with Watermelon and a Bee, 194

In this still life, one of the hundreds of photographs commissioned for Vogue magazine, color and lighting work together to emphasize the succulence of summertime eating. The pale, neutral background concentrates attention on the bread and fruit, and their delectable colors are emphasized by diffused overhead light that minimizes shadows. The bee, recalls Penn, was dead, carefully placed for effect.

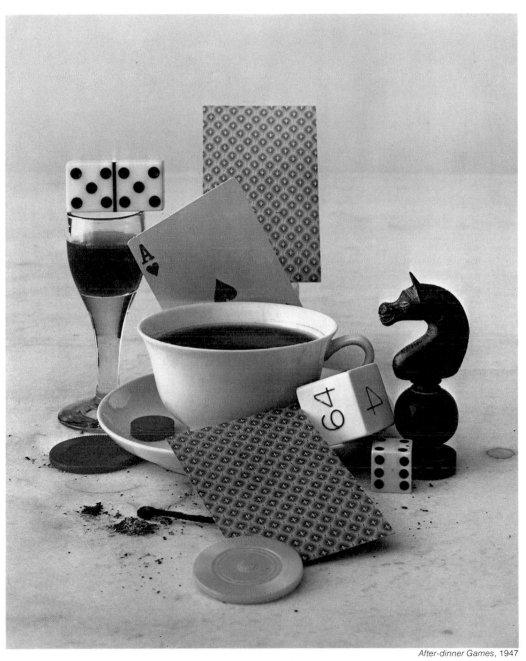

This 1947 still life commemorates a period in Penn's career when he and other artists frequently gathered after dinner in New York City's Hotel Lafayette for cards, conversation and coffee. Penn used slow color reversal film in an 8 x 10 view camera and long exposures —15 minutes or more —to combine rich color with maximum detail.

After-dinner Games, 1947

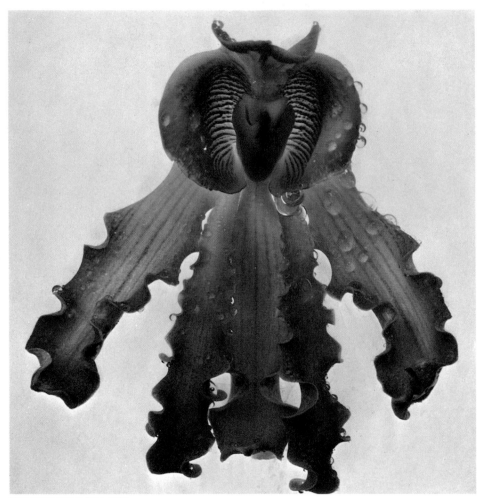

The delicate colors and unusual perspective of a Honduras orchid, shown upside down as it was originally published in Vogue, give an impression that the flower is a mythological monster with the head of a ram and lavender and orange tentacles. To make the blossom almost translucent—as it would appear when held against a window pane—Penn wired it to a sheet of milk glass placed vertically in front of his strobe lights.

Magnificent Animal Face, 1970

A common Oriental poppy named Showgirl was given uncommon presence in this life-sized close-up, part of a series of flower pictures that Penn produced between 1967 and 1973.

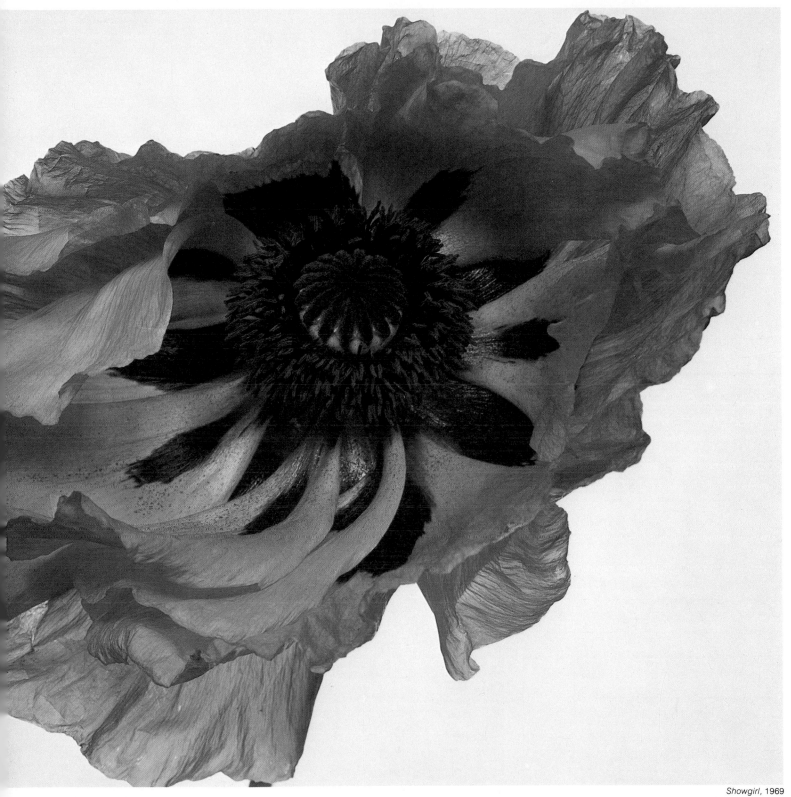

Showgirl, 1969

To picture a troupe of Moroccan dancers —or *guedras* —as artfully as if they were high-fashion models, Penn posed them against a neutral background and carefully supervised their poses and clothes. The women were photographed in a portable studio Penn constructed in the Saharan frontier town of Goulimine.

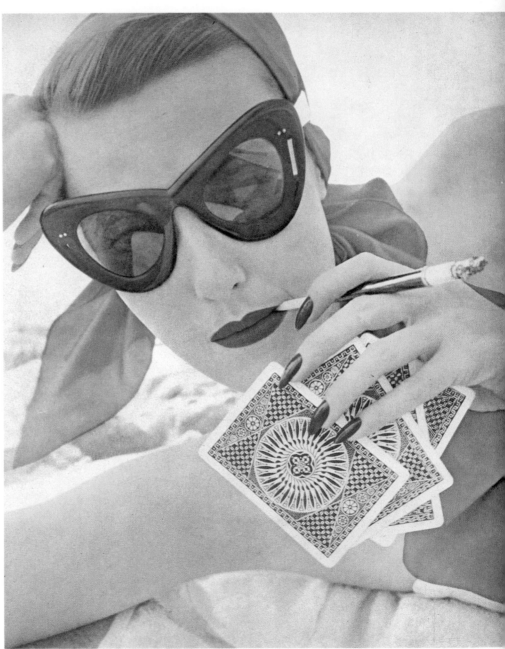

An elegant New York lady playing canasta on the beach was photographed under an umbrella to reduce shadows. The resulting emphasis on bold color to establish the shapes and forms is a characteristic Penn innovation.

Girl with Playing Cards, 1949

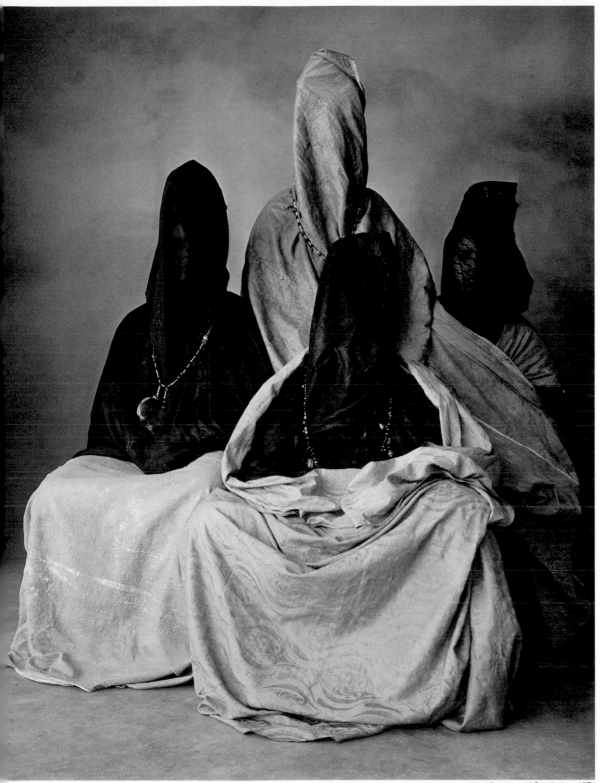

The Guedras of Goulimine, 1971

Eliot Porter's Beloved Nature

When Eliot Porter took up color photography, he had already won acclaim as a black-and-white photographer of the f/64 school—the California group known for exquisite detail captured with big view cameras set for the smallest lens opening, f/64. What he brought to color was the characteristic f/64 technique: a love of detail, pin-sharp focus, a passion for truth and a tendency to concentrate on the close-up and near-at-hand. In a typical Porter photograph a handful of gray-green grasses and orange-flecked rocks stands for a whole meadow *(page 150),* and his fondness for shooting down from above often results in landscapes with no horizon line *(right and page 152).*

In Porter's hands, color film became a new tool for the meticulous description of nature. A tireless worker entirely devoted to his craft, he has been known to wait for days in a specially built blind to photograph a shy bird, and when he is not in the field he is in the darkroom. There, he makes his own prints, using the dye transfer method. In this process three separate negatives are made from the original transparency, one for each primary color. Three positives are then produced on special film, one for each negative, and they are printed in succession on one sheet. Although costly and time-consuming, the process gives accurate and fade-resistant color rendition.

Porter photographs, he says, primarily for "personal esthetic satisfaction," not to promote causes. But his magnificent prints, reproduced in widely disseminated books and posters, played a major role in rallying the public to the need for conserving the beauties of the wilds.

Hobblebush Berries, 1956

The yellows and reds of hobblebush leaves and berries were photographed at medium-close range—four feet from Porter's 4 x 5 view camera—in New Hampshire. Used in Porter's first book, "In Wildness is the Preservation of the World," this photograph accompanies a quotation from Thoreau that says in part, "Color stands for all ripeness and success."

The icy blue waters of a snow-fed waterfall and the fresh green leaves of an Adirondack Mountain springtime glitter and glow in this photograph taken in Beaver Meadow Falls, near St. Huberts, New York. Porter's pictures made up a book that helped protect the 5.7 million-acre preserve, which was threatened by development.

Beaver Meadow Falls, St. Huberts, 1965

Twisted branches and the remnants of a hollow trunk are all that remain of a dead tree on Great Spruce Head Island, the Maine island where the photographer has spent summers since boyhood. The overall grayness of the coloring reinforces the suggestion of antique tragedy conveyed by the gnarled and blasted tree.

Eider Nest, 1964

On Barred Island in Penobscot Bay off the coast of Maine, a nest of eider duck eggs was photographed from about six feet away. Like most of Porter's close-ups the picture, shot from above, reveals no horizon line.

Wrecked Tree, 1964

The Modern Innovators: Eliot Porter

The fiery color and jagged shapes of the rocky walls
of a canyon dramatically suggest the doom that
sometimes awaits even such seemingly permanent
aspects of nature, as it did this one. The scene no
longer exists. The picture was made in 1962 in Glen
Canyon, an area extending 100 miles across the
Utah-Arizona border, which in 1963 was dammed up
and submerged under the waters of Lake Powell.

A fantasy of swirling color caused by the reflection of
autumn leaves and sky in a New England brook is
retrieved from abstraction by a few fallen leaves
floating on the water. A demanding printmaker,
Porter was satisfied with this one. "Maybe a
bit contrasty," he says, "but that's what I saw."

Pool in a Brook, 195

Wall at Moonlight Creek, 1962

Redbud in Bottom Land, 1968

A flowering redbud tree photographed in Red
River Gorge, Kentucky, in 1968, is surrounded by the
fresh greens and blues of leaves and sky in
the spring, a favorite season of the photographer

Red Tree, 1967

This photograph of a sumac tree in glowing
colors signals summer's end and the coming of fall.
This picture and the one opposite were among
65 prints included in a one-man show at New York
City's Metropolitan Museum of Art in 1979.

Color Moods of Ernst Haas

Ernst Haas came to color photography early in a career as a photojournalist. City streets have most often been the subjects for his stories. In them Haas used color to invent a new kind of picture essay in which story line gave way to mood, atmosphere and expression.

In 1952, the jazzy splendors of New York City, for example, inspired pictures with sharp, jagged outlines and strong, forceful colors *(right and opposite page).* Three years later, the faded glories of Venice were recorded in soft outlines and pale, subdued colors *(page 158).* In the 1960s, Haas turned his camera on subjects from nature—the heart of a rose or the stunning vistas of mountains and plains—and transformed the world into patterns of pure color *(pages 160-163).*

But even when Haas focused on people, he subordinated form to expressions of mood and energy. In a brilliant series of photographs of motion, he took advantage of the slow speed of early color film to create blurred images that captured the very essence of activity *(page 159).*

Third Avenue Reflection, 1952

Under the furled wings of a raised awning, the towers of midtown Manhattan are reflected in the window of a Third Avenue beer parlor. Haas's 1952 pictures of New York City were his first using color film; they were so successful that Life devoted 24 pages in two issues to them—the longest color story the magazine had ever published.

Poster Painter, Times Square, 1952

The sweep of lavender and gold in this picture
was created by a man painting a comet for an
advertisement in Times Square, but Haas made it
an appealing photograph by tripping his shutter at
just the right moment: when the man bent over to
mix his paints.

Gondolas at San Marco, 1955

Out of a blue mist, the columns, palaces and ornamental lampposts of St. Mark's Square in Venice emerge as backdrop to the jutting prows of gondolas. The photographer could use a 1/200-second shutter speed to stop the motion of the swaying boats because enough light penetrated the mist to permit a short exposure.

Bullfight, Madrid, 1955

The vivid scarlet of a bullfighter's cape dominates a
picture in which charging bull (left) and torero
(right) are mere blurs. Slow color reversal film and
fading afternoon light forced a 1/5-second
shutter speed, but gave just the effect desired,
depicting a bullfight, the photographer said, as "a
spectacle of motion, the perfection of motion."

Snow Figures, 1964

This close-up of fresh snow covering rocks on the bed of a shallow river suggests the contours of human bodies, but the cold blues and crystalline whites add an eerie note.

Growing and Wilting Cactus Leaves, 1969

In the extreme close-up made possible by a macro lens, two leaves of a Mexican cactus, one wilted and dying, the other erect and healthy, form a striking abstract composition dominated by the thin red edge of the healthy one.

An old road and a line of telephone poles that seem
to climb up into the sky provided unusual opportunity
to express the great distances of the American West.
To make the near poles all seem the same size — and
not massive and widely spread when compared to
those farther away — a long-focal-length lens was
used. Its distortion of perspective turned the row of
poles into a simplified line, pulling the viewer into the
ever-receding space of the West.

Highway to Las Vegas, 1960

Larry Burrows' War

When Larry Burrows went to Vietnam in 1961 for *Life,* he had an assignment no other photojournalist had ever been given: to photograph a war in color. Up to this time, color was considered too pretty for pictures of tragedy and misery, and there were technical problems as well. Processing and reproducing color had required too much time for news stories—unlike black and whites, they could not be shot on Friday and published on Monday. As a result, few photojournalists were experienced in shooting color. Burrows was. He was noted for his virtuosity in copying fine paintings, and he applied that talent to taking stirring color pictures in seemingly impossible conditions.

Burrows' sober, understated pictures stuck close to the real colors of war: the drab green of combat fatigues and tropical forests, against which pink, ivory and ebony skin and red blood and white bandage stood out pathetically and horribly.

Burrows also performed feats of daring under fire, getting shots that would have been missed by someone less intrepid. "Larry," recalled one reporter, "is either the bravest man I ever knew—or the most nearsighted." His most memorable Vietnam pictures were taken in the thick of combat, when he was being shot at or was hanging half out of a diving bomber. In these circumstances, he once noted modestly, he was unable to have complete control over composition. Eventually his luck ran out. He was killed in action in 1971—but not before he had shown the world what war in Vietnam was like.

In a waterway of the Mekong Delta, Viet Cong prisoners are herded aboard a small boat by South Vietnam troops. The picture appeared on the cover of a 1963 issue of Life. It was the first of more than a hundred stories that Burrows filed in nine years from Vietnam.

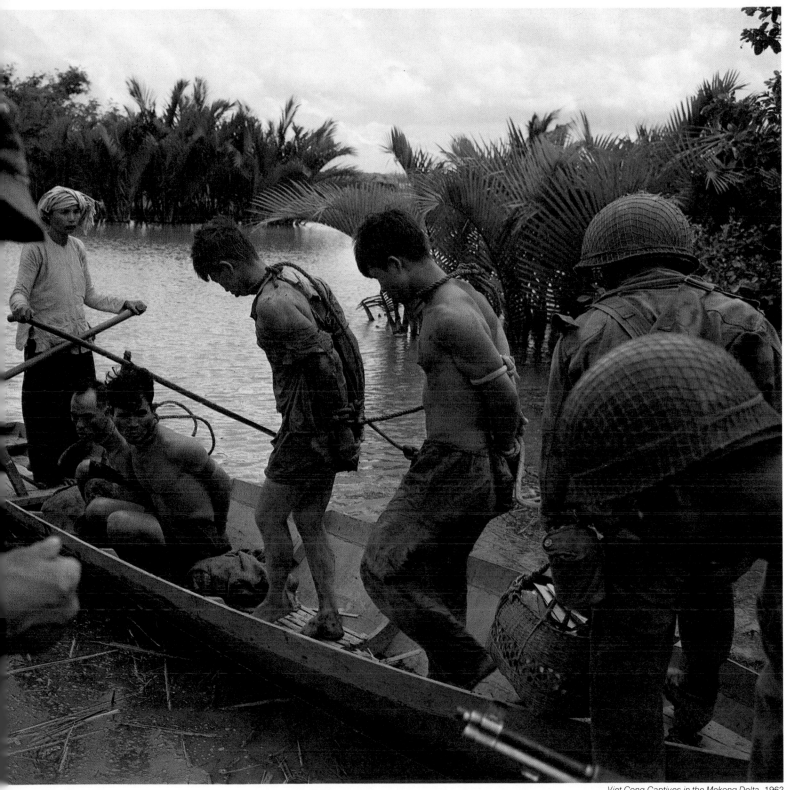

Viet Cong Captives in the Mekong Delta, 1962

In the Vietnam twilight, when Communist ground troops would begin their activities, the gunners of a converted C-47 cargo and passenger plane called Puff, The Magic Dragon, direct tracer fire at a jungle target. In this technical tour-de-force, Burrows leaned halfway out an open door and computed the exposure needed to record both the plane's interior and the twilight colors of a darkening sky. Somehow he kept the camera so steady the lines of tracer fire appear unblurred.

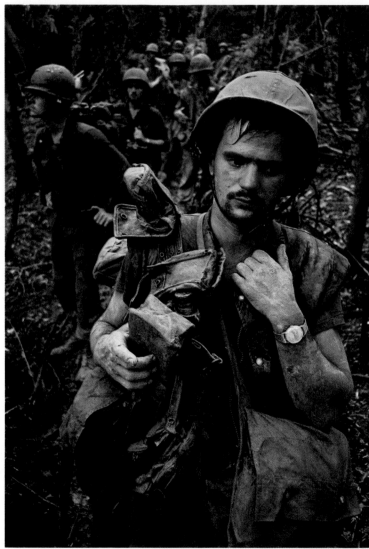

Haggard Patrol near the Demilitarized Zone, 1966

Filing warily through a South Vietnam thicket, Marines search for enemy infiltrators. Against the olive-drab background of jungle and uniforms, the flesh tones of an anxious soldier's face stand out, focusing attention on the human element of the war.

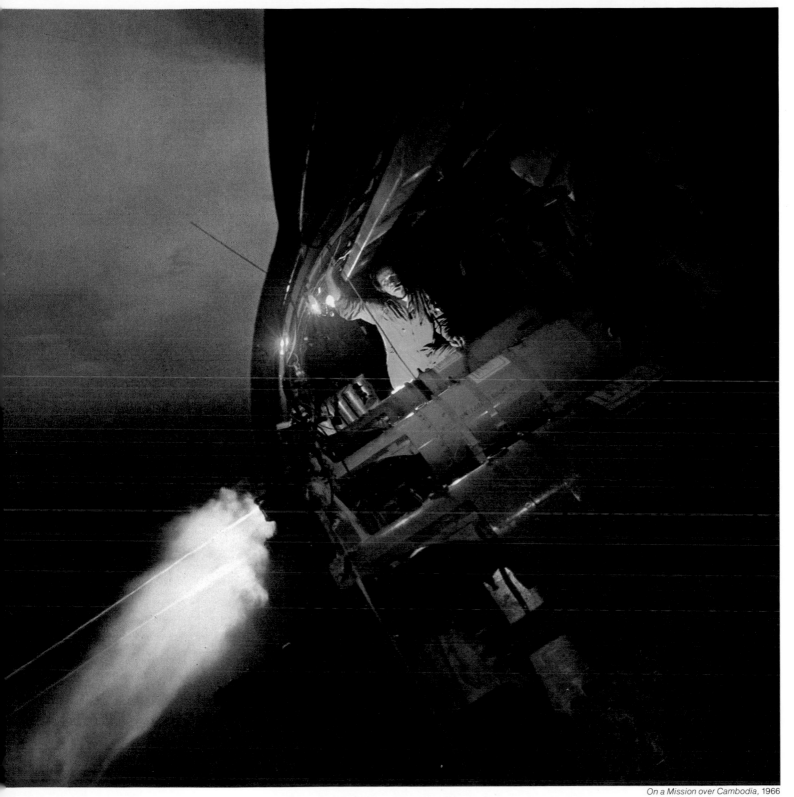

On a Mission over Cambodia, 1966

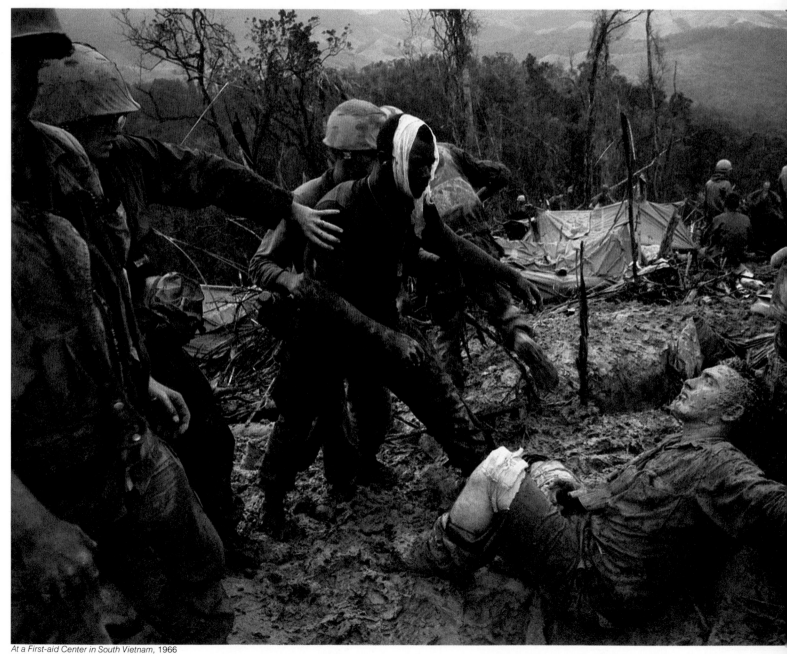

At a First-aid Center in South Vietnam, 1966

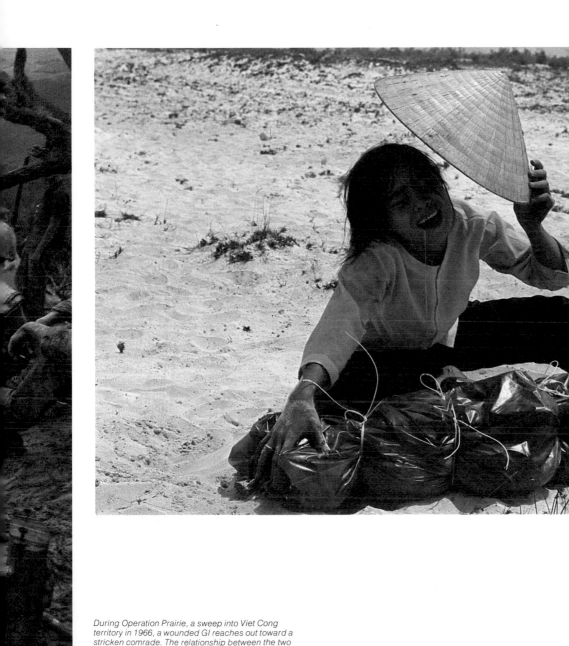

A Woman Wails, 1968

A Vietnamese woman wails over the plastic-wrapped remains of her husband, found in a mass grave near the city of Hue, where he had been killed by Viet Cong during the 1968 Tet offensive.

During Operation Prairie, a sweep into Viet Cong territory in 1966, a wounded GI reaches out toward a stricken comrade. The relationship between the two figures — one bloodied and tense, the other almost one with the mud in which he lies — has elevated this Burrows picture into a classic that expresses the suffering all combat soldiers endure.

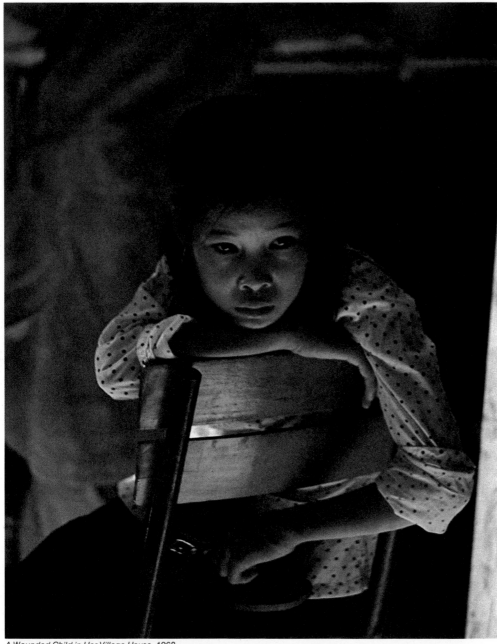

A Wounded Child in Her Village House, 1968.

Nguyen Thi Tron, a 12-year-old Vietnamese girl who lost a leg when she entered a forbidden war zone, sadly reflects on her future by the flickering light of a fire. Burrows, who followed Tron's fortunes through her months of recovery and therapy, sums up the impact of war on the innocent in this picture whose muted browns and light, warmer flesh tones add to the pathos of the young girl's expression and pose.

WINSTON BOYER: *Night Angel,* Lamplight on Apartment House, Nice, France, 1976

For the Best Color, Home Processing

There is one good reason for processing color pictures in a home darkroom: control. The photographer who develops and prints a color image himself can ensure that all the influences on the picture — time, temperature, chemical concentrations — meet not only the rather strict rules for good color but also the special requirements of the individual picture. He can do this fairly easily thanks to greatly simplified procedures, prepackaged kits containing all the necessary chemicals, and innovative equipment that has revolutionized color processing. And although some of the techniques and equipment differ from those that are used in processing black-and-white pictures, the differences are easy to adjust to.

The basic advantages of home processing apply to all kinds of color materials — negatives, prints and transparencies. But most amateurs follow the lead of professionals by leaving the processing of transparencies to commercial laboratories; a considerable number of steps is involved, and even small variations in conditions can severely affect the results. Although prints from developed transparencies are easy to make *(pages 206-207)*, transparencies are generally not printed but rather are shown on a screen with a projector *(right)*. Both the development and printing of color negative film, on the other hand, are comparatively straightforward procedures and they are undertaken by many amateurs and professionals.

The real payoff comes in making prints — from color negatives or from transparencies — because the photorapher can manipulate so many characteristics of the image. He can make a picture lighter or darker to compensate for incorrect exposure in the camera, correct colors or change them for artistic effect, crop out unwanted sections of the image, and vary the printing time of specific parts of the picture by dodging or burning in portions that are too dark or too light. Thus the photographer continues to shape the content, the size and the colors of a picture through the final moments of processing.

The basic advantages of home printing apply to prints from both color negatives and transparencies. But like the majority of the color printmakers whose works are reproduced at the end of this chapter *(pages 208-214)*, most photographers who want maximum control prefer to work with color negative film. Negatives give much greater freedom in adjusting colors and exposure.

For developing color negative film, there are several kits to choose from. The most widely used are the Kodak C-41 *(page 178)*, Beseler Process CN2 and Unicolor K2. All three of these are chemically similar processes and are capable of developing most — but not all — brands of color negative film; to make certain, check the box or the film cassette; if it calls for C-41 type processing, any of these three kits will work.

A second set of chemicals is needed to develop prints from color negatives, and a different set for prints from transparencies. Of the many kits available for

Although prints are easily made from slides in the home darkroom (pages 206-207), most slides are displayed by projecting them onto a screen with a projector like the one above. The most popular of several types, it operates semiautomatically: Pressing a button causes one slide to be lifted up from behind the lens while another from the circular tray drops down into position.

printing from negatives, the Kodak Ektaprint 2 and the Beseler 2-Step are the most widely used; the Beseler 2-Step process *(page 178)* is especially popular because its chemicals can be purchased in the small quantities that occasional color printmakers prefer. For making prints from transparencies, two processes that are commonly employed are the Kodak Ektaprint R-1000 and the Ilford Cibachrome P-12 system.

Major advances in equipment, begun in the mid-1970s, have also greatly eased the once-tedious task of color printing. The key device is an enlarger with built-in precision filters, known as dichroic filters, which permit the printmaker to adjust colors so that they balance properly by simply setting a few knobs. This not only produces better results but eliminates the time-consuming nuisance of inserting and removing filters, as must be done in color printing with a conventional enlarger *(page 198)*. An auxiliary device, called a color analyzer *(pages 180-181)*, also speeds color printing; a sophisticated variant of the light meter, the analyzer eliminates much trial-and-error testing in adjusting color balance. Once it is set up for a particular reference picture that has given a good print, it indicates how to adjust the enlarger to balance color and control exposure for printing other images similar to the reference image.

There have also been major changes in the humbler hardware required to process prints. Although one or two trays are occasionally needed, a processing drum has replaced most of them. Not only does a drum use smaller quantities of chemicals and make it much easier to maintain the proper temperature, but once a drum is loaded and the light-tight lid secured, the entire developing process can be carried out with the lights turned on.

The following pages list in detail the equipment and supplies needed for modern color processing as well as complete procedures for mixing chemicals, developing color negatives and producing color prints from both negatives and transparencies. In addition, the sections on mixing chemicals and developing color negatives can serve as guidelines for processing slide film; many of the steps are the same and several brands of chemicals required for slide processing are available for home use. The techniques have been carefully supervised by Herbert Orth of the Time-Life Photo Lab. They should assure properly developed color images and creative rewards as well. □

Setting Up a Color Darkroom

Though color pictures can be processed at home by adapting equipment used for black and white *(pages 198-201),* some special devices will make the job easier. Most important among them are an enlarger designed to handle both black-and-white and color work, and an accessory voltage regulator. Also helpful are an electronic analyzer for balancing color in prints and a print processing drum. These pieces of color equipment are pictured opposite, together with all the other hardware used to develop color film and to make color prints.

To the right in the picture are "wet side" materials. These items, used with chemicals, should be laid out near the darkroom sink. "Dry side" items around the enlarger should be kept as far as possible from the wet side to prevent any contamination by the chemicals. The timer in the middle is used with both wet and dry materials.

The equipment for developing color film is the same as that employed for black-and-white film. Only in printmaking are there differences.

The color enlarger preferred by most amateurs today is equipped with special filters that speed adjustment of the hues of a projected image. Since most household current varies in voltage from time to time, and a deviation of a few volts can cause discernible color shifts in prints, a voltage regulator is necessary. It compensates for these variations by adjusting the current before it reaches the enlarger *(diagram, page 180).*

A useful piece of equipment is the color analyzer; this device for measuring light acts much like a light meter and aids in adjusting the enlarger's filters. A light-tight processing drum for prints, which functions much like the developing tank used for film, permits processing in room light once the drum is capped. Processing solutions are then poured into the drum, and the drum is agitated either by rolling it back and forth, or by putting it on a motorized base.

Because the tolerances used in color processing are stringent, the instruments that measure the time and temperature should be of good quality. The film developer temperature must remain within a quarter of a degree (F.) of the temperature prescribed, so a thermometer that errs by less than that amount is essential; one that will register a temperature change quickly, such as the dial-type shown here, is the most useful. A timer easily readable in dim light, fitted with a large, luminous dial and sweep-second hand is convenient; it should be able to time up to 60 minutes.

Most of the rest of the equipment is the same as that used in black-and-white processing: bottles and a graduate that hold either a quart (32 ounces) or a liter (34 ounces) for mixing, measuring and storing chemicals; a basin to bathe the bottles in to keep them at the proper temperature; a tray for washing prints; sponges to wipe newly washed prints and negatives before drying; a magnifier to ensure that the image projected on the enlarger easel is precisely focused; a brush for cleaning negatives and slides; and a frame to hold negatives and paper when making contact prints. A piece of black cardboard is used in color processing to mask part of a test print during the preliminary adjusting of enlarger settings *(pages 192-193).*

The waterproof gloves in the picture are essential equipment; color processing chemicals are caustic — always wear gloves when handling them.

1	color analyzer
2	voltage regulator
3	enlarger
4	enlarging easel
5	focusing magnifier
6	camel's-hair brush
7	contact printing frame
8	test-print masking card
9	timer
10	five-gallon plastic basin
11	pint chemical bottles
12	waterproof gloves
13	funnel
14	graduate
15	stirring rod
16	film developing tank and reels
17	metal clips for drying negatives
18	film cassette opener
19	scissors
20	viscose sponges
21	thermometer
22	one 8 x 10 tray
23	motorized base for agitator
24	drum print processor

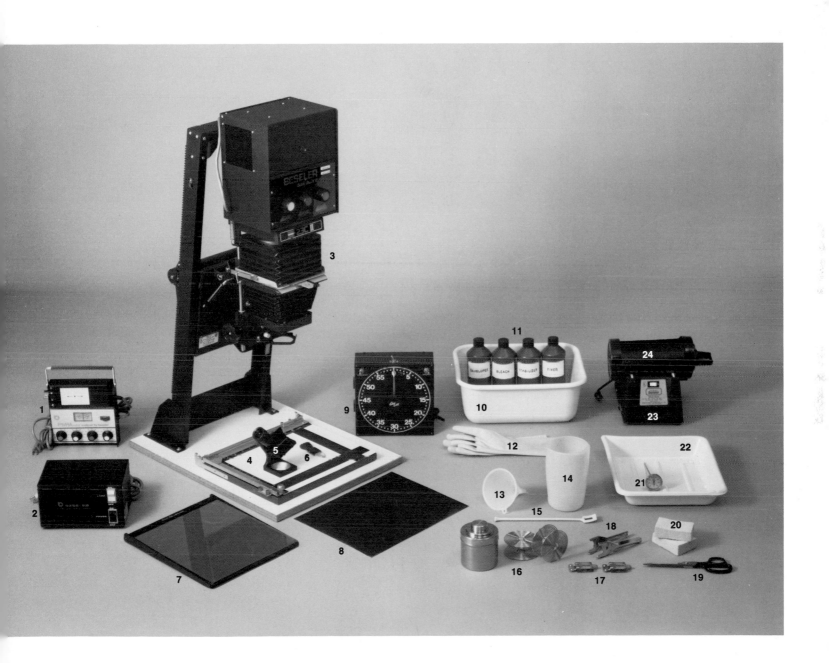

Chemicals in Kits

Most amateurs buy color chemicals in kits. These kits contain prepackaged liquids and powders in what may seem a bewildering variety. Actually, most of the kits supply ingredients for no more than four solutions, and prepackaging simplifies the mixing and measuring: Usually, all the user does is empty the contents of the container into a graduate—only water needs to be measured. The containers are clearly labeled for the sequence in which they should be mixed. In addition, most kits yield solutions in amounts that are economical for home use.

The three color processing kits pictured—Kodak Flexicolor C-41 for developing negatives, Beseler 2-Step for printing negatives and Cibachrome P-12 for printing transparencies—are among the most popular and are the ones described in the step-by-step processing explanations beginning on page 182. However, many other kits are frequently used, such as Beseler CN2 and Unicolor K2 for developing negatives, Kodak Ektaprint 2 and Unicolor R2 for printing negatives, and Kodak R-1000 and Unicolor RP-1000 for printing transparencies.

Some kits such as the Beseler 2-Step produce solutions in metric rather than the "English" measures still common in the United States (although not in England). However, all kits give equivalent English and metric measures for each quantity at each stage in the instructions, and most equipment can be used with either measuring system. (A table for adapting U.S. to metric measurements appears on page 235.) Graduates generally are marked off in cubic centimeters (metric) as well as ounces (English);

most pint bottles are large enough to hold 500 cubic centimeters (about 17 ounces), and quart bottles will hold a liter; thermometer dials are marked in both Centigrade and Fahrenheit degrees.

Each manufacturer's kit, like each type of film, creates subtly differing colors and levels of contrast, and deciding which brand to use depends partly on personal taste as well as ease of use. Some kits require more separate processing steps or more precise temperature regulation than others; some have liquid chemicals, which are easy to mix, while others offer powders, which are available in smaller quantities, that can be used and discarded with a minimum of waste.

Once the chemicals are mixed, the most unstable of them—a developer for prints from transparencies is one—begin to break down after about two weeks. The others can be kept in mixed form for at least four weeks. Unopened packages of color printing paper remain usable for at least one year if kept in a refrigerator. After the package is opened, the paper will retain its qualities for several months.

The chemicals in all color processing kits are more corrosive than the ones used for black-and-white pictures. Wear plastic gloves to protect the hands and a plastic apron to protect clothing. The acids in some solutions may also corrode plumbing pipes; when disposing of the used chemicals, flush them down the drain with water running from the faucet. The Cibachrome P-12 kit, which includes a bleach containing sulfamic acid that should be neutralized before the solution is discarded, provides a packet of powder for this purpose.

For developing color negative film at home, the Kodak Flexicolor C-41 kit includes (left to right, in order of use): six bottles that make up two one-pint batches of developer; one packet and two bottles for one pint of bleach; one bottle for one pint of fixer and another for one pint of stabilizer.

For processing color prints from color negatives the Beseler 2-Step kit includes materials for preparing 34 ounces each of developer (one bottle, three packets at left) and bleach-fix (two packets at right). There are several brands of printing paper that can be used with these chemicals, such as Ektacolor 74 RC (far left), Ektacolor 78 RC and Unicolor RB.

Ingredients in the Cibachrome kit, which makes color prints from transparencies, are numbered for sequence of use. Solutions in the two bottles marked 1 make developer; chemicals from the bottle marked 2 and the two packets marked 2 (in front of bottles) make bleach; solutions from the bottles marked 3 make fixer. The numbered cups are used for measuring. The packet of neutralizing agent (lower right) is used to keep discarded bleach from damaging plumbing. Printing paper (lower left) must be purchased separately.

An Enlarger Fine-tuned for Color

To create a pleasing color print, the color of the enlarger light must be adjusted. This so-called balancing is required partly to correct variations in the color generated by the lamp itself. But balancing also must compensate for the differences in the color reactions of film, paper and processing chemicals. It is accomplished by placing one or more filters of a primary color in the path of the light.

In the past, enlargers had to be adapted for color printing with supplementary acetate or gelatin filters. Now, in enlarger heads specially designed for color printing, color filtration is modified by adjusting three knobs on the enlarger head to control color filters inside.

These filters, a special type known as dichroic, are constructed of glass coated with ultra-thin transparent layers. Like the dyes in conventional filters, the coatings selectively block part of the color spectrum and pass the rest, but they do so with much greater precision.

An accessory, the color analyzer *(right and opposite, lower picture),* aids in adjusting enlarger filters by gauging the color values and overall light intensity of the image projected on the easel. It must be calibrated before use by setting its dials for the values of a previous reference image—arrived at by the method shown on pages 192 and 193. Once the analyzer is calibrated, its meter guides the setting of filters and aperture to produce a good print from any negative or slide similar to the reference.

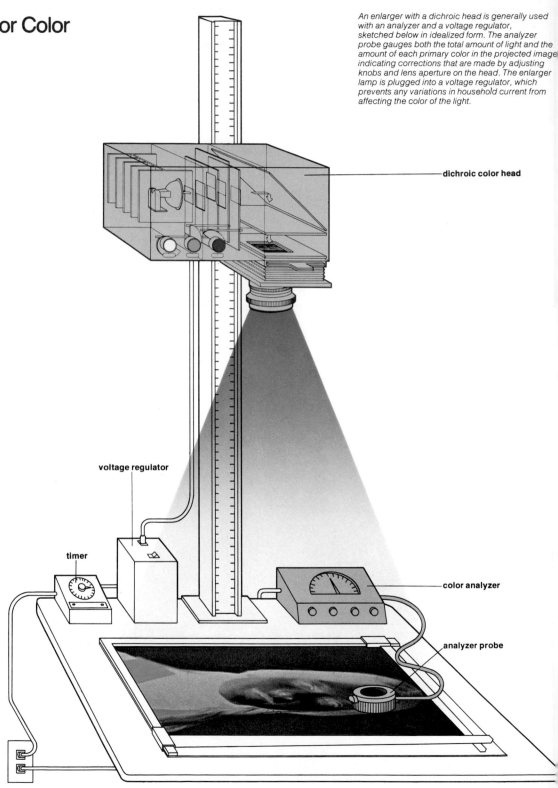

An enlarger with a dichroic head is generally used with an analyzer and a voltage regulator, sketched below in idealized form. The analyzer probe gauges both the total amount of light and the amount of each primary color in the projected image, indicating corrections that are made by adjusting knobs and lens aperture on the head. The enlarger lamp is plugged into a voltage regulator, which prevents any variations in household current from affecting the color of the light.

dichroic color head

voltage regulator

timer

color analyzer

analyzer probe

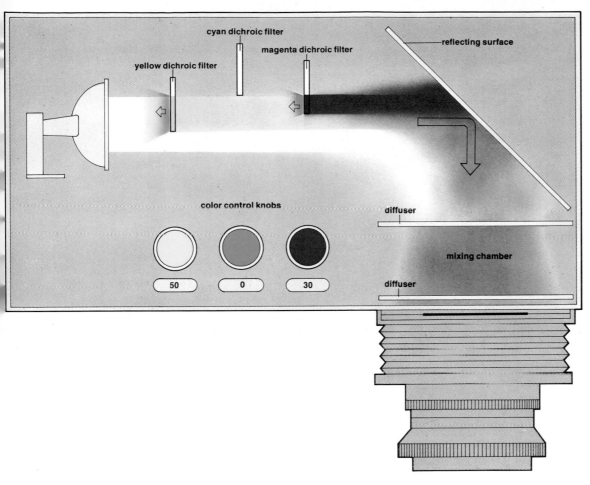

Inside the enlarger color head, dichroic filters are positioned by color control knobs to correct the color of the light. The number—between zero and 200—under each color knob indicates how much the knob's complementary color in the image is changed. In this example, the cyan filter knob is set at zero—the correction of its complement, red, is rarely required—so that the cyan filter is out of the beam. The setting of 50 for the yellow filter indicates that a large amount of blue light—yellow's complement—is being removed from the beam for color balance; the 30 setting for the magenta filter removes proportionately less of its complement, green. Beyond the filters, filtered and unfiltered light is blended in a mixing chamber.

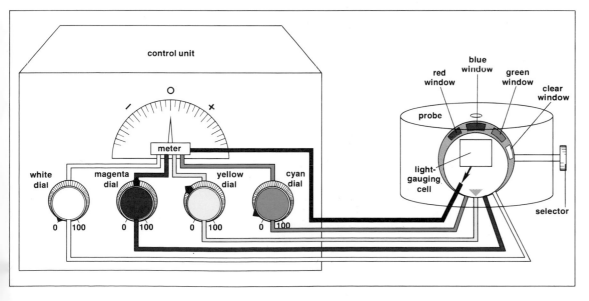

Inside the probe of a color analyzer are red, blue, green and clear windows positioned by a selector keyed with their complements—cyan, yellow and magenta—and with white for clear. The selector positions each window over a light-gauging cell, which indicates light intensity on the control unit meter. With the selector at yellow and at magenta, the corresponding enlarger knobs are turned until the meter needle centers at zero—those colors are then preliminarily balanced. At cyan, the enlarger aperture is adjusted to center the needle. These three steps are then repeated for final balance. At white, the aperture again is adjusted for exposure. The control unit dials are not used during printing; they are preset with a reference picture (page 203).

Processing Color Negatives

After equipment and supplies have been assembled, the final step before processing of color pictures begins is the mixing of chemicals—in the case illustrated here step by step, the C-41 materials for developing color negative film. This kit produces two separate pints of developer and one pint each of the other solutions; the developer becomes exhausted more quickly than the others.

For uniform results, the water used in mixing should be measured carefully and water temperature should be kept at 80° to 90° F. for the developer and bleach, and at 70° to 80° F. for the stabilizer and fixer. A shortcut for adjusting water temperature is shown in Step 1 *(right)*. After each chemical is mixed, the table and implements—funnel, stirring rod, graduate, thermometer—must be thoroughly washed to prevent contamination.

1 adjust the water temperature

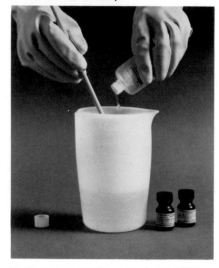

Place the stem of the thermometer under the faucet and adjust the taps until the temperature of the water is 80° to 90° F. To protect your hands, gloves should be worn while mixing solutions.

2 mix the "A" developer

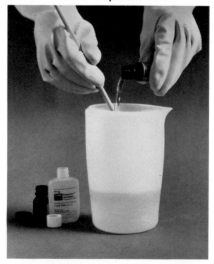

Into the graduate pour 11 ounces of water at 80° to 90° F. and slowly add the contents of one of the two bottles of "part A" of the developer. Then stir the solution until it looks uniform.

3 add the "B" developer

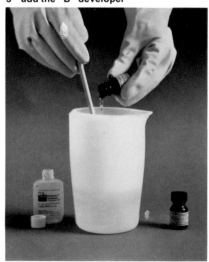

Empty one of the two bottles of "part B" of the developer into the graduate and stir the mixture until uniform. For proper chemical reaction, developers must be added in this order.

4 add the "C" developer and water

Empty a bottle of "C" developer into the graduate. Stir until well combined. Then slowly add water at 80° to 90° F.—from a container, not from the faucet—to make a total of 16 ounces.

5 store the mixed developer

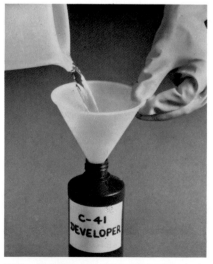

Holding the funnel steady, fill the pint bottle marked C-41 Developer with the freshly mixed solution, pouring slowly to allow air within the bottle to escape. Cap the bottle and put it aside.

6 wash contaminated implements

The graduate, funnel, stirring rod, thermometer and table must be washed thoroughly; all have been exposed to the developer. Washing must be done after each solution is mixed.

7 open the bleach packet

Pour 11 ounces of water at 80° to 90° F. into the graduate. Cut the bleach packet without squeezing it. Keep the cut end away from the face. The powder can harm eyes and nasal passages.

8 prepare the bleach

Pour the powder into the graduate and stir. Then add the "B" and "C" bottles of bleach. Mix well; add water for a total of 16 ounces. Pour the solution into its bottle. Wash the equipment thoroughly.

9 prepare the fixer

Pour 11 ounces of water at 70° to 80° F. into the graduate. Empty the bottle of fixer. Add enough water to make a total of 16 ounces. Store the fixer. Wash the equipment thoroughly.

10 prepare the stabilizer

Again pour 11 ounces of 70° to 80° F. water into the graduate; empty the bottle of stabilizer. Add enough water to make a total of 16 ounces. Stir until the chemicals are dissolved. Store.

11 put the bottles into a water bath

Place the four bottles of solutions in a deep tray filled halfway with water at 100° F. This bath stabilizes the temperature of the chemicals close to the level required for proper development.

Developing in a Tank

After the chemicals are mixed and in their water bath *(Step 11, preceding page)*, the development of color negative film is ready to begin. The film must be loaded into the developing tank *(Steps 1-5, this page)* in complete darkness: It is wise to practice the procedure first with a roll of outdated film. Once the light-tight developing tank is covered, the rest of the steps can be performed in room light.

The temperature of the developer solution is crucial. It cannot vary more than ¼° F. from the recommended 100.5° F. Time is also critical. Allow for the time required to drain solutions from the tank, and when reusing developer, be sure to increase the developing time in accordance with the instructions on the kit.

1 open the film

In total darkness, open the film container, popping off the end of a 35mm cassette with an opener. With other types of film, remove the cartridge side or unroll the paper backing.

2 cut the film end

After removing the spool from its protective covering, use the scissors to square the end of the film if necessary. Put the scissors out of the way to avoid scratching the film.

3 thread the reel

Holding the spool so that the film unwinds off the top, insert the end into the reel core. Make sure the reel is held so that the outer ends of its spirals are at the top and face the film.

4 wind the film

Bow the film. Slowly push the film into the grooves so that the reel rolls forward on a flat surface, or turn the reel in your hand. Each coil should fall into its own groove; if two coils touch, begin again.

5 put the reel into the tank

Put the loaded reel into the tank. If developing one reel, first insert an empty reel as a spacer. Place the light-tight cover on the tank. Lights may now be turned on. Put on gloves.

6 adjust the developer temperature

To get the developer to exactly 100.5 ± ¼° F. — this temperature must be held within one fourth of a degree — put the bottle, with the thermometer in it, into warm or cool water.

7 fill the tank with developer

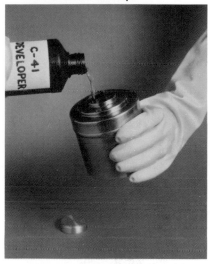

With developer at 100.5° ± ¼° F., slowly pour into the tank through the light-tight filler opening, holding the tank at a slight angle to let air escape and avoid splashing. Fill to overflowing.

8 start the timer; dislodge air bubbles

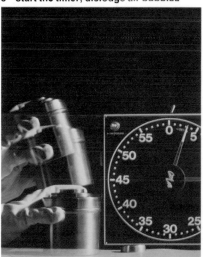

Start the timer, preset to the developing time — three and a quarter minutes. Bang the tank against the table a few times to dislodge air bubbles that could cause uneven development.

9 cap the tank

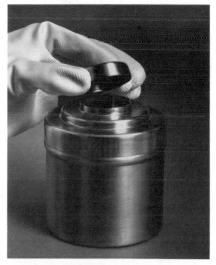

Place the cap on the cover's light-tight filler opening so that developer cannot spill out of the tank during the following step of agitation.

10 agitate the tank

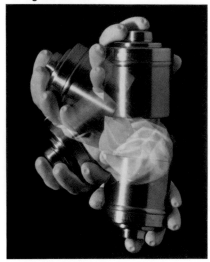

Use a gentle inversion motion to agitate the tank for 30 seconds. This keeps fresh solution in contact with the film, ensuring even development. Do one cycle per second.

11 maintain bath temperature

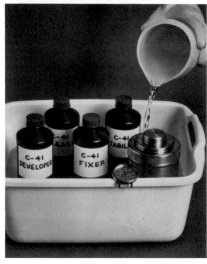

After the first agitation, put the tank in a water bath for 13 seconds, then agitate again for two seconds. Add warm or cold water to the tray as necessary to maintain the correct bath temperature.

12 empty the tank

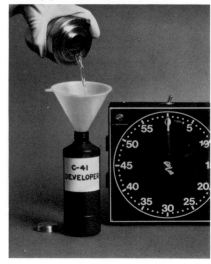

Alternate two-second agitations with 13-second water baths until the end of developing time. When 10 seconds remain, pour the developer back and return it to the bath. Wash the funnel.

13 bleach the film

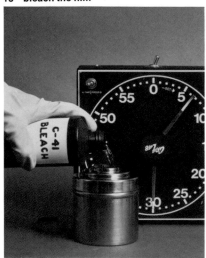

Fill the tank with bleach and start the timer, which is preset to six and a half minutes. Repeat the procedures for agitation, and stabilize the temperature at 100° F. ± 5° F.

14 empty the tank

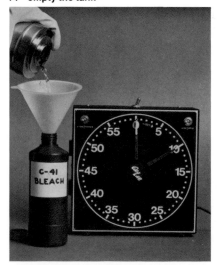

With 10 seconds left on the timer, pour the bleach back into its brown plastic bottle. Replace the cap on the bottle and put it back in the water bath. Wash the funnel.

15 wash the film

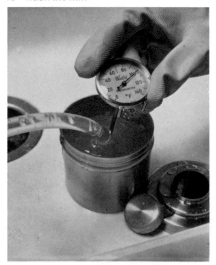

Open the tank and direct water from a hose into the center of the reel; water temperature should be 100° F. ± 5° F. Continue for three and a quarter minutes. Wash the cover, lid and funnel.

16 add fixer

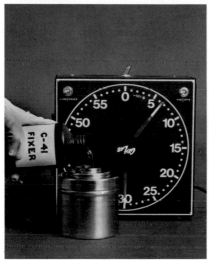

Fill the tank with fixer and start the timer, which is preset to six and a half minutes. Steps for dislodging air bubbles, temperature control, agitation, and draining are the same as for bleaching.

17 final wash

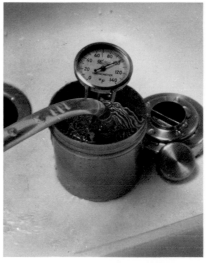

Wash the film for three and a quarter minutes, following the procedure used in Step 15. It is important to continue to maintain the temperature. Shake the tank gently.

18 add the stabilizer

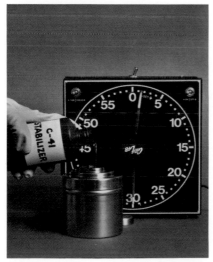

Fill the tank with stabilizer and start the timer, which is preset for one and a half minutes. With 10 seconds left, pour the stabilizer back into its brown bottle. Cap the bottle and put it back into the water bath.

19 dry the negatives

After washing the film four minutes inside the tank, remove the film, hang it to dry—clips on the bottom prevent curling—and gently wipe it with sponges. Drying time is about two hours.

tips for processing color

To adjust the temperature of a small bottle or tank of solution, insert the thermometer and then hold the container under the hot or cold water faucet. When using chemicals in a tray (pages 199-201), adjust the temperature of liquid by placing a clean glass of hot water or ice water—whichever is needed—in the tray; move it slowly through the solution, constantly checking the temperature until the desired level is reached.

An electric skillet can be used to keep a warm-water bath at a constant temperature. Fill the skillet with water and turn its thermostatic control to the lowest setting. After the water has begun to warm, place a bottle of solution containing a thermometer into the water and slowly adjust the control upward until the thermometer registers the desired temperature.

The most common cause of streaked color film is incorrect agitation. Follow the rule for agitation exactly (Step 10, page 186), taking care not to overdo.

To cover tiny scratches in the nonemulsion side of a negative, rub a dab of petroleum jelly—Vaseline—lightly over the surface. The jelly will prevent the scratch from showing up in the finished print.

If regular darkroom gloves or household gloves are too heavy to allow as much dexterity as you need—particularly in making prints—try the thin gloves that surgeons wear. They cost about the same and are available at drugstores.

Luminous tape, sold in photo supply stores, affords a handy way to mark small objects you need to find in the dark: a timer switch, a cassette opener, a filter holder, a tray. Its glow is visible to the eye but too dim to harm photographic materials if used sparingly.

A large plastic sheet, such as an old shower curtain, provides a liquid-proof, easily stored cover for the wet table in an improvised darkroom. It is easy to wipe clean—an essential consideration for color processing.

Getting Ready to Print

When negatives are developed and are ready to be printed, the first step is an odd one: Take the printing paper out of the refrigerator. The paper has three delicate layers of gelatin emulsion that can be affected by heat and humidity, and it should be stored in its original sealed box in the refrigerator at 50° F. or less. If possible, it should be kept in the freezer.

The paper should be taken out, however, at least two hours before it is to be used so that its temperature can rise to room level. Then the sheets that are required may be removed—in the dark-room—from the package and placed in a separate container *(right)*. Before the package of unused sheets is returned to the refrigerator, the excess air should be pressed out of the moistureproof bag and it should be carefully resealed.

The time to take the paper out of the refrigerator is an hour before the printing chemicals are mixed *(opposite);* the mixing, and setting up the equipment *(pages 189-190),* takes about an hour. The step-by-step sequences for mixing are based on the Beseler 2-Step processing kit illustrated on page 178. It is set up for metric quantities, but the amounts suit American equipment, and its instructions specify measurements both in metric units and in the units used in the United States. Metric can also be converted by referring to the table on page 235.

Because only an ounce or two of each solution is used at one time, they will deteriorate less rapidly if poured into two bottles; while liquid in one bottle is being used, the other is kept sealed for later use. The chemicals are clearly labeled so they can be mixed in proper sequence. Like all color chemicals, they must be handled with extreme care; wear gloves and heed warnings on the package.

Color printing paper can be removed (in darkness) from its moistureproof foil wrapper after it has had time to warm up—the supply is kept in a refrigerator or freezer to prevent spoilage.

The sheets to be used are placed in a lightproof container until they are needed. An empty paper box—one marked "unexposed" in large letters—can serve this purpose well.

1　label the bottles

Mark two clean pint storage bottles for the "Step 1" solution. Mark two others for the "Step 2" solution. After mixing, the solutions will be divided to extend their useful life.

2　pour water into the graduate

Hold a thermometer under the faucet, and adjust the taps until the water temperature is between 77° and 86° F. Then fill a clean graduate with 24 ounces of water. Wear gloves when mixing solutions.

3　add contents of bottle "A"

Take the small bottle labeled "Step 1, Part A" from the kit. Shake it vigorously, then slowly pour its contents into the graduate while stirring. Make sure the solution is thoroughly mixed.

4　add packets "B," "C" and "D"

Add the powder in the packet labeled "Step 1, Part B" to the graduate while stirring. Mix until completely dissolved. Then, in sequence, add the "C" and "D" powders, mixing each in the same manner.

5　add water

Slowly add water at 77° to 86° F. to bring the total volume in the graduate to 34 ounces. This solution is caustic. To avoid splashing, add the water from another graduate, not the faucet.

6　mix the solution

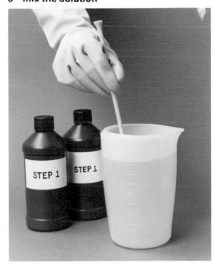

Stir until the solution is thoroughly mixed. It must be well blended before it is poured into the two bottles labeled "Step 1" to assure that both bottles contain mixtures of equal strength.

7 fill both "Step 1" bottles

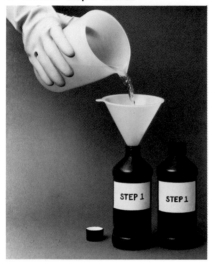

Using a funnel, pour the freshly mixed solution into the two bottles labeled "Step 1." Pour slowly to allow air within the bottles to escape. Cap the bottles and set them aside.

8 wash contaminated implements

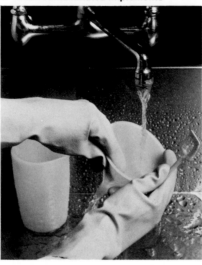

Thoroughly wash the graduate, funnel, stirring rod, thermometer and working surfaces that have been exposed to the "Step 1" chemicals.

9 add water and packet "A"

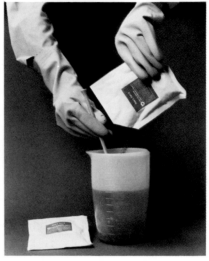

Fill the clean graduate with 24 ounces of water at 77° to 86° F. Then add the powder in the packet labeled "Step 2, Part A" to the water while stirring. Mix until completely dissolved.

10 add packet "B" and water

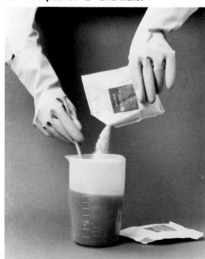

Add the powder in the "Step 2, Part B" packet to the graduate while stirring. Mix until it is dissolved. Then add water at 77° to 86° F. to bring the volume to 34 ounces. Mix thoroughly.

11 fill both "Step 2" bottles

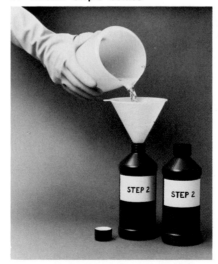

Using a funnel, slowly pour the freshly mixed solution into the bottles marked "Step 2." Cap the bottles and wash the implements and working surface thoroughly.

precautions

The instructions and warnings that come with individual chemicals and appear on direction sheets should be read carefully before the chemicals are opened. The chemicals may irritate the skin or the eyes. And many of the chemicals are poisonous if swallowed or inhaled. If a solution spills onto the skin, wash the area immediately with water. Gloves — rubber or plastic — should be worn, especially for mixing and pouring solutions and for cleaning the darkroom. Before removing gloves after each use, wash them with water.

Keep all working surfaces, trays, tanks and other containers clean.

The quality and life of the processing solutions depend on their remaining free of contamination.

Do not mix chemicals in the dry side of the darkroom: they can spot prints.

Balancing the Enlarger with a Test Print

It may be tempting to start on the first print as soon as the chemicals are mixed, but preliminary test prints are essential to set up the enlarger's color filters to produce a desirable balance of hues.

These test wedges generally need to be prepared only once for a particular combination of enlarger, film, printing paper and paper developer; the same tests will then serve as a reference for producing prints from similar negatives. Of course, if any element of the combination is altered—if a new negative is of a hazy blue landscape instead of a sunny portrait, for example—another set of test wedges will usually be necessary.

The wedges help find the correct settings for the enlarger's dichroic filters, or the correct combination of acetate or gelatin filters to use with a black-and-white enlarger. Such advance testing is necessary because of variations in the elements that determine the colors in a print: the color in the negative (which depends on subject and type of film), the paper and chemicals being used, and the color of the enlarger's light.

Film and paper are made with standardized chemicals; manufacturers test each batch of paper and recommend filter settings for using it with each common type of film. But since two enlargers, even of the same model, rarely give off light of the same color, these recommended settings must be further refined for the particular enlarger being used. And differences among subjects and developers must also be allowed for.

In the step-by-step demonstration on the following six pages, a Kodacolor II negative is tested on Kodak's Ektacolor 74 RC paper, processed in Kodak Flexicolor C-41 chemicals. Three filter combinations are tried—one recommended by the paper manufacturer, one with less filtration and one with more. Each of the filter combinations is tested on a separate sheet of paper, and each sheet is given three different exposure times by uncovering successive portions, producing a total of nine wedge-shaped tests. After the prints are developed *(pages 194-195),* the colors on the test wedges are judged against a reference set of pictures in which colors vary by a known amount *(pages 196-197).*

After the basic filter settings have been determined, only minor changes are necessary to correct for variations between the test negative and another that is to be enlarged. These adjustments are best made by comparing the colors in the new negative with those in the test negative using a color analyzer *(pages 202-204).* Settings will also need adjustment for a new batch of paper; paper manufacturers provide a filtration guide with each box *(below, right).*

Nearly all color corrections are made using only the enlarger's yellow and magenta filters. Once set for proper filtration these two can make changes in all three primary colors. Cyan is reserved for sophisticated special effects. Different filter combinations may be needed when printing from slides *(page 206).*

The amount of color change that each filter or filter setting will produce is indicated by numbers near the dichroic head knobs or by similar numbers on acetate and gelatin filters. The numbers range from 0 to 200: The higher the number, the more the filter blocks its complementary color and thus alters the color of the enlarger's light. Filter settings are noted in shorthand form. On the following pages, for instance, the combination that is recommended by the paper manufacturer is a magenta setting of 35 and a yellow setting of 50, written as 35M+50Y+0C. The test settings that bracket this one are 40M+60Y+0C and 30M+40Y+0C. (The cyan filter (C) is so rarely used that many instructions omit it, specifying only the M and Y settings.)

Because the filters block light, exposure times may have to increase. As a general rule, yellow corrections require little or no change in exposure time, but every 10-unit change in the magenta filter setting requires a 20 per cent increase or decrease in exposure time.

When making test wedges, use a properly exposed negative, one that is neither too dark nor too light. Close-ups of people provide good test negatives because it is easy to tell when flesh tones appear natural and thus to judge the color balance. Photo supply stores sell standardized test negatives (called Shirleys after the model who posed for the original one). But the best test negative is one that is typical of a photographer's own work and shows a familiar subject.

WHITE LIGHT DATA		
CC	-10	M
CC	00	Y
Ex. Factor	70	

Because the color response of paper often varies, package labels indicate filter adjustments needed to compensate. This is usually called white light data (because the print is made in an enlarger with a white light source). The notation -10M above calls for a 10-unit reduction in the magenta setting ordinarily used, while 00Y indicates no adjustment in the yellow filter. The Ex. Factor (Exposure Factor) is a figure that is used, according to a formula given in the manufacturer's instructions, for computing the new exposure time. White light data is used only when switching to a new batch of paper, not for the initial tests shown on the following pages.

Exposing the Test

Before making the test prints, the negative and the enlarger should be prepared as they would be for any printing. The negative must be completely clean. A fingerprint or a tiny bit of dust can enlarge into a distressing spot on the final print. Careful sweeping with a fine camel's-hair brush is usually all that is needed to rid the negative of dust. Or a small rubber syringe can be used to puff away the particles. Fingerprints can be avoided by handling the negative by the edges, but if one appears, it can usually be removed by gingerly wiping the negative with cotton moistened with film cleaner, a solvent sold at most camera stores.

After placing the negative in the enlarger carrier, make sure that it is centered. Before turning off the room lights, set the filter control knobs to the settings for the first print.

1 clean the negative

Using a camel's-hair brush, carefully clean all dust off the negative. Then wipe the negative carrier and place the negative in it so that the emulsion (dull) side faces the easel.

2 insert the negative

Open the enlarger head and insert the negative carrier. Make sure the carrier is properly positioned before closing the head.

3 set the filters

Set the three filter knobs slightly above the settings recommended by the paper manufacturer. For this demonstration, the settings were 40M (magenta), 60Y (yellow) and 0C (cyan).

Many of the steps in printing the test negative are the same as those used for other printing—adjusting image size and focus, for example. The differences arise during exposure.

Three prints are made with filter settings that bracket the manufacturer's recommendation. In the demonstration here, using a Kodacolor II negative and Ektacolor 74 RC paper, the first setting is 40M+60Y+0C, the second 35M+50Y+0C, the third 30M+40Y+0C. Also, each print is divided into three wedge shapes of differing exposure times by masking parts of the paper with cardboard. Moving the mask allows one wedge in the first print to be exposed 21 seconds, another 16 seconds and the third for 11 seconds. In the second print, the wedges are exposed for 17, 13 and 9 seconds; in the third for 13, 10 and 7 seconds.

1 adjust image size

Turn on the enlarger, open its lens aperture completely and disengage the dichroic filters for focusing. Projecting onto plain paper, raise or lower the head to get the desired image size—here 8 x 10.

2 focus the image

Looking through a focusing magnifier, adjust the focus control of the enlarger until the image is sharp When it is, stop down the lens to f/8. Reengage the dichroic filters.

3 mark the enlarger head position

Mark the position of the enlarger head on the column with tape. Then take out the printing paper and insert it into the easel, emulsion side up.

4 expose the test print

Holding the mask over two thirds of the paper, expose the first wedge 5.5 seconds. Reset the timer for 5.5 seconds, shift the card and expose; remove the card and expose 11 seconds.

5 put the print into the drum

Curving the print, emulsion side inward, slide it into the processing drum. Cap the drum, turn on the lights, and process the print (pages 194-195); make the other two test prints using the other filter settings.

Processing in a Drum

Once a print is in the lightproof processing drum *(Step 5, page 193),* it can be developed with the room lights turned on. All of the processing steps can be performed at room temperature, as well, although times vary depending on the temperature of the room—chemicals work faster at higher temperatures. At 66° F., for example, processing times for "Steps 1" and "2" solutions and a water wash are approximately 20 minutes; but on an extremely hot day, at 96° F., the procedure would take about six minutes. Exact times for the various temperatures are given in the instruction sheet that comes with the processing kit.

Most processing drums require only one and a half ounces of each solution. To keep this small quantity of liquid in continual contact with all the print surface, however, the drum must be agitated constantly. The best way to do this is with a motorized base. Support the base on a level surface so that solutions will not accumulate at one end of the drum.

The drum can also be agitated manually, by rolling it back and forth on a flat surface every second for the first 20 seconds; after that, roll it once every other second until the processing time is up.

Colors in a print cannot be judged *(pages 196-197)* until the print is completely dry. If the print is simply clipped to a line *(Step 10, opposite),* drying will take about an hour. For faster drying, direct warm—not hot—air toward the print from a hair dryer.

1 measure the "Step 1" solution

Working with chemicals at room temperature, pour one and a half ounces of "Step 1" solution from one of the bottles into a clean graduate. Be sure to wear gloves when working with color chemicals.

2 put the drum on its base

Set the drum containing the exposed print on the motorized base, or place it on a level surface where it can be rolled back and forth by hand.

3 pour "Step 1" solution into drum

Pour the solution into the drum. Start the timer, preset to the processing time that the instructions specify for the existing room temperature, and switch on the motor. Wash the graduate.

4 drain the drum

When the time is up, switch off the motor and pour out the solution by tilting the drum slightly over the sink. Then tilt the drum more, holding it so that the spout faces downward, and shake.

5 measure the "Step 2" solution

Pour one and a half ounces of solution from one of the bottles marked "Step 2" into the clean graduate. Then find the "Step 2" processing time for room temperature on the instruction sheet.

6 pour solution into drum

With the drum on the base, pour the solution from the graduate into the drum's spout. Run the base for the required time. Then drain completely.

7 remove the print

Open the drum and remove the print. Because the emulsion is soft and will remain so until the paper is dry, grip the print only on the back and edges. Place the print in a clean tray.

8 wash the print

Wash the print in running water for six minutes. To protect the emulsion, use a hose (above) or run water from the tap into a corner of the tray.

9 wipe the print

Place the print on a clean surface and gently wipe both sides with a sponge to remove excess moisture. Use a sponge that is kept just for this purpose to avoid contamination.

10 dry the print

To dry the print, hang it on a line with spring clothespins. Wash the drum and graduate thoroughly. The drum must be thoroughly dried before making another print.

With the 40M+60Y+0C filter settings, all three wedges in this test print come out too blue. They, like the other tests, are judged against the standardized reference strip below, which was prepared for this volume.

With filtration at 35M+50Y+0C the tests are closer. The center wedge was judged the best of the nine, though still blue and too dark. A switch was made to 35M+45Y+0C and one second less exposure to make the final print (opposite).

With the 30M+40Y+0C filter setting, the three test wedges turn out to be on the reddish side. For the photographer who prefers warmer skin tones in his pictures, this filter combination might be the choice for further adaptation.

Too red: add magenta and yellow

Too green: subtract magenta

Too blue: subtract yellow

Too cyan: subtract magenta and yellow

Too magenta: add magenta

Too yellow: add yellow

Judging the Test to Achieve True Color

When the three test prints *(top row, opposite)* are dry, they provide clues to aid in making a final print *(right)*. Judge overall color balance by examining the sheets together in even light.

In the tests shown here, the sheet on the left came out obviously too blue, the one on the right too red. The middle sheet comes the closest to pleasing, natural colors, and its middle wedge appears to have the best color of all.

The final balancing of color is made by checking the best wedge against a group of pictures whose colors are distorted a known amount. Such a strip can be homemade or bought ready-made—or the strip employed in this demonstration *(opposite, bottom)* can be used as a general reference. Alternatively, the colors of the test print can be distorted by viewing them through a succession of filters; the filters then act as a guide for color correction.

At first glance the reference strip's prescriptions seem contradictory. The cure for a print that is too magenta, for example, is to increase—not decrease—the magenta setting. The reason, of course, is that the colors in the print are the reverse of the colors in the negative. Increased magenta in the light thus produces less magenta in the print. Similarly, the excess blue that appears in the best wedge is compensated by increasing the amount of blue in the light, that is, by lowering the setting of the filter that absorbs blue, the yellow filter.

The best wedge is used again to correct the exposure time. In the example illustrated here, the best wedge was a little too dark, so the exposure was reduced by one second.

The final combination: 35M+45Y+0C and 12 seconds' exposure.

Adapting Black and White Equipment

Although a dichroic head color enlarger and a processing drum simplify color printing, equipment used for black-and-white printmaking will serve. Almost all black-and-white enlargers and processing trays can be adapted for color.

A few accessories must be purchased to color-convert a black-and-white enlarger such as the condenser type shown at bottom right. A color-corrected enlarger lens is necessary: Most four- or six-element lenses that were manufactured after 1960 meet this requirement; but, if in doubt, make a test print in which light and dark colors abut; if a rainbow appears where the two colors meet, the lens is not color corrected. Also, add a piece of heat-absorbing glass below the light source. A voltage regulator *(page 180)* is highly recommended.

The principal item required is a set of color filters; the type depends on the enlarger. Inexpensive acetate filters, called CP (color printing) filters, can be used if the enlarger, like the one shown, has a built-in filter drawer between the lamp and negative. If the enlarger does not have a filter drawer, a filter holder must be attached below the lens and more expensive gelatin filters, called CC (color correcting) filters, must be used.

To determine the filters needed to produce a pleasing print, groups of filters, called filter packs, are used to make test wedges. The filter packs serve the same purpose as the dichroic filter settings on a color enlarger *(pages 191-193)*. For each common film type, paper manufacturers supply a starting filter pack recommendation, but tests are essential. All CC and CP filters bear density numbers corresponding to those on a dichroic head knob. A 40M (magenta) filter, for example, is four times denser than a 10M filter.

In combining filters of the same color, add together their densities: two 20Y filters give the same strength of yellow as one 40Y filter. Any number of filters can be combined, but in practice it is best to use as few as possible.

Filter sets often include red filters. A red filter does the work of separate magenta and yellow filters of the same density, allowing the printmaker to work with fewer filters.

An ultraviolet filter must be a part of every filter pack or installed permanently in the enlarger to prevent color distortions caused by ultraviolet light. If handled carefully and kept away from heat and moisture, both CC and CP filters will last for years, but eventually they will fade or buckle, and must be replaced.

A filter-equipped black-and-white enlarger is used to make the color test wedges and prints in the same way as a dichroic head enlarger. Follow the procedures described on pages 192-195.

For tray processing, most photographers will already have the equipment that is needed—a thermometer, a timer, gloves, scissors and trays *(page 177)*. Chemicals should be purchased in relatively large quantities; each tray requires a quart of solution, and the solutions, which become exhausted more quickly in open trays than in a drum, must be replenished frequently *(page 201)*.

For processing in trays, the Beseler 2-Step kit and the Ektaprint 2 kit are both widely used. Although both chemicals permit development at a wide variety of temperatures, the developer tray should be put in a larger tray containing water to keep the temperature constant. This extra tray is needed only for working in extreme temperatures—in a cold basement, for example, or on a very hot day.

1 cut the filters to size

Select a filter pack recommended by the paper manufacturer for the first test print (pages 192-193) and cut the filters in it to fit the enlarger's filter drawer. Include one ultraviolet filter.

2 insert the first filter pack

Stack the filters flat in the drawer one at a time; sequence does not matter. Expose the first test sheet in three wedges as shown on page 193, Step 4. Repeat with the other two test filter packs.

After being exposed, prints to be processed in trays should be put into a light-proof container like the black-lined paper box marked EXPOSED in the illustration at right. The processing must be carried out in total darkness, so advance preparation is essential. Have gloves and scissors near the container holding the exposed prints. Position the developer and the bleach-fix trays a few inches apart and fill each with one quart of solution.

In the following demonstration, three sheets of paper—the most that can be conveniently handled—are developed at one time. A clipped corner on one sheet enables the printmaker to keep track of the sheets by touch so that he gives each one the development time it requires. The only difficult part is learning to interleave the sheets while wearing gloves. But dexterity comes quickly with practice.

3 snip a corner on the first sheet

With the lights out, snip a corner off one sheet to mark it as the first sheet to go into the developer. Put on gloves and arrange the three sheets, emulsion (smooth) sides up, with the clipped sheet on top.

4 put the clipped sheet into the developer

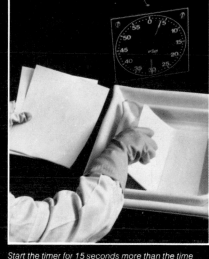

Start the timer for 15 seconds more than the time recommended for chemicals and temperature. Turn the clipped sheet over and—when the 15 seconds have elapsed—slip the sheet into the developer.

5 press the paper down

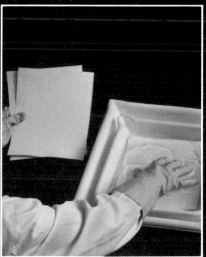

Press the sheet down so that it is completely covered by the developer. The emulsion side is now facing down and will remain this way during the rest of the developing and fixing cycle.

6 agitate the paper in developer

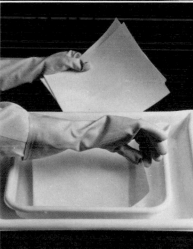

When the first sheet is immersed, gently grasp its top edge and agitate it back and forth for about five seconds. This and the previous step together should take about 20 seconds.

7 immerse the next two sheets

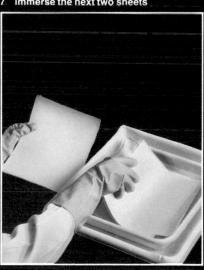

Immerse the second sheet 20 seconds after the first, agitating as before. After another 20 seconds, repeat with the last sheet. The sheets are now in order, the first one on the bottom.

8 lift out the first sheet

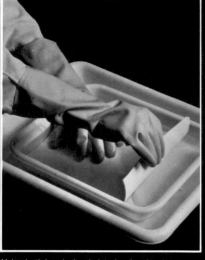

Using both hands, begin interleaving the sheets. To start, press down with one hand to prevent sliding. With the other hand grasp the bottom sheet by one edge and tug it out of the pile.

9 reimmerse the first sheet

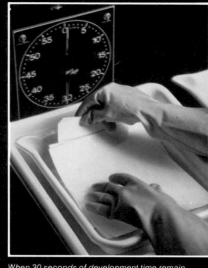

Holding the just-removed sheet lightly by opposite edges, reimmerse it, without draining, on top of the pile. Agitate it (Step 6). Then methodically interleave the other sheets.

10 remove the first sheet



When 30 seconds of development time remain, interleave to bring the clipped sheet to the bottom of the pile. Then pull it from the solution so that it is completely out when 20 seconds are left.

11 drain the sheet

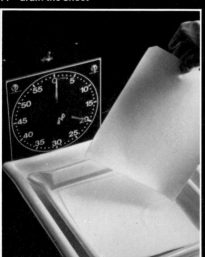

Start counting the seconds out loud to know when to remove the next two prints (now at 20 and 40). Drain the clipped sheet into the tray for not more than 20 seconds.

12 bleach-fix the first sheet

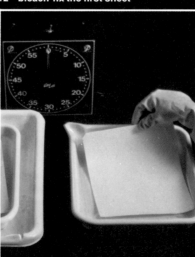

Put the clipped print into the bleach-fix; repeat with the other prints at 20-second intervals. Use the right hand in the bleach-fix and the left hand in the developer to prevent contamination.

13 bleach-fix the other sheets

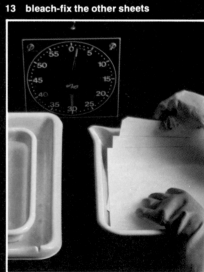

Bring both hands to the bleach-fix tray when the last print has been transferred. Then set the timer for the time required for the chemicals and temperature; interleave and agitate prints as before.

As soon as the prints have had their full treatment in the bleach-fix solution, the room lights may be turned on for the final wash. To protect the emulsions from being damaged by the water stream, run water at a moderately slow rate into a corner of the tray.

After washing, gently wipe each print on both sides with a clean sponge to remove the excess moisture. Then dry the prints by hanging them on a line with spring clothespins; direct warm air from a hair dryer at them to speed drying. If a large number of prints are to be processed, one of the widely available drying racks is helpful. Wet prints may have a blue cast; wait until a print is completely dry before evaluating it.

After the solutions have processed the first three prints, they lose some of their potency and need replenishment. This is done by adding small quantities of fresh chemicals to the solutions in the tray and discarding some of the used solution.

If the Ektaprint 2 process *(page 174)* is used, three ounces of fresh solution must be added to each tray, three ounces of old solution must be discarded and the processing times must be increased by 15 seconds for the next three prints. After that, each new batch of three prints requires three ounces of fresh solutions, three ounces discarded from each and a 30-second increase in processing times.

This procedure can be repeated as necessary—for as many as twelve 8 x 10 prints per quart. The partially exhausted solutions can be stored for a day or two. Make sure to pour them into bottles other than the ones that contain any unused solutions to prevent them from contaminating the fresh chemicals.

14 turn the prints over

15 wash the prints

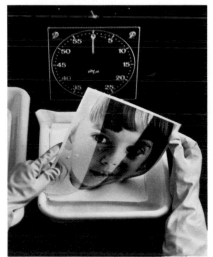

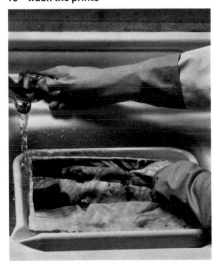

When the time for the bleach-fix bath is up, turn the prints over, one at a time, and transfer them to a clean tray near the sink for washing. The room lights may now be turned on.

To wash away bleach-fix solution, run water into a tray corner; water temperature and wash time will vary with chemicals used. Interleave the prints, draining the tray a few times and allowing it to refill.

A Shortcut to Good Results: The Color Analyzer

With a device known as a color analyzer, a previously unprinted negative or slide can be made into a pleasing print on the first try. The analyzer performs this time- and paper-saving feat by comparing the color of the enlarger light that is projected through the new negative with the light that was beamed through a reference negative to make a satisfactory reference print. Generally, a reference negative is one from which a successful test print was produced by the methods described on pages 191-197, but any negative will do if the filtration and exposure used to make a good print are recorded.

The analyzer must first be calibrated for the values of the light used to make the reference print. The reference negative is placed in the enlarger and projected onto the analyzer's probe, centered on the easel. The enlarger filter settings, lens aperture and magnification must be the same as for the reference print. The analyzer is manipulated to gauge separately the amounts of red, green and blue light in the projected image, and then the total amount of all colors combined. For each of the four measurements, a dial on the analyzer is turned until the needle on the analyzer meter centers.

At this point *(Step 9),* the analyzer dials indicate the color values and exposure that produced proper color balance in the reference image. The dials should not be moved and their positions should be recorded for future use. The analyzer can now compare the values of light passing through another negative with these recorded values. If the values differ, the meter needle will deflect from center. The enlarger filters or lens aperture — not the analyzer dials — are then adjusted until the needle returns to center.

Green and blue light in the new image are adjusted by changing the magenta and yellow filter settings. To control red light, however, the enlarger's lens aperture — not the cyan filter — is adjusted. For the final adjustment, overall intensity, the lens aperture is again used. This last adjustment affects the other three, so the sequence may have to be repeated.

In the procedure demonstrated here, the analyzer measures one spot of the projected image. This spot must be the same color in the reference negative and the one to be printed. The reference negative should therefore contain a common hue. Do not move the probe during measurement or turn on the room lights while the analyzer is on; either can cause inaccuracies. Film, paper and processing must be the same for the print being made as for the reference. A minor adjustment may be needed when using paper from a different batch *(page 191).*

1 insert the reference negative

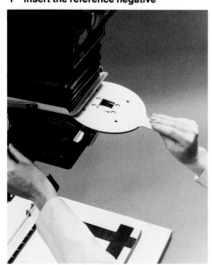

Put the reference negative in the enlarger. This should be one that was used to make a properly exposed and color-balanced reference print.

2 set the filters

Turn the filter-control knobs on the enlarger head to the previously recorded settings that were used to make the reference print.

3 prepare to focus

With the retractor lever, shift the filters out of the enlarger's light beam. Open the lens to its largest aperture for focusing. Turn off the room lights.

Turn on the enlarger, adjust the image size to that of the reference print and focus. Stop down the lens to the aperture used to make the reference print. Reengage the filters.

Place the photosensitive probe on a medium flesh tone in the middle of the projected image. The pinhole opening on the top of the probe should be directly under the enlarger lens.

Switch on the analyzer. Turn the probe selector — a device that moves color windows into position under the enlarger light beam — to cyan.

7 calibrating the analyzer for cyan

On the control unit, turn the cyan dial until the meter needle centers. The analyzer is now set for the cyan value in the reference image.

8 completing calibration

Switch the probe selector to yellow, magenta and white in succession, and repeat Steps 6 and 7, centering the meter needle with the appropriate dial. The analyzer is ready to evaluate a new negative.

9 insert the new negative

Put the negative to be analyzed in the enlarger. Adjust image size and focus. Then place the probe on a flesh tone at the image center. If necessary, move the negative to center a flesh tone.

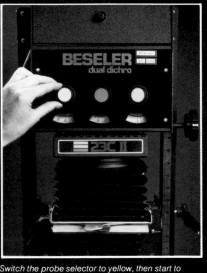

Switch the probe selector to yellow, then start to turn the knob on the enlarger head that controls the yellow filter. When the needle on the analyzer meter points to zero, stop turning.

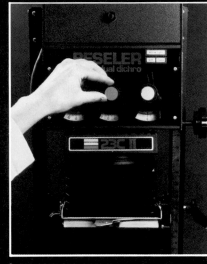

Switch the probe selector to magenta and turn the enlarger magenta knob until the meter needle points to zero. Preliminary adjustment of magenta and yellow filtration is now complete.

12 balancing for cyan and white

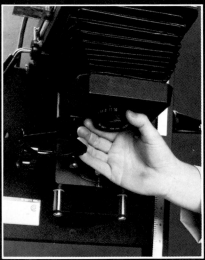

Turn the probe selector to cyan. Adjust the aperture of the enlarger lens, not the enlarger cyan knobs, until the needle centers on zero. Repeat Steps 10 th[]h 12 to refine the settings.

13 set the timer

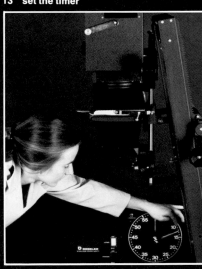

Turn the selector to white. Adjust the aperture of the enlarger lens until the needle centers. Set the timer for the time used for the reference print — here, 13 second[]expose the new negative.

Even with a color analyzer to help create balanced color, most photographers prefer to produce a contact sheet, which shows all frames of a roll of film printed together, before making enlargements. It provides a quick and economical means of selecting the negatives that will give the best results.

In black-and-white processing, making a contact sheet is the initial step. This cannot be done in color processing, for the enlarger must first be color-balanced.

The reason that advance balancing is necessary becomes obvious as soon as the first contact sheet is made. The sheet will, typically, contain pictures that were made at different times of different subjects, with different lighting and different colors. If the enlarger had not been balanced, even the pictures that had been correctly exposed in the camera would be off-color on the contact sheet, and there would be no way of judging which of several shots of a subject was the best. Balancing solves this dilemma.

Balanced with the basic filter settings used for the reference print, the enlarger will produce nearly correct color from any negative that has good density and good color balance. This is usually sufficient for a contact sheet, permitting the selection of a particular negative to be enlarged, but final color correction for the enlargement is best done with the aid of a color analyzer.

The procedure for making color contact sheets is essentially the same as that for making black-and-white ones. After development, roll film is cut into lengths that will fit into a contact printing frame—for 35mm film, strips of six frames each. Place the strips and the color printing paper in the printing frame with emulsions facing each other.

To make certain that the contact sheet gets the same exposure as the best reference print did, use the enlarger beam to expose the paper, adjusting the enlarger as for the reference print: enlarger head at the same height, exposure time and lens aperture the same. After the contact sheet has been processed, wait until the paper is completely dry before evaluating colors.

1 insert the negatives

Touching only the edges, put the negative strips into the top of the printing frame so that film emulsion sides face down. In darkness, place paper, emulsion side up, on the bottom. Close the frame.

2 process the contact sheet

After exposure—use the enlarger, set as for the test print (pages 192-193), for illumination—process the paper in trays (pages 199-201, Steps 3-15) or a drum (pages 194-195, Steps 1-10).

3 choose the best frames

With a magnifier, go over each frame on the sheet and select those that appear likely to need the least correction for color and density. Circle their frame numbers with a crayon or with a grease pencil.

Color Prints from Slides

Vivid prints made from transparencies are, if anything, easier and quicker to produce than prints from negatives.

The method demonstrated here can make prints with exceptionally rich color because it employs the unusual Cibachrome process. In most color prints, the dyes are formed chemically during development. But with Cibachrome, dyes brighter and more permanent than those created during development are put into the emulsion when the printing paper is being manufactured. The unnecessary dyes are bleached out during processing, leaving behind the colors that form the final image.

In making this kind of print, much as in printing from a color negative *(pages 188-197),* the first efforts should be directed toward a reference print that will establish basic exposure and filtration. Only one or two test prints are usually needed because printing conditions are not as critical for slides as for negatives—variations in exposure and filtration have less effect on the color.

The chemical differences between the materials used for printing from nega-

tives and those used for printing from slides, as well as some properties peculiar to Cibachrome, can all profoundly affect details of technique. Cibachrome paper is quite slow, for example, and often needs changes in the enlarger aperture to avoid prolonged exposure times.

Direct printing from slides, regardless of process, is a positive-to-positive procedure. In printing from slides, the effects of change in exposure or filtration are the opposite of those in negative-to-positive printing: More exposure, for example, makes a print lighter, not darker, and dodging and burning-in have the reverse effect. Print borders will be black, not white, if the easel covers them during exposure, and dust on the slide will produce black spots on the print.

In positive-to-positive printing, filter adjustment becomes easier to understand. Simply reducing the filter strength of an unwanted color will lessen that color in the print. To remove excess yellow from a print, for example, decrease the yellow filtration. To remove green, add magenta, green's complement, or reduce yellow and cyan. The cyan filter, when printing

from slides, is used for color corrections and is not reserved for special effects as when printing from negatives *(page 191).*

Mix processing solutions *(page 179)* before beginning the printing sequence pictured here. One ingredient is a powder that has to be dissolved in hot (100° to 125° F.) water. The rest are concentrates that are mixed into water of room temperature. Once mixed, the solutions should be used promptly; the developer has a storage life of two weeks. The bleach and fixing solutions, which will last from four to six months, are best mixed one quart at a time. Wear gloves.

A processing drum makes it easy to use the small amounts of solutions needed to process each print. Recommended temperature for the solutions and the water wash is 75° F. plus or minus three degrees. Within that range, processing takes 12 minutes. However, solution temperatures can be as low as 65° F. or as high as 85° F. if the processing times are changed as specified in the manufacturer's instructions. Rinse the drum after each print is processed; a drop of residue can ruin the next print.

1 cut open the slide mount

For precise focusing, remove the transparency from its mount. If the mount is cardboard, cut one quarter inch off the long side and pull apart. If the mount is plastic, snap the sides apart.

2 remove the transparency

Grasp the transparency by a corner to pull it free, being careful not to touch the emulsion. Clean it, put it into the negative carrier, and insert the carrier into the enlarger.

3 expose the print

Focus the image and adjust the filters, lens aperture and timer to the settings used for the reference print that was previously made for slides. Turn off the room lights and expose the print.

4 insert the print

Curl the print toward the emulsion and put it into a dry, clean drum. Seal the drum. Turn on the lights. If trays are used, keep the lights turned off until ready for the fixing stage.

5 measure the solutions

Measure out each solution—developer (1), bleach (2) and fixer (3)—to the amount shown on the measuring cup. Follow the sequence of Steps 6, 7, 8 three times, once for each solution.

6 pour in the solution

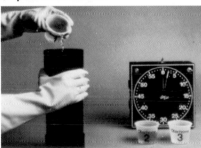

For each stage of processing, set the timer and empty the cup of solution into the drum. At room temperature—between 72° and 78° F.—total processing time will be 12 minutes.

7 agitate the drum

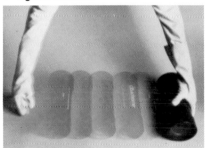

To prevent streaking caused by uneven spread of the solutions, agitate the processing drum at each stage by rolling it back and forth on the top of the darkroom table, or by using a motorized base.

8 drain the drum

After use, drain each solution for 15 seconds into a beaker containing a teaspoonful of a neutralizing powder provided with the Cibachrome chemicals. Used solutions can then be discarded.

9 wash the print

Carefully remove the print from the drum and wash it in rapidly flowing water for three minutes. Do not let the stream of water strike the print directly because it could damage the surface.

10 wipe the print

To hasten drying, gently squeegee the back of the print. Never use a hot drum dryer: Cibachrome has a plastic base that can stick to the drum and ruin both print and drum.

11 dry the print

For final drying, the print may be placed on an absorbent surface or hung up (as shown). For extra speed, use a hair dryer on the warm setting, which will produce a dry print in a few minutes.

The Artistry of Master Printmakers

The seven photographers whose prints are reproduced on this and the following pages work with a variety of processes: Patty Carroll *(right)* and Winston Boyer *(opposite)* produce 11 x 14 prints from transparencies *(pages 206-207);* some of them enlarge from negatives *(pages 186-205)* and Joel Meyerowitz contact-prints from 8 x 10 negatives. All, however, have undertaken printmaking from their determination to control their images from exposure to final print.

Some of the photographers do their own printing to ensure the print's complete fidelity to the colors they remember in the original subject. Joel Meyerowitz works to produce what he calls "ultimate description"—a print "incredibly true to the scene." He keeps a log while shooting to remind himself in the darkroom of such subtle points as the faint hues reflected by white walls *(page 211).*

Other photographers print their own pictures to bring out critical details or colors that might be lost in laboratory processing. Frequently these photographers shoot in extremes of light—Arthur Ollman *(page 210)* takes pictures in the middle of the night—and the resulting slides or negatives need manipulation in the darkroom to preserve essential elements. Mitch Epstein *(page 213)* often finds it necessary to block one corner with a mask or hand filter to get detail from an unevenly exposed negative.

Whatever their reasons for making their own color prints, these photographers have in common the ability to see the image in the camera's viewfinder as a final print, and the skill to realize that vision in the darkroom. "I can't separate picture taking from printmaking," says Leland Rice. "Being able to get exactly the final print I want is crucial."

PATTY CARROLL: *Pompano Beach, Florida,* 1978

Retaining the delicate balance of purple and orange in this shot of a Florida condominium—a slide made at twilight—required allowance for changes in contrast introduced by the positive-to-positive printing process. The entryway and light would have stood out glaringly against their darker surroundings if Carroll had not masked the bright areas for all but three seconds of a 45-second exposure.

Boyer, who uses positive-to-positive printing, anticipates the effects on his final image of both film and print material. In this California coastal vista, he knew that the muted foreground hues would turn out richer and sharper than they appeared to the eye. He also knew that the distant mountains and bay would merge with the sky if they were given the same exposure as the foreground. To compensate for this in printing, he darkened the upper third of the picture, exposing it for 15 seconds and the rest of the image for 60 seconds.

WINSTON BOYER: *Morro Bay, California,* 1979

To reproduce the luminous quality of this sunlit room, Meyerowitz gave extra printing exposure to the dense area around the window. Because the extra exposure would have made that area too yellow, he compensated by adjusting the enlarger filters to add a small amount of yellow to the light.

ARTHUR OLLMAN: *Sunset District, San Francisco, 1977*

Arthur Ollman created this otherworldly night view with a very long exposure that upset the color balance normally created by negative film's three layers. In processing he rebalanced some colors— the gray pavement—to normal, but left others unreal.

JOEL MEYEROWITZ: *Provincetown, Massachusetts*, 1977

This early-morning view of a Buddhist temple in the ancient Japanese capital of Kyoto consists of two superimposed images: the temple's wooden colonnade combined with its ornate roof tiles dripping melting snow. Composites such as this are most easily created from two negatives placed in the enlarger one atop the other and printed simultaneously. Exposure generally must be almost twice the normal time.

KUNIO YAMAMURA: *Picture Tales of Kyoto*, 1974

A dramatic sundown shot of desert nomads in
northwestern India left Epstein with a tricky negative
to print: darkly silhouetted figures against a
pastel sky. With a short exposure and some dodging
of the darkest areas, he was able to print the
figures clearly; he added about a third more
exposure time to the sky to darken it but masked
that area with a specially cut magenta filter to
prevent an excess of magenta.

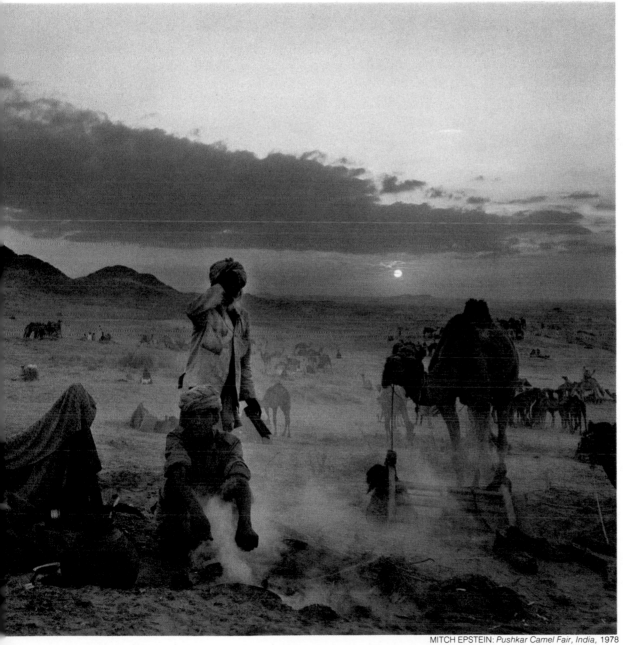

MITCH EPSTEIN: *Pushkar Camel Fair, India, 1978*

To capture the patterns created by the accumulations of pastel paints in an artist's spray booth, Rice spent hours adjusting his lights and his 4 x 5-inch camera striving for a perfect negative. Nevertheless, some darkroom improvements were required: He dodged the blue area at right to give it the silvery quality he remembered, and had to burn in the upper left corner to darken it.

LELAND RICE: *Los Angeles,* 1977

BEA NETTLES: *Fantastic Skies,* 1978

A World of Synthetic Color

When humorist Gelett Burgess wrote in the 19th Century, "I never saw a Purple Cow, / I never hope to see one . . ." he obviously did not anticipate some of the more adventuresome color photographs of the second half of the 20th Century. A purple cow would certainly be unremarkable in a world that includes a magenta horse, a salmon child and a woman whose scarlet skull gleams inside a blue profile of her head, all of which may be seen on the accompanying pages. Nor is this flouting of realism restricted to the rendering of color. Images are distorted, combined in startling photographic fantasies, even mutilated. In some instances, color pigments in an emulsion are literally scrambled to achieve a dramatic effect. The disquieting image of a one-eyed figure shown on page 224, for example, is the result of just such a manipulation. Painter-photographer Lucas Samaras shot a self-portrait with instant film, and before the emulsion had completely hardened, he began to press on the picture with the blunt end of a nail file. His poking caused the soft emulsion to mix and merge, producing a mottled, impressionistic effect.

Although such pictures bewilder many viewers, the leading exponents of color manipulation are serious creative artists with little or no interest in shock value for its own sake. Many of them began with conventional photography, but they have increasingly found orthodox methods and images too confining. One New York photographer put it this way: "A number of us have ideas that can't be realized by conventional techniques. Therefore we use others."

These innovative techniques range from the use of lasers and computers to the revival of 19th Century procedures like toning and hand-tinting black-and-white photographs. Hand-tinting dates back to the daguerreotype, when the technique was widely used to make portraits seem more lifelike. Toning, the use of a chemical bath to alter the color of shaded areas of a picture, was also traditionally employed to lend a lifelike warmth to black-and-white images. But today, when color film will produce far more realistic hues than could possibly be achieved by hand-tinting or by toning a black-and-white photograph, color manipulators are putting the time-honored techniques to totally different ends. Gwen Widmer, for example, gave her picture of a museum's desert diorama *(page 223)* an oddly heightened air of unreality by painting on colors that were just slightly exaggerated, and Naomi Savage used a series of toning baths to produce an image of a waif with a weird salmon-colored face *(page 221)*.

Other traditional techniques used to manipulate black-and-white photographs — copying and recopying images, masking part of an image, or making a composite by printing two or more negatives on the same paper — create particularly strange effects when color is added, as the pictures on pages 220 and 222 show. And when color film and chemicals are juggled, the results are just as strikingly unexpected. To create the magenta horse on page 226, Pete Turner processed his reversal film in chemicals meant for color negative film,

which switched light and dark areas and caused the colors to be inverted *(page 14)*. Thus a black horse against a blue background became a clear horse against a yellow background until Turner again altered the color by copying the image using a magenta filter.

Several of the manipulated color images that appear on the accompanying pages owe as much to painstaking craftsmanship as to the imaginative use of materials and techniques. The fanciful, fairy-tale image on page 217 was carefully constructed by photographer-teacher Bea Nettles with components culled from Indian miniature paintings, a self-portrait and photographs of the sky. Without using photographic paper, Nettles built up her image on a sheet of vinyl, coated repeatedly with layers of light-sensitive colored liquids. She exposed each layer to one of five different negatives as well as to various cutout shapes, taking, in all, 20 exposures to complete the print.

The search for new color effects has led some experimenters to test equipment not associated with traditional picture taking. Courtney Milne, for example, went to the offices of a company that had developed a computerized laser scanning process for making color prints from slides. By adjusting controls on a TV-like previewing monitor, he achieved dramatic color shifts in the sunset picture shown on page 232. Venturing even further from conventional photography, David Root used an office copying machine that reproduced in color to create a fragmented, life-sized mural of a ballerina *(page 229)*.

Such are the potentials that modern technology has brought to the color experimenter. But arguments about the merits of using color interpretively instead of realistically in photography have been going on since the days of Louis Daguerre and William Fox Talbot; the controversy will undoubtedly continue for as long as photographers feel strongly about the medium. However, one has only to look at a picture like Jerry Uelsmann's *Birth Image (page 220)* to recognize that the exponents of photographic manipulation are engaged in a powerful, if at times disturbing, means of expression, one that would be impossible to realize through conventional methods of color photography. □

Toning Black-and-White Images

Toning—adding color to a black-and-white print by placing it in a chemical solution—is a technique that dates back to the early days of photography, but it can produce wholly contemporary looking pictures when employed by such skilled photographers as Jerry N. Uelsmann and Naomi Savage.

Uelsmann, who produced the picture at right, began by making a paper print of two back-to-back sandwiched negatives of the girl's head, then a paper print of the house interior. A negative of the man lying in the sand was then printed, and before that print was developed, it was exposed through the two previous paper prints. The resulting black-and-white picture contained two negative images (the girl and the room) as well as one positive image (the stretched-out man). Next Uelsmann covered the image of the girl's face with rubber cement, a simple form of masking, and placed the print in blue toning chemical for five minutes. The cement-protected face was unaffected by the toner, but the rest of the print acquired a cold bluish tint. Finally he reversed that process, using a yellow toner to produce a gold face.

Mrs. Savage did not attempt to tone parts of her picture separately when she created the print on the opposite page. From a black-and-white negative, she made a paper print that was deliberately overexposed and overdeveloped in order to create deep, contrasting tones. This was then placed successively in blue, red and yellow toners, each additional color altering those introduced before. Since the process can be watched as it progresses, Mrs. Savage simply halted each stage when the color looked right to her.

JERRY N. UELSMANN: *Birth Image,* 1968

NAOMI SAVAGE: *Child*, 1965

Tints Added by Hand

The practice of hand-tinting black-and-white pictures with pencils, watercolors and oil paints has been popular since the 1840s because it allows color to be precisely and selectively applied. The finished effect can be lushly romantic, like the draped nude at right by two Spanish brothers, Ramón and Antón Eguiguren, or curiously unreal, like Gwen Widmer's vista opposite.

The image that the Eguiguren brothers colored is a photomontage. Each element—the weathered walls, the woman, her cloth wrap—was shot on a separate piece of black-and-white film. After the prints had been cut apart and pasted together, the composite image was tinted with watercolors, copied on color negative film and then printed.

The subject of Gwen Widmer's eccentric landscape is actually indoors—a desert diorama in the Field Museum of Natural History in Chicago. To enhance the scene's not-quite-natural look, the photographer recorded it on black-and-white film, then produced an enlargement purposely light and low in contrast. A light, soft print was easier to cover with the photographic oil paints she used, in subtly heightened colors, to underscore the view's counterfeit quality. The flat, almost shadowless lighting looks especially odd under a blue desert sky with its touches of twilight pink.

RAMÓN AND ANTÓN EGUIGUREN: *from Red Cloth series,* 1978

GWEN WIDMER: *from Places I Have Been series,* 1974

Far-Out Effects with Instant Film

LUCAS SAMARAS: *Phototransformation,* 1973

NORMAN LOCKS: *Suzy Pouring Tea,* 1977

The instant film that is so popular for family snapshots and studio tests provided the three dissimilar images reproduced here. The two photographs shown above were shot in the ordinary way, then manipulated; the one opposite is a photogram, a picture produced by exposing film without a camera.

Photographers Norman Locks and Lucas Samaras create their distorted images by using Polaroid's popular SX 70 camera. When an SX 70 picture is ejected from the camera after being shot, the image is still developing and the color dyes, sealed between layers of plastic, are in an almost liquid state. They do not fully harden for hours, and during this time, pressure on the surface causes the malleable colors to shift and bleed, thus scrambling and redefining the image.

Samaras used a nail file to rearrange the still-liquid dyes and to achieve the paint-stroke texture in his Cyclops-like self-portrait. Locks used a dentist's tool to press in the bold outlines and patterns in his tea scene.

Len Gittleman made his swirling melange of colors on an 8 x 10 sheet of professional Polacolor II. In the darkroom he placed curled pieces of colored paper on the film, then exposed it with filtered reflected light from his enlarger.

224

LEN GITTLEMAN: *Polaroid Photogram*, 1980

A Machine to Alter Colors

PETE TURNER: *Magenta Horse,* 1969

A lonely magenta horse almost lost against a limitless, fiery-red sky, and a menacing dark-blue cannon ball that dominates the somewhat lighter-blue scene of an Arab fort in Southeast Africa were created by the freelance photographer Pete Turner with the assistance of a color-slide duplicator.

A duplicator is simply a camera with which the photographer can make an exact copy of a transparency or, if he prefers, can increase or decrease the density and contrast of the image in the copy. When density and contrast are changed, the various colors are usually also altered. If the photographer wants to make major modifications of color, he places a color filter over the lens when making a copy.

Turner took the original picture of the cannon ball and fort at dusk with a blue filter over the lens and Kodachrome in the camera. But to generate the sense of power that is evident in the picture,

PETE TURNER: *Cannon Ball,* 1970

he increased its contrast by copying it — also onto Kodachrome film and also through a blue filter.

Making the picture of the horse was more complicated, requiring copying twice. Turner, who is known for his work in altering the colors of pictures, also made this original on Kodachrome film, using a blue filter. The horse came out black and the background blue. To make the striking version shown here, he placed that transparency in a color-slide duplicator and copied it on Ektachrome reversal film. By processing the Ektachrome as a negative rather than reversing it to a positive transparency, he inverted the colors: The blue background became yellow, and the black horse a clear area. Turner now made a copy of the Ektachrome transparency on Kodachrome, using a magenta filter over the lens. The filter turned the yellow area red and gave the horse its lonely-looking magenta hue.

227

Artistry with Office Copiers

The copiers that reproduce letters and records in offices are not generally considered to be cameras, nor are they often used for imaginative picturemaking. Yet the office copier is a camera containing a lens and light-sensitive material and it does make pictures. There is a twist: The subject must be brought to the camera.

When the copiers are used by artists, they can produce startling results, as the two color experiments on these pages demonstrate. Both were made by a process that creates a positive image directly from powdered inks or dyes, which are transferred to almost any kind of paper by a charge of static electricity.

Ellen Land-Weber, a California photography teacher, created the arrangement of delicately translucent seaweed at right with a 3M color copier. She first pressed the seaweed in a book to flatten it. She then she laid the strands on the machine, which has one of its light sources in its cover; using only the cover light, she backlighted the seaweed to capture its translucence. She copied some of the elements once and others twice onto a special transfer paper. Then she cut out the images and pressed them onto a sheet of rag paper, transferring the images onto the rag paper.

The multiple view of a ballerina *(opposite)* by David Root, a Washington, D.C., designer-photographer, consists of sixty 8½ x 14-inch color copy prints. To record the dancer, he positioned various portions of her body directly on the machine and copied them. He filled in the remaining sections with copy prints of postcards and gauzy fabric.

ELLEN LAND-WEBER: *The Natural Selection of Haeckel,* 1979

DAVID ROOT: *Ballerina*, 1978

Using Light to Add Color

To obtain these strange, sometimes sinister, abstractions, John Svoboda combined black-and-white transparencies, ordinary color film and colored lights. For the portrait on the opposite page, for example, he began with a physician's X-ray of his wife's head, from which he made 4 x 5 copies, one positive, one negative, on high-contrast film. Then he took a silhouette of his wife with a 4 x 5 view camera and copied it on high-contrast film.

At this stage Svoboda was ready to add color. With two transparencies, one that showed a dark skull against a clear background and another one that showed a clear head against a dark background, Svoboda made a sandwich, laid it over a piece of Ektachrome film in a contact printer and exposed the film to green light. The result was a dark skull inside the head against a green background. Taking his third transparency—this one with a dark head against a clear background—and superimposing it over the unprocessed Ektachrome, Svoboda made another contact exposure; this time blue light was used to turn the head blue against the green. Finally the last exposure was made on the still unprocessed sheet of Ektachrome, using a transparency that showed a dark background and light skull. Red light was used and the picture achieved its ultimate form: a transparency of a red skull inside a blue head on a green field.

The other pictures shown here were made in essentially the same manner, using several generations of black-and-white transparencies printed singly and in pairs on color film, each exposure of the color film being made with a different hue of light.

JOHN SVOBODA: *Experiments,* 1967-1969

JOHN SVOBODA: *Transparent Portrait*, 1969

Poster Colors from a Laser

COURTNEY MILNE: *Wakaw Sunset,* 1979

To create this oddly hued Saskatchewan sunset, Canadian photographer Courtney Milne converted a normal, realistic slide into one resembling a poster, deliberately compressing its wide range of colors into a few flat tones. Milne produced the effect on a special machine that employs computerized laser beams to make high-quality color prints from slides. The laser beams gauge the colors in the slide. Then the information enters a computer that controls a second set of lasers that re-create the original picture on color negative film. Rather than trying to achieve natural-looking results, however, Milne used the adjustable controls on the machine to alter colors until he got the combination of artificial hues he wanted.

Comparison of U.S. and Metric Units of Measurement

The United States lags far behind the rest of the world in adopting the universal system of metric measures— millimeters for inches, kilograms for pounds, liters for quarts, Celsius for Fahrenheit. Although January 1, 1979, signaled the official debut of American metrics—after that date wine had to be bottled in liters—the complete switchover to metrics in the United States promises to be slow and confusing as manufacturers place both the U.S. and metric measurements on their products.

To facilitate conversion in the years ahead, readers of the American edition of this book will find the measurements commonly used in photography included in the tables on this page.

Length

Inches (in.)	Millimeters (mm)	Feet (ft.)	Meters (m)	Miles (mi.)	Kilometers (km)
1 = 25.4		1 = .305		1 = 1.61	
2 = 50.8		2 = .610		2 = 3.22	
3 = 76.2		3 = .914		3 = 4.83	
4 = 102		4 = 1.22		4 = 6.44	
5 = 127		5 = 1.52		5 = 8.05	
6 = 152		6 = 1.83		6 = 9.66	
7 = 178		7 = 2.13		7 = 11.3	
8 = 203		8 = 2.44		8 = 12.9	
9 = 229		9 = 2.74		9 = 14.5	
.040 = 1		3.28 = 1		0.621 = 1	
.079 = 2		6.56 = 2		1.24 = 2	
.118 = 3		9.84 = 3		1.86 = 3	
.157 = 4		13.1 = 4		2.49 = 4	
.197 = 5		16.4 = 5		3.11 = 5	
.236 = 6		19.7 = 6		3.73 = 6	
.276 = 7		23.0 = 7		4.35 = 7	
.315 = 8		26.2 = 8		4.97 = 8	
.354 = 9		29.5 = 9		5.59 = 9	

Weight

Avoirdupois ounces (oz. avdp.)	Grams (g)	Avoirdupois pounds (lb. avdp.)	Kilograms (kg)
1 = 28.4		1 = .454	
2 = 56.7		2 = .907	
3 = 85.0		3 = 1.36	
4 = 113		4 = 1.81	
5 = 142		5 = 2.27	
6 = 170		6 = 2.72	
7 = 198		7 = 3.18	
8 = 227		8 = 3.63	
9 = 255		9 = 4.08	
.0353 = 1		2.20 = 1	
.0705 = 2		4.41 = 2	
.106 = 3		6.61 = 3	
.141 = 4		8.82 = 4	
.176 = 5		11.0 = 5	
.212 = 6		13.2 = 6	
.247 = 7		15.4 = 7	
.282 = 8		17.6 = 8	
.317 = 9		19.8 = 9	

Capacity—Liquid Measure

U.S. fluid ounces (fl. oz.)	Milliliters (ml)	U.S. liquid pints (pt.)	Liters (l)	U.S. liquid quarts (qt.)	Liters (l)
1 = 29.6		1 = 0.473		1 = .946	
2 = 59.1		2 = 0.946		2 = 1.89	
3 = 88.7		3 = 1.42		3 = 2.84	
4 = 118		4 = 1.89		4 = 3.79	
5 = 148		5 = 2.37		5 = 4.73	
6 = 177		6 = 2.84		6 = 5.68	
7 = 207		7 = 3.31		7 = 6.62	
8 = 237		8 = 3.79		8 = 7.57	
9 = 266		9 = 4.26		9 = 8.52	
.0338 = 1		2.11 = 1		1.06 = 1	
.0676 = 2		4.23 = 2		2.11 = 2	
.101 = 3		6.34 = 3		3.17 = 3	
.135 = 4		8.45 = 4		4.23 = 4	
.169 = 5		10.6 = 5		5.28 = 5	
.203 = 6		12.7 = 6		6.34 = 6	
.237 = 7		14.8 = 7		7.40 = 7	
.271 = 8		16.9 = 8		8.45 = 8	
.304 = 9		19.0 = 9		9.51 = 9	

Temperature

Celsius (Centigrade) (C.°)	Fahrenheit (F.°)
100	212
95	210 / 205 / 200
90	195 / 190
85	185 / 180
80	175 / 170
75	165 / 160
70	155
65	150 / 145
60	140 / 135
55	130 / 125
50	120
45	115 / 110
40	105 / 100
35	95 / 90
30	85 / 80
25	75 / 70
20	65 / 60
15	55
10	50 / 45
5	40 / 35
0	32 / 30
-5	25 / 20
-10	15 / 10
-15	5 / 0

Bibliography

General

Busselle, Michael, *Master Photography*. Rand McNally & Company, 1978.
De Maré: *Color Photography*. Penguin Books, 1968.
Eastman Kodak:
 **Adventures in Existing-Light Photography*. Eastman Kodak, 1969.
 **Color as Seen and Photographed*. Eastman Kodak, 1966.
Editors of *Life*, The, Larry Burrows, *The Compassionate Photographer*. Time Inc., 1972.
Focal Press Ltd., *Focal Encyclopedia of Photography*, McGraw-Hill, 1969.
Fondiller, Harvey V., ed., *The Popular Photography Answer Book*. Ziff-Davis Publishing Company, 1980.
†Haas, Ernst, *The Creation*. The Viking Press, 1971.
*Lahue, Kalton, ed., *Petersen's Big Book of Photography*. Petersen Publishing Company, 1977.
†Meyerwitz, Joel, *Cape Light*. Boston Museum of Fine Arts, and New York Graphic Society, 1978.
†Newman, Arnold, *One Mind's Eye*. David R. Godine, 1974.
Porter, Eliot, *Intimate Landscapes*. The Metropolitan Museum of Art, 1979.

History

Auer, Michel, *The Illustrated History of the Camera: From 1839 to the Present*. New York Graphic Society, 1975.
†Eder, Josef Maria, *History of Photography*. Columbia University Press, 1945.
Friedman, Joseph S., *History of Color Photography*. Focal Press, 1968.
Gernsheim, Helmut, and Alison, *The History of Photography from the Camera Obscura to the Beginning of the Modern Era*. McGraw-Hill, 1969.
Mees, C. E. Kenneth, *From Dry Plates to Ektachrome Film*. Ziff-Davis, 1961.
Newhall, Beaumont:
 The Daguerreotype in America. Dell, Sloan and Pearce, 1961.
 The History of Photography from 1839 to the Present Day. The Museum of Modern Art, Doubleday, 1964.
Penn, Irving, *Moments Preserved*. Simon and Schuster, 1960.
Petruck, Peninah R., ed., *The Camera Viewed*. E. P. Dutton, 1979.
Pollack, Peter, *The Picture History of Photography*. Harry N. Abrams, 1958.
Sipley, Louis Walton:
 A Half Century of Color. Macmillan, 1951.
 Photography's Great Inventors. American Museum of Photography, 1965.
Wall, E. J., *The History of Three-Color Photography*. American Photographic Publishing Co., 1925.

Science of Color

Bartley, S. Howard, *Principles of Perception*. Harper & Row, 1958.
Begbie, G. Hugh, *Seeing and the Eye*. Natural History Press, 1969.
Burnham, Robert W., et al., *Color: A Guide to Basic Facts and Concepts*. Wiley, 1969.
*Eastman Kodak, *Color as Seen and Photographed*, Data book E-74. Eastman Kodak.
Evans, Ralph M.:
 Eye, Film and Camera in Color Photography. Wiley, 1969.
 An Introduction to Color. Wiley, 1948.
Le Grand, Yves, *Light, Colour and Vision*. Wiley, 1957.
*Minnaert, M., *The Nature of Light & Colour in the Open Air*. Dover, 1964.
Mueller, Conrad G., and Mae Rudolph and the Editors of Time-Life Books, *Light and Vision*. Time-Life Books, 1969.

Technique

Eastman Kodak:
 Adventures in Color-Slide Photography, AE-8. Eastman Kodak, 1975.
 Basic Developing, Printing, and Enlarging in Color, AE-13. Eastman Kodak, 1978.
 Kodak Color Darkroom Dataguide. Eastman Kodak, 1979.
 Kodak Color Dataguide, R-19. Eastman Kodak, 1968.
 Kodak Color Films, Color Data Book E-77.
 Eastman Kodak, 1968.
 Kodak Professional Photoguide. Eastman Kodak, 1975.
 Printing Color Negatives, Data Book E-66. Eastman Kodak, 1969.
Feininger, Andreas:
 Successful Color Photography. Prentice-Hall, 1969.
 The Color Photo Book. Prentice-Hall, 1969.
James, Thomas H., ed., *The Theory of the Photographic Process*. Macmillan Publishing Co., Inc., 1977.
Lewis, Eleanor, ed., *Darkroom*. Lustrum Press, 1979.
Nadler, Robert, *The Color Printing Manual*. Amphoto, 1977.
Spencer, D. A., *Color Photography in Practice*. Focal Press, 1966.
Stone, Jim, ed., *Darkroom Dynamics: A Guide to Creative Darkroom Techniques*. Curtin & London, Inc. and Van Nostrand Reinhold Company, 1979.
Thompson, C. Leslie, *Colour Films*. Chilton, 1969.
Vestal, David, *The Craft of Photography*. Harper & Row, 1975.
Wade, Kent, *Alternative Photographic Processes*. Morgan & Morgan Inc., 1978.

Magazines

American Photographer, CBS Publications, New York City.
Aperture, Aperture Inc., Millerton, New York.
British Journal of Photography, Henry Greenwood and Co., London.
Camera, C. J. Bucher Ltd., Lucerne, Switzerland.
Camera 35, U.E.M. Publishing, New York City.
Darkroom Photography, PMS Publishing Co., San Francisco.
Modern Photography, ABC Leisure Magazines, New York City.
Petersen's Photographic, Petersen Publishing Co., Los Angeles.
Popular Photography, Ziff-Davis Publishing Co., New York City.
Zoom, Publicness, Paris.

*Available only in paperback
†Also available in paperback

Acknowledgments

The index for this book was prepared by Karla J. Knight. For their help in preparing this book, the editors would like to express their gratitude to: Myles Adler, Teterboro, New Jersey; Thomas F. Barrow, Asst. Curator of Collections, George Eastman House, Rochester, New York; Adam Bartos, New York City; Lee Boltin, New York City; Isabella Brandt, Chicago, Illinois; The New York Botanical Garden, Bronx, New York; Charles Bray, LaserColor Laboratories, New York City; Russell Burrows, New York City; Walter Clark, Rochester, New York; Charles and Tirca Cohen, New York City; Louis M. Condax, Rochester, New York; Corporate Information Department, Eastman Kodak Co., Rochester, New York; Susan Dean, LaserColor Laboratories, West Palm Beach, Florida; Ehrenreich Photo-Optical Industries, Inc., Garden City, New York; Alfred Geller, Royaltone Inc., New York City; Leopold Godowsky Jr., Westport, Connecticut; Professor L. Fritz Gruber, Cologne, Germany; David Haberstich, Asst. Curator, Section of Photography, Smithsonian Institution, Washington, D.C.; Ira S. Itzkowitz, Hoyaltone Inc., New York City; Dorothy Kehaya, New York City; Carole Kismaric, Managing Editor, *Aperture*, New York City; Kiki Kogelnick, New York City; Peter Krause, General Manager, CIBA Corporation, New York City; Abraham Kurtz, New York City; Thomas Mason, Manager, Product Publicity, Advertising and Promotion Dept., GAF Corporation, New York City; Robert E. Mayer, Manager, Photographic Services, Bell & Howell Photo Sales Co., Chicago, Illinois; Minolta Corporation, Ramsey, New Jersey; Robert Mobley, McLean, Virginia; Beaumont Newhall, Director, George Eastman House, Rochester, New York; Jess E. Nicotera, Public Relations, 3M Co., New York City; Al Nordheden, New York Horticultural Society, New York City; Horace D. Randolph, Museum Technician, Section of Photography, Smithsonian Institution, Washington, D.C.; Bob Rose, Beseler Photo Marketing Company, Inc., Florham Park, New Jersey; Jerry Samuels, Arkin-Medo Inc., New York City; Mrs. Louis W. Sipley, Philadelphia, Pennsylvania; Robert A. Sobieszek, Curatorial Asst., George Eastman House, Rochester, New York; and John D. Upton, San Clemente, California.

Picture Credits *Credits from left to right are separated by semicolons, from top to bottom by dashes.*

COVER: Kishin Shinoyama, Tokyo; Harald Sund; © Ernst Haas.

Chapter 1: 11: Sebastian Milito. 12: Light bulb photo by Harold Zipkowitz; egg photo by Sebastian Milito; drawing by Pierre Haubensak. 13: Light bulb photo by Harold Zipkowitz; apple photo by Ken Kay; drawing by Pierre Haubensak. 14, 15: Sebastian Milito. 16, 17: Photographs by Robert Crandall, Herb Orth; drawings by Nicholas Fasciano. 18, 19: Photographs by Robert Crandall, Herb Orth, Sebastian Milito; drawings by Nicholas Fasciano. 20, 21: Drawings by Jack Nelson, Forte Inc. 22: Drawing by Nicholas Fasciano. 23-25: Sebastian Milito. 26, 27: © Pete Turner. 28: Polaroid by Marie Cosindas. 29: John Chang McCurdy. 30: Joel Meyerowitz. 31: Shiro Shirahata, Tokyo. 32: William Eggleston, courtesy Lunn Gallery/Graphics International Ltd. 33: Stephen Shore. 34, 35: Jay Maisel; Bill Binzen. 36, 37: Photographed by Phil Marco © 1976; © Gilles Larrain. 38, 39: John Launois from Black Star. 40, 41: Lennart Nilsson, from *A Child Is Born* published by Delacorte Press/Seymour Lawrence Dell Publishing Company, New York; courtesy Jet Propulsion Laboratory, California Institute of Technology. 42: Danny Lyon, courtesy E.P.A.-Documerica. 43: Bill Gillette, courtesy E.P.A.-Documerica. 44, 45: © 1980 Alon Reininger from Contact. 46, 47: Harald Sund. 48: Reid Miles. 49: Gene Laurents. 50, 51: Franco Fontana, Modena, Italy; Gary Braash. 52, 53: Art Kane; Syl Labrot. 54: Ken Kay.

Chapter 2: 57: Dmitri Kessel, courtesy Firms of the Société Lumière, Lyon. 59: Paulus Leeser, courtesy Smithsonian Institution. 60: Color separations by Herb Orth after originals by Frederic Ives. 61: Dye transfer print by Louis Condax, courtesy George Eastman House — drawing by Nicholas Fasciano. 62: Courtesy American Museum of Photography-3M Company, Société Française de Photographie, courtesy American Museum of Photography-3M Company. 63: Paulus Leeser, courtesy George Eastman House. 65: Drawing by Nicholas Fasciano; light bulb photo by Harold Zipkowitz. 66: Paulus Leeser, courtesy George Eastman House. 68, 69: Courtesy Eastman Kodak Company. 70: Courtesy Kodak Research Laboratories. 72, 73: Drawings by Otto van Eersel. 75-78: Dmitri Kessel, courtesy Firms of the Société Lumière, Lyon. 79, 80: Derek Bayes, courtesy Kodak Ltd.

Chapter 3: 83: Harald Sund. 86, 87: Jean-Max Fontaine. 88-91: Bill Binzen. 92, 93: Douglas Faulkner. 94, 95: Maitland A. Edey. 96, 97: Harald Sund. 98, 99: Alfred Eisenstaedt for *Life*. 100: Farrell Grehan. 101: Bill Binzen. 102, 103: Donald Hinkle; Leif-Erik Nygards. 104: Norman Rothschild.

Chapter 4: 107: Evelyn Hofer. 110: Jay Maisel. 111: Humphrey Sutton. 112: John Dominis for *Life*. 113: Vernon Merritt III for *Life*. 114, 115: Sam Zarember. 116: © Enrico Ferorelli 1979. 117: © Enrico Ferorelli 1978. 118: Peggy Barnett. 119: Charles Blackwell; Peggy Barnett. 120: Evelyn Hofer. 121: Charles Blackwell (2); Evelyn Hofer. 122, 123: Evelyn Hofer. 124: Anthony Donna. 125: John Zimmerman. 126, 127: Nina Leen for *Life*. 128: Sebastian Milito. 129: Richard Meek. 130, 131: Farrell Grehan. 132, 133: Ken Kay. 134: Lee Boltin, courtesy Tirca Karlis Gallery, Provincetown, Massachusetts.

Chapter 5: 137: Bert Stern; © Warren Martin Hern 1980 — Richard Rowan; original photograph by Roger Mattingly, courtesy Russell Burrows. 140: Irving Penn, courtesy *Vogue*, © 1953 by The Condé Nast Publications Inc. 141: Irving Penn © 1954, DeBeers Consolidated Mines, Ltd. 142: Irving Penn, courtesy *Vogue*, © 1948 (renewed) 1976 by The Condé Nast Publications Inc., courtesy The Museum of Modern Art, New York (gift of the photographer) 143: Irving Penn, courtesy *Vogue*, © 1949 (renewed) 1977 by The Condé Nast Publications Inc. 144, 145: Irving Penn, courtesy *Vogue*, © 1970 by The Condé Nast Publications Inc.; Irving Penn, courtesy *Vogue*, © 1969 by The Condé Nast Publications Inc. 146: Irving Penn, courtesy *Vogue*, © 1950 (renewed) 1978 by The Condé Nast Publications Inc. 147: Irving Penn, courtesy *Vogue*, © 1971 by The Condé Nast Publications Inc. 148-155: Eliot Porter. 156-163: Ernst Haas. 164-170: Larry Burrows for *Life*.

Chapter 6: 173: Winston Swift Boyer. 174: Drawing by Walter Hilmers Jr., HJ Commercial Art. 177-179: Al Freni. 180: Negative copied by Ken Kay. 181: Drawing by Nicholas Fasciano — drawing by Walter Hilmers Jr., HJ Commercial Art. 182-195: Al Freni. 196, 197: Dorothea Kehaya. 198-206: Al Freni. 207: Jack Escaloni, except top left, Al Freni. 208, 209: Patty Carroll; Winston Swift Boyer. 210: Arthur Ollman. 211: Joel Meyerowitz. 212, 213: Kunio Yamamura, Kyoto; Mitch Epstein. 214: Leland Rice.

Chapter 7: 217: © Bea Nettles. 220: Jerry N. Uelsmann. 221: Naomi Savage. 222: Ramón and Antón Eguiguren. 223: Gwen Widmer. 224: Lucas Samaras, courtesy The Pace Gallery, New York; Norman Locks. 225: Len Gittleman. 226, 227: © Pete Turner. 228: Ellen Land-Weber, copied by Fil Hunter. 229: David Root, copied by Fil Hunter. 230, 231: John Svoboda. 232: Courtney Milne, Saskatoon, Canada.

Index
Numerals in italics indicate a photograph, painting or drawing.

238